IMAGES
of America

LYCOMING COUNTY'S
INDUSTRIAL HERITAGE

IMAGES
of America

LYCOMING COUNTY'S INDUSTRIAL HERITAGE

Robin Van Auken
and Louis E. Hunsinger Jr.

ARCADIA
PUBLISHING

Copyright © 2005 by Robin Van Auken and Louis E. Hunsinger Jr.
ISBN 978-1-5316-2241-1

Published by Arcadia Publishing,
Charleston, South Carolina

Library of Congress Catalog Card Number: 2004117971

For all general information, contact Arcadia Publishing:
Telephone 843-853-2070
Fax 843-853-0044
E-mail sales@arcadiapublishing.com
For customer service and orders:
Toll-free 1-888-313-2665

Visit us on the Internet at www.arcadiapublishing.com

CONTENTS

ACKNOWLEDGMENTS

Lycoming County has provided stable jobs for many and fortunes for a few. Settlers transformed its pioneer villages into thriving communities where generations of immigrants found opportunity and made homes. However, Lycoming County's century of great prosperity and productivity ended in the 1960s. The economic boom of the 1950s created labor shortages, and to overcome this, corporations worldwide looked to countries where unemployment was high and labor was cheap. Soon, American companies began exporting jobs, leaving those that did not undercut and out of business.

This book is a nostalgic tribute to the hardworking people who built Lycoming County and, in doing so, built America. It is a message of loss and, sometimes, a message of corporate abandonment.

We are grateful to several individuals, organizations, and institutions for their valuable support in the making of *Lycoming County's Industrial Heritage*. Richard Ogurcak suggested the topic of lost labor. His passion for the subject and his enthusiasm convinced us that a book about industry could be appreciated.

This book is a photographic sampling of local industry and individuals that were published by the *Grit* newspaper. We are particularly appreciative for the use of the *Grit* collection, preserved by the *Williamsport Sun-Gazette*. We thank publisher John Yahner and editor Dave Troisi for their unflagging generosity.

The James V. Brown Library staff has been most supportive; we thank executive director Janice Trapp and librarians Tricia Haas, Nancy Shipley, and Wanda Bower for their interest in our project. We also recognize the Lycoming County Genealogy Society volunteers and the Lycoming County Historical Society staff, particularly executive director Sandra Rife, for their continued support.

Finally, we thank Sarah and Lance Van Auken, Janice Ogurcak, and Doris and Louis Hunsinger Sr. for their editorial assistance.

—Robin Van Auken and Louis E. Hunsinger Jr.

INTRODUCTION

The Revolutionary War ended when Congress ratified the Treaty of Paris on January 14, 1784. On October 23, 1784, a treaty with Native Americans for the acquisition of lands east of the Allegheny Mountains was signed at Fort Stanwix in Rome, New York, and the Pennsylvania Land Office opened on May 1, 1785. The price for land was £30 for 300 acres. To prevent speculation, only actual settlers were able to buy vacant land until 1817.

Soon, emigrants flocked to the valley to build homes and farm the land that would become Lycoming County. Most of the original settlers who left during the "Big Runaway" returned, claiming it by virtue of preemption right. By the mid-1790s, the bulk of the region's population was settled in the West Branch Valley. Its residents resented having to attend to matters in Northumberland, the county seat 50 miles away in Sunbury. From 1786 to 1795, petitions were made to the state assembly for a new county. On February 1, 1796, the new county was named Lycoming, after the creek that had once formed the boundary line between Northumberland and the disputed Native American lands.

In 1795, Michael Ross employed surveyors to lay out the town, and on July 4, 1796, he began selling lots for Williamsport. It was incorporated as a borough in 1806 and became the new county's seat. In 1856, after its incorporation as a city, Williamsport began to show signs of rapid improvement. Its population, only 1,615 in 1850, jumped to 5,664 in 1860. The economic outlook for the city, and for the region, was most encouraging. The developing lumber business would soon be a powerful factor in the progress of the town, and its resultant industries.

In addition to Williamsport, Lycoming County consists of a number of important municipalities. Montoursville was named for Andrew Montour, a Native American interpreter who lived along the Loyalsock Creek. The first settler was John Else, whose father purchased 200 acres on Mill Creek in 1807. Gen. John Burrows bought land in Montoursville in 1812. James Moore then purchased Burrows's land in 1814 and built the first bridge across Loyalsock. A post office opened on April 23, 1831, and Montoursville was incorporated as a borough on February 21, 1853.

Jersey Shore was so named because its first settlers, Reuben Manning and his nephew Thomas Forster, were both from Essex County, New Jersey. As the settlement grew and was incorporated as a borough on March 15, 1826, it became known as Jersey Shore.

Northeast of Jersey Shore lies Salladasburg, founded in 1837 by Capt. Jacob Sallade, who also owned the town's gristmill. Robert McCullough's tannery was the leading industry in the early years of Salladasburg, which was incorporated as a borough in 1884.

South Williamsport was settled by Germans at Hagerman's Run, an area near the Market Street bridge. It was once known as Rocktown because of the rocky soil found there. Another section of present-day South Williamsport was called Bootstown, named for a nearby man who had stolen a pair of boots. Jacob Weise started the South Williamsport Land Company, with 40 acres, and the area was incorporated as a borough on November 29, 1886.

Located at the mouth of Mosquito Creek, DuBoistown was once owned by Samuel Boone, brother of Hawkins Boone, a martyred Native American fighter and cousin of Daniel Boone. Andrew Culbertson established a gristmill and sawmill there, and in 1856, John DuBois laid out a town. DuBoistown was incorporated as a borough on October 14, 1878.

Jeptha Hughes bought land in eastern Lycoming County on March 23, 1816, laid out a town, and named it Hughesburg. Paul Willey opened the first tavern there in 1820, and the first

post office was established in 1827. Now named Hughesville, it was incorporated as a borough on April 23, 1852.

The borough of Picture Rocks lies north of Hughesville, and nearby, a ledge of rocks rises from the bank of the Big Muncy Creek to a height of more than 200 feet. The first settlers found a number of Native American pictographs painted on the rocks. A. R. Sprout and Amos Burrows founded the town in the fall of 1848, naming it Picture Rocks. The first post office was established in 1861, and the borough was incorporated on September 27, 1875.

Cornelius Low was likely Montgomery's first settler in 1778, with John Lawson and Nicholas Shaffer following soon. A post office was established in the town, then called Black Hole, on March 26, 1836, with Samuel Ranck as its first postmaster. In 1853, Black Hole became Clinton Mills and, in 1860, Montgomery Station. Built on land taken from Clinton Township, Montgomery became a borough on March 27, 1887.

Muncy was one the earliest places to be settled in the West Branch Valley, surveyed by John Penn in 1769. Four brothers—Silas, William, Benjamin, and Issac McCarty—settled the area in 1787 and bought lots. In 1797, Benjamin McCarty laid out the town that he named Pennsborough. It grew slowly, earning the nickname of "Hardscrable." The first post office was established in April 1801, and Pennsborough was incorporated as a borough on March 15, 1826. On January 19, 1827, the name was changed to Muncy.

One

AGRICULTURE
AND LUMBER

The first improved land in Lycoming County was a 300-acre property on Muncy Creek, owned in 1760 by Dennis Mullin. The first Colonial-era farms, according to historian John F. Meginness, most likely were three small parcels dating to 1761. The first was a four-acre tract of cleared, half-fenced land belonging to Bowyer Brooks; the second, a three-acre clearing and a small dwelling belonging to Robert Roberts; and the third, a four-acre tract and house owned by James Alexander. Meginness writes that these men "may have been early adventurers" who disputed treaty lines and tried to drive out the Native Americans.

The most ambitious settler was Samuel Wallis, a Muncy land speculator who moved to the area in 1768. Having acquired all the land that he could in his own name, he negotiated with others to buy land and then transfer it to him. Thus, he bought thousands of acres upon which he built his plantation, Muncy Farms, in 1769.

Robert Martin erected the first gristmill as early as 1797 or 1798. It stood on the west side of Lycoming Creek.

George Edkin of New York began the first nursery in 1794, bringing with him a large number of apple, peach, pear, and plum tree shoots. Settlers in Muncy Valley, and up the river as far as Williamsport, bought his fruit trees.

In addition to agriculture, Lycoming County's most lucrative natural resource was its forests. Settlers cut logs for two reasons: to build cabins or to clear land. Soon, the need for finished lumber arose, and the area's timber industry began.

After logs were cut, they had to be transported to sawmills. Roland Hall built the first sawmill in the county in 1792 on the banks of Lycoming Creek. Although crude in its construction, it provided lumber for many of the first houses in the area. Peter Tinsman introduced circular saws at Williamsport's first steam-powered sawmill on January 1, 1852. Prior to 1854, there were no planing mills in the area. However, the boom in construction demanded a rapid method of surfacing and dressing lumber. This new industry soon employed more than 500 men and boys.

Lycoming County quickly evolved into a major lumber center. To catch the millions of logs floating down the river, enterprising lumbermen built the Susquehanna Boom, a chain of logs stretching across the river. The six-mile stretch was able to hold 300 million feet of logs at one time. At the height of the lumber era, 30 sawmills operated in the area. In 1873, the peak year, 1,582,450 logs were converted into lumber.

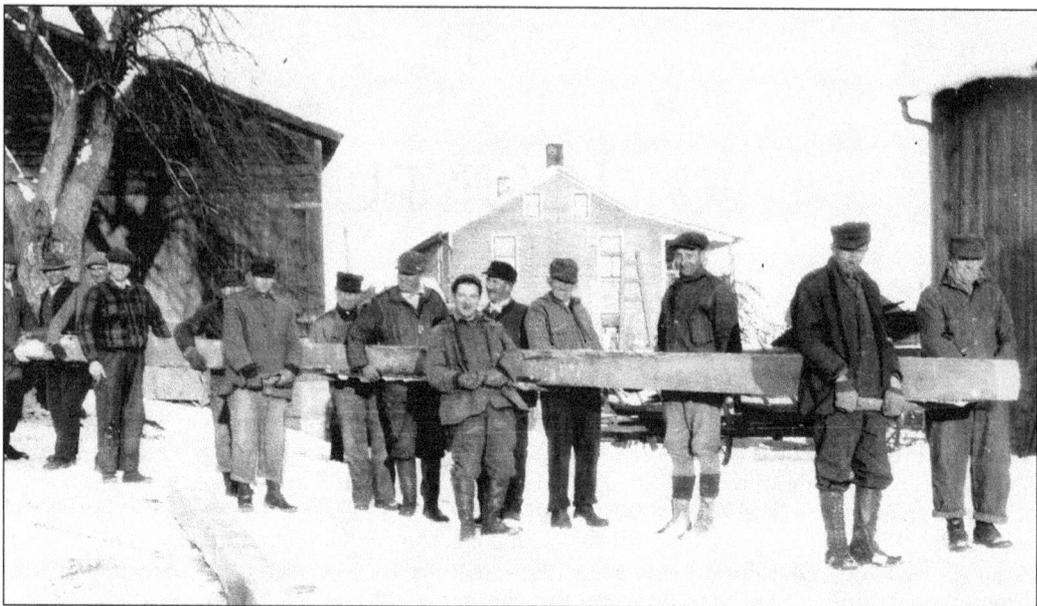

Farmers gather in the winter of 1931 to help a neighbor with an old-fashioned barn raising. Men from the surrounding area, along with their wives and children, attended the event at the Norman Beach farm on Hepburnville Road. With two carpenters, George Long and Charles Nunn, to boss the job, these 40 sturdy tillers of the soil erected the heavy framework in a single day. (December 15, 1931.)

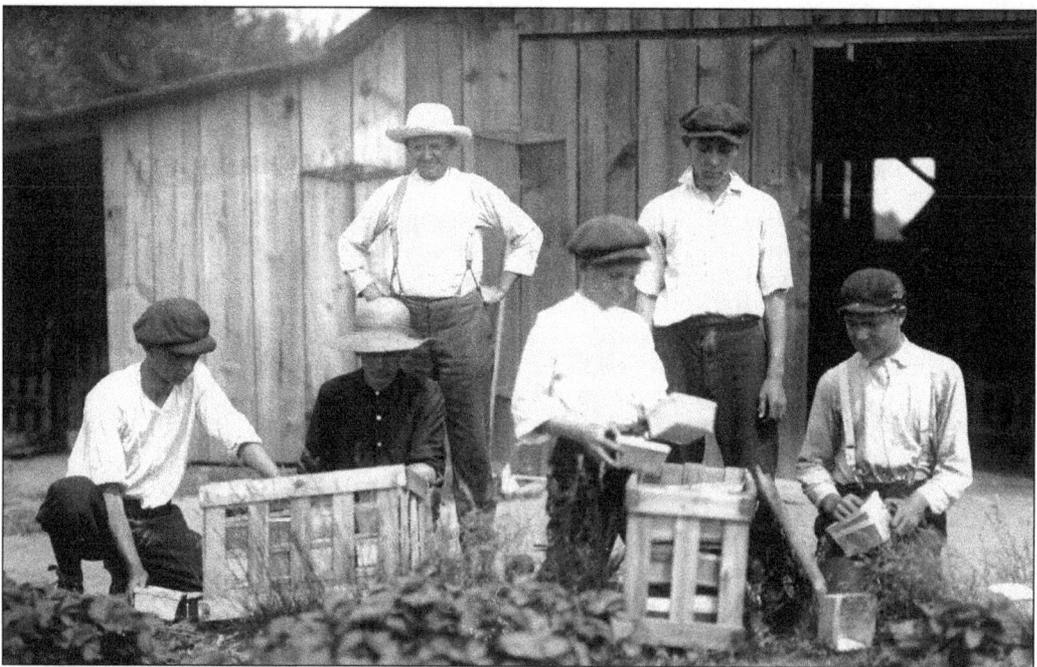

Young boys earn a summer's wage picking strawberries on the King and Nuse Farm in Montoursville. Strawberry picking is still a popular summer outing, the *Grit* newspaper reported in 1920, "but for the farm worker it is a labor that can make backs ache, wreck knees and cause a permanent distaste for the red berry." (*c.* June 1920.)

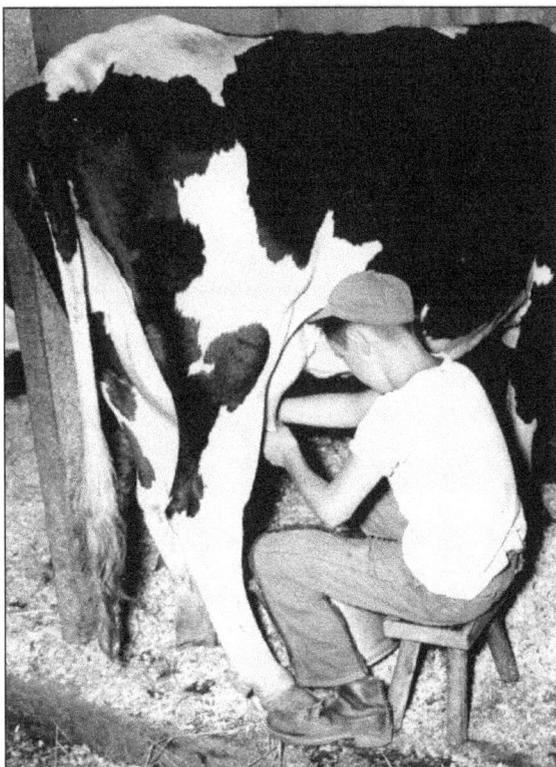

Dale Young of Sylvan Dell Road milks a cow on his father's farm. The dairy industry saw significant changes in the 1940s. During World War II, inventors designed tanks, pumps, and machinery that made it possible to handle milk in bulk. Cows were brought in to the milking parlor, an automatic milking machine was attached to the udder, and milk was pumped into large tanks and immediately cooled. (July 21, 1946.)

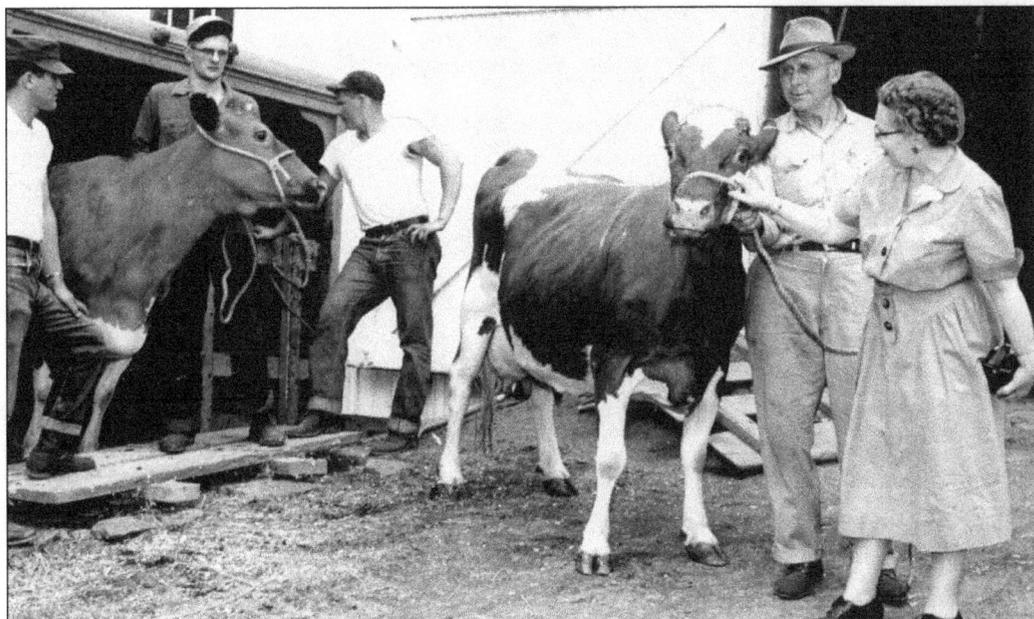

Guernseys are unloaded from trucks at the Wyno Farm, the new home for 113 valuable purebred cattle from the Northwest. At right, Roy Jones of Portland, Oregon, manager of the Wandamere Farm, where the cattle were purchased, shows one of the animals to Lucinda (Mrs. Alvin) Bush. After 1950, the use of artificial insemination enabled farmers to improve the milk-production potential of each animal. (April 25, 1954.)

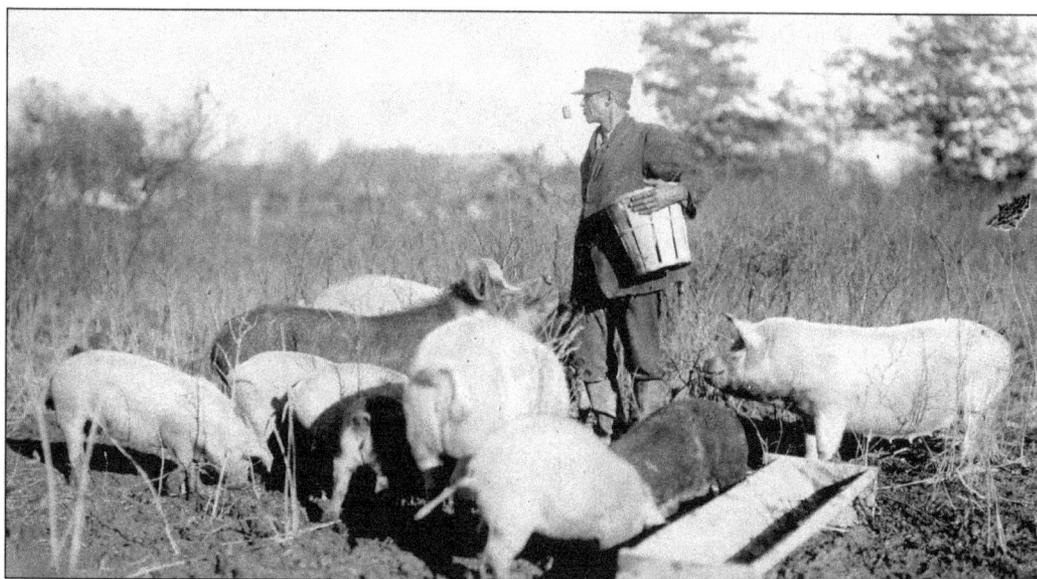

J. E. Whitman, proprietor of a pig farm in Old Union Park, owned some of the finest porkers in Lycoming County. Whitman had 80 pigs and planned to build a concrete hog pen that would shelter an additional 100. He fed his pigs cooked garbage and treated the animals as pets. Here, he feeds his favorite, Blackie, as well as several other hogs. (November 21, 1915.)

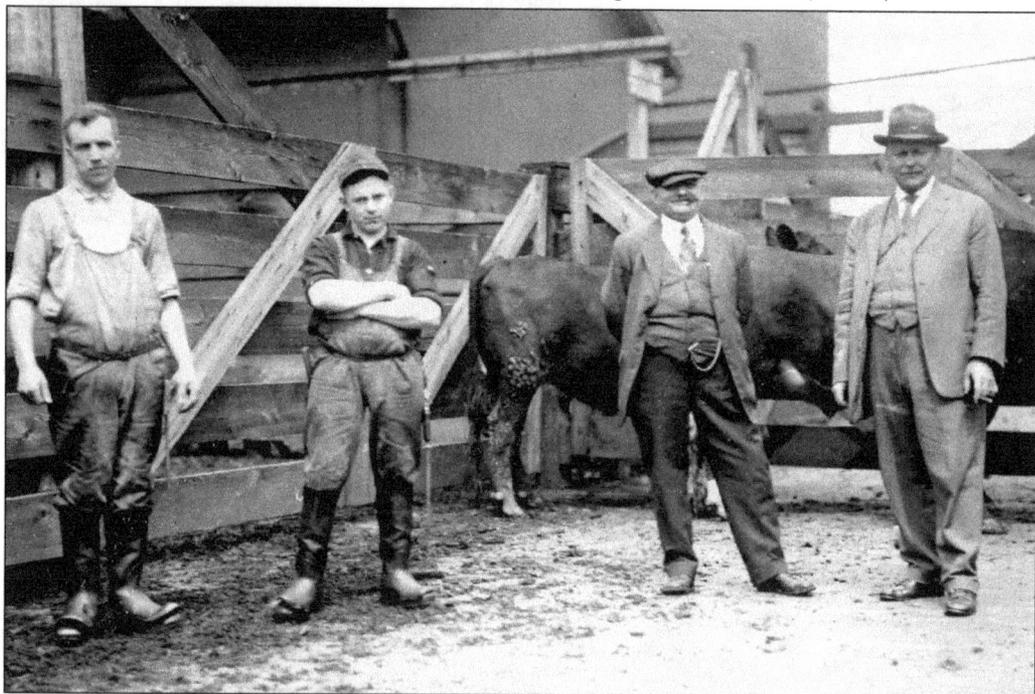

Butchers at John Peters's slaughterhouse pose for a photograph for a newspaper feature about superior beef cattle. Brought from Kentucky and fattened in Lycoming County, the cattle yielded a very high meat percentage. Because the cows' weights were significantly higher, the slaughterhouse claimed that the time and trouble required to produce the meat was warranted by the high price it commanded. (May 2, 1915.)

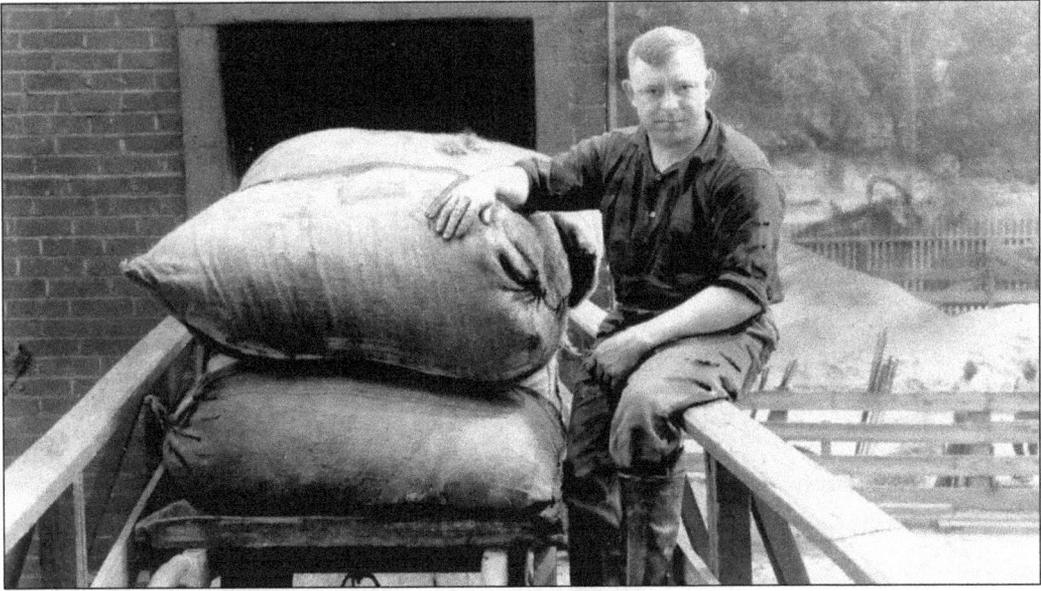

Nothing goes to waste at John Peters's slaughterhouse. This bag of hog bristles to be used in the making of brushes is just one of the byproducts of the packing plant, located east of Williamsport. In addition to brushes, hog bristles were used in the upholstery business and in the manufacture of automobile seats. Hoofs and bones were ground up to make fertilizer. (July 30, 1922.)

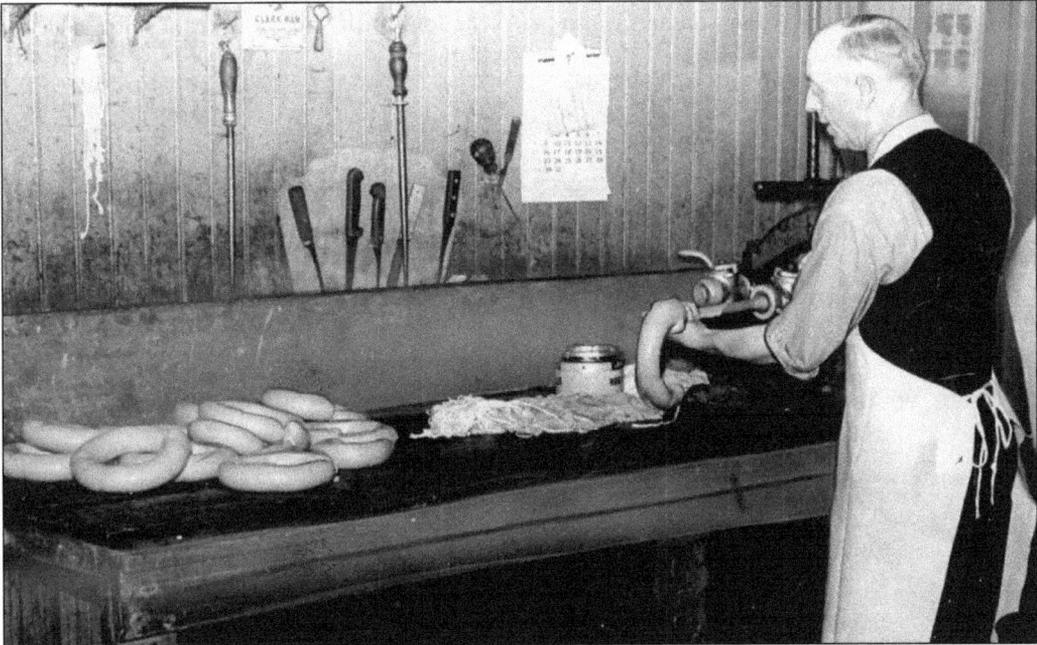

At a shop in Williamsport's east end, a butcher demonstrates how beef becomes bologna. After trimming and cutting, he seasons the meat and prepares it for the grinder. A second cutter grinds the meat into finer texture, and then the ground meat is forced into casings using compressed air. Next, the butcher cooks the coils of bologna in a vat of hot water, and then the meat is smoked. (January 8, 1939.)

13

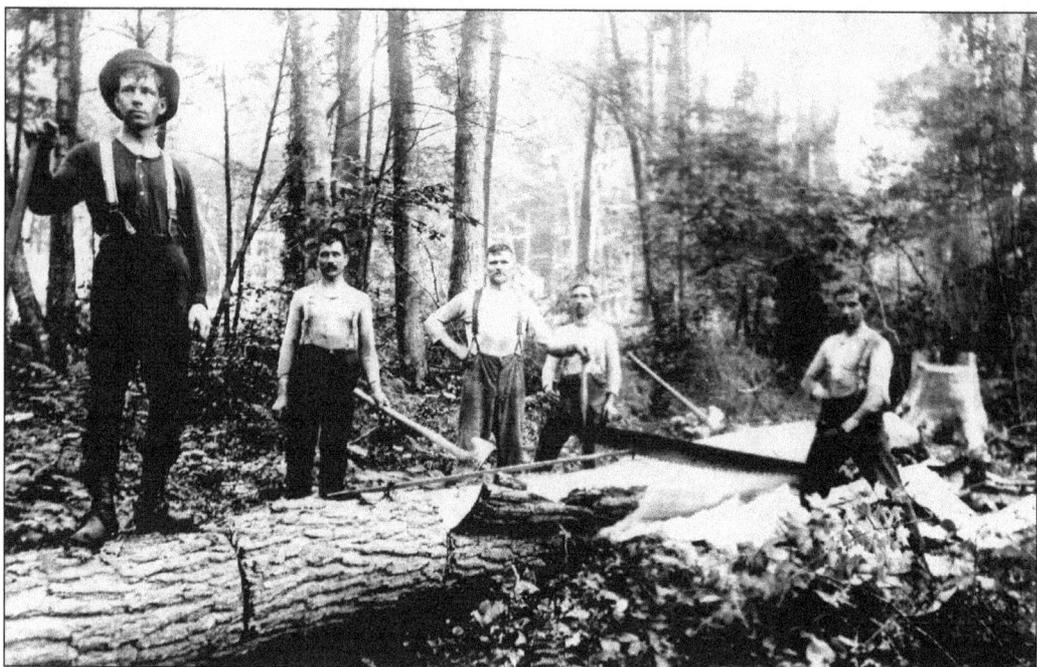

Hardy lumbermen strip "spudding" bark from a felled tree. Each logger earned about $2.50 a day on his specific job. Choppers notched the tree to direct the fall, fellers used crosscut saws to remove the bark, sawyers cut the tree into various lengths, scalers determined the amount of board feet in each log, and haulers transported the logs to the nearest stream to float to the river. (c. May 1900.)

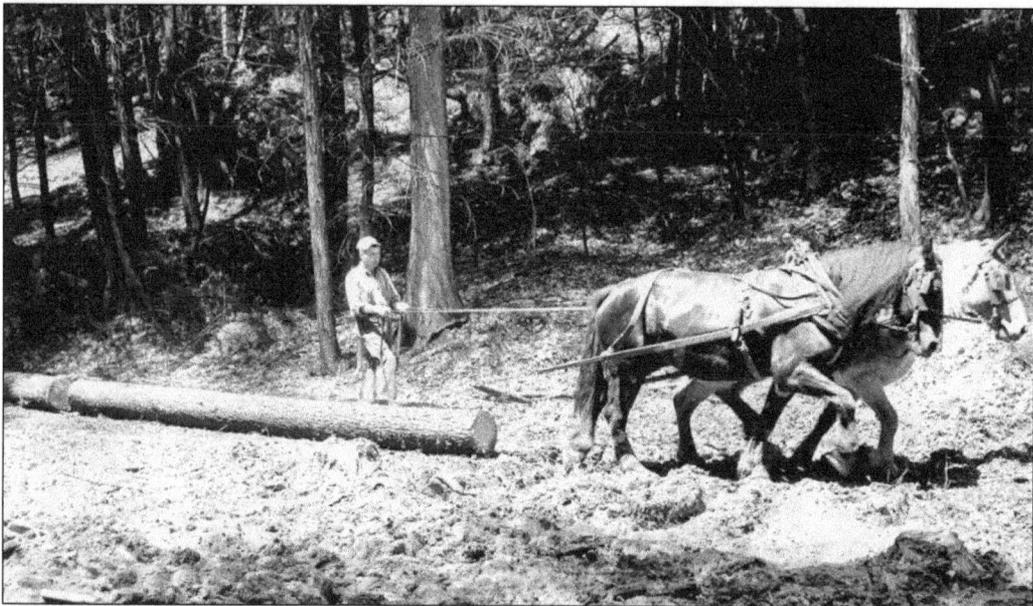

A team of horses skids logs out of the dense woods. These white pines, felled in the Daugherty's Run area, measured as much as 38 inches around the base. Many of the trees were more than 100 years old at the time they were felled. The hauling continued year round, with sleds in the winter, so that logs would be ready to float in the spring. (June 9, 1946.)

14

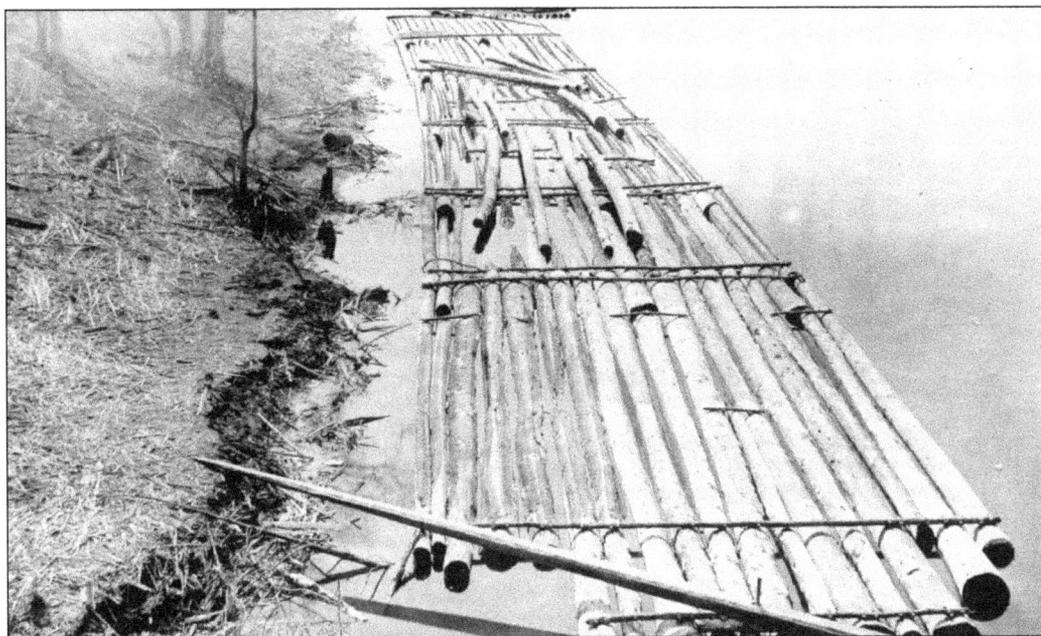

Before the development of the rail system in Lycoming County, the simplest solution was to transport logs by floating them downstream. Log rafts were the primary means of moving the lumber. The most common style of raft was the boom type, essentially a floating fence that held quantities of free-floating logs. (c. April 1890.)

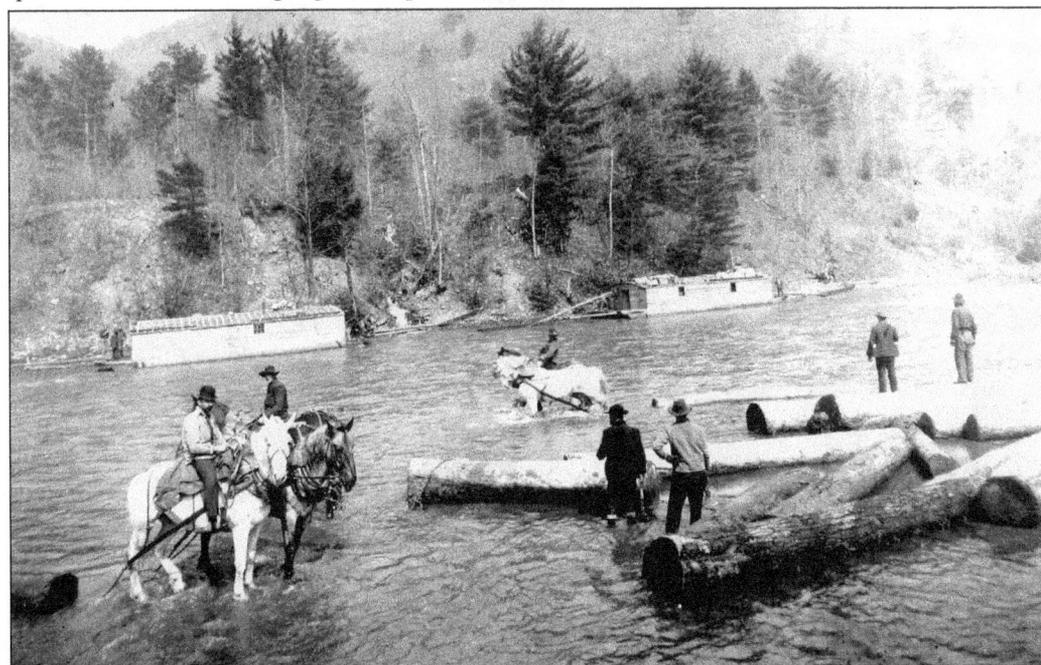

A work crew pulls logs into Little Pine Creek below English Center. Many of these logs were floated to mills downstream from where they were harvested. English Center, once the core of a thriving timber industry, had its own tannery, numerous sawmills, lumberyards, and ancillary trades often found in a lumber town. (c. June 1880.)

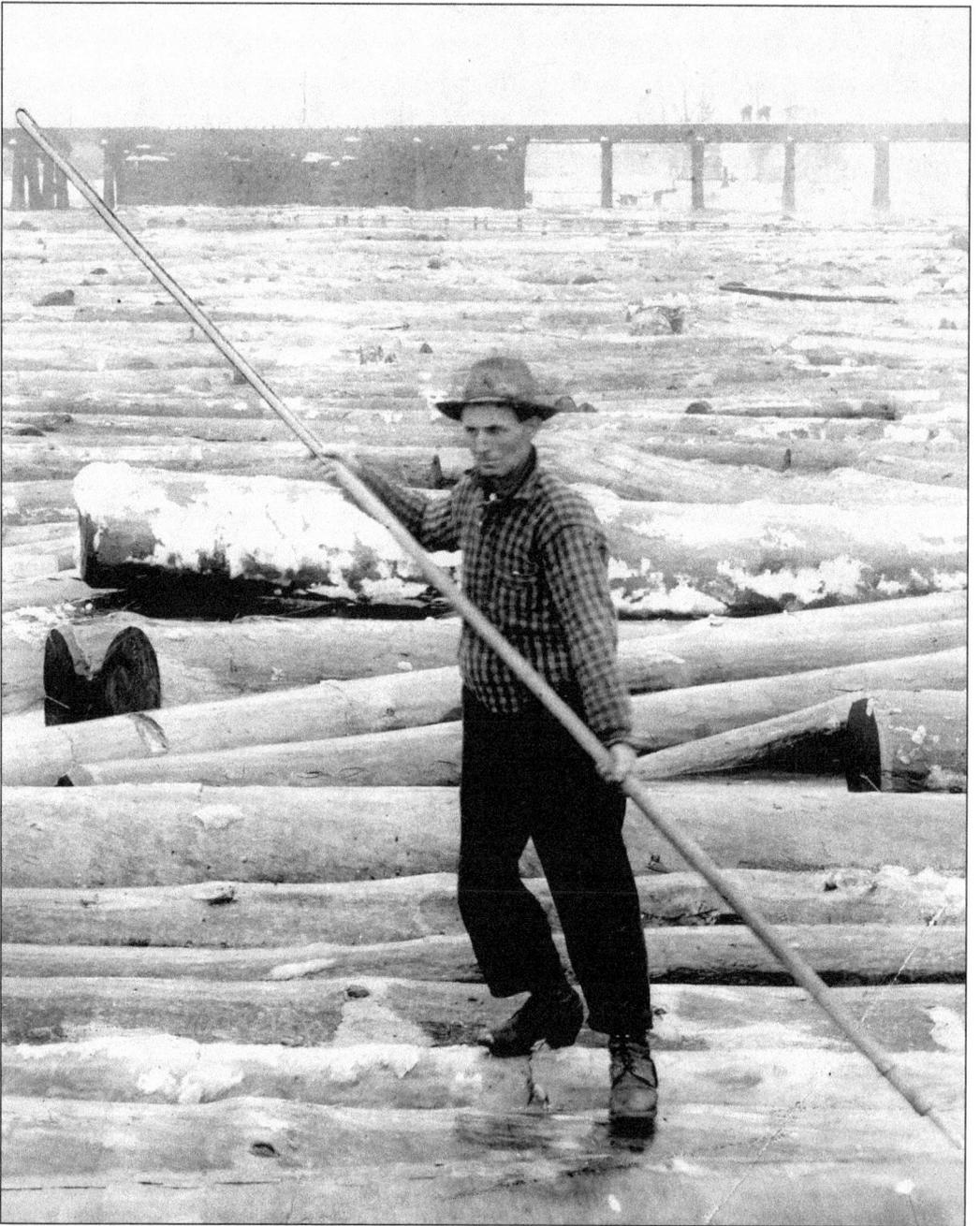

A man balances himself with a pole in the middle of a group of logs on the river. These boisterous daredevils, from the lumberjacks in the logging camps to the jam crackers who worked the Susquehanna Boom, were collectively called "boom rats," and their antics provided a humorous element to the harvesting and shipping of logs and timber. Some of their tools were pile poles, cant hooks, peaveys, crosscut saws, and brands used to mark the lumber. Booms were built to divert the logs down the river. From 1862 to 1894, lumber was king, and at the peak of the era, more than one and one-half million logs were cut from the mountain slopes annually. (August 24, 1930.)

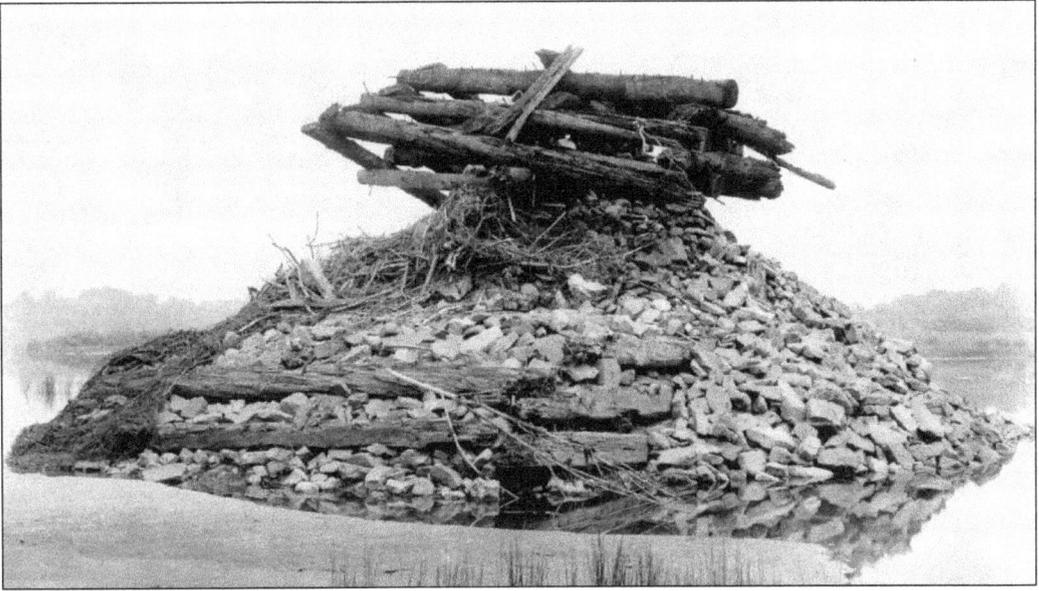

An old pier is crowded with heavy timbers at the old Susquehanna Boom, a remnant of Williamsport's lumbering era. A disastrous flood in 1894 put most of the remaining lumbermen and sawmills out of business. The abandoned old boom attracted hundreds of swimmers during the hot summer of 1916. On one Wednesday that summer, between 1,200 and 1,500 swimmers occupied the area of the old boom. (August 13, 1916.)

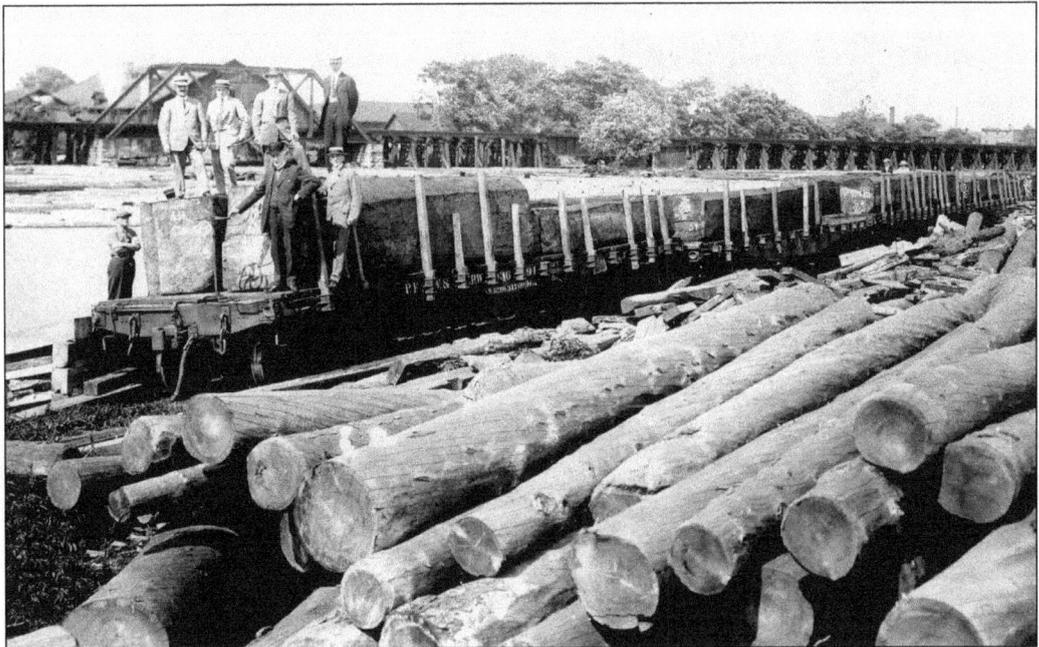

This trainload of 51 mahogany logs was used by the J. K. Rishel Company. The African mahogany, sawed and handled by the Central Pennsylvania Lumber Company, was considered the finest consignment of mahogany logs handled by an inland mill. The logs ranged in size from 2 to 5 square feet in width and 18 to 40 feet in length. They contained more than 75,000 board feet. (June 21, 1914.)

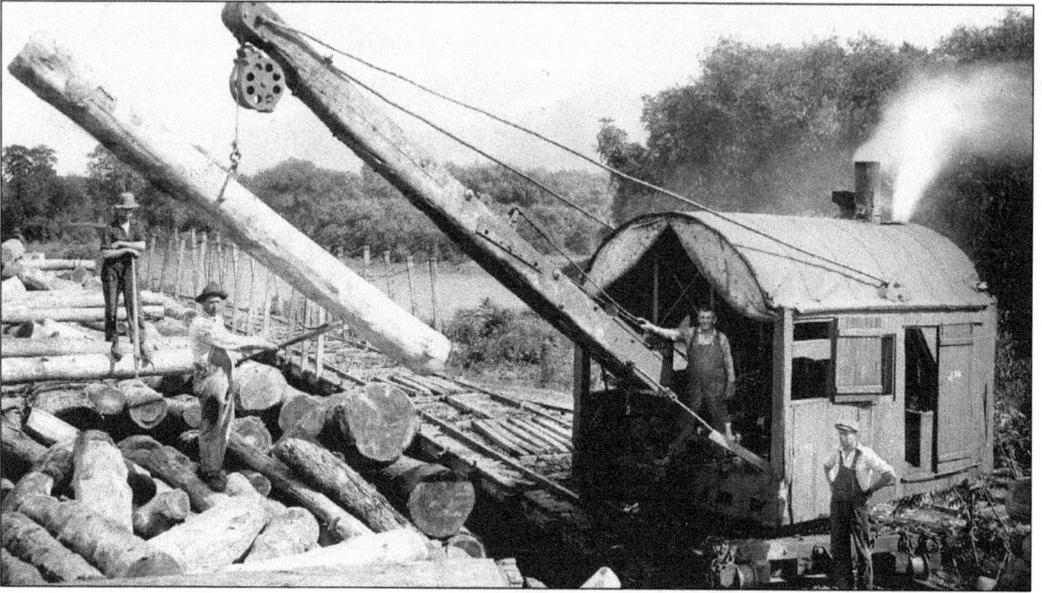

Lumbermen move logs at a pond with a steam loader. Car-mounted loaders rode on top of the flatcars or log cars that moved along either permanently affixed or temporary railroad tracks. This photograph shows a self-propelling, rail-mounted version of the Model D loader that rode directly on the tracks. The loader reduced a lumber company's payroll, sometimes as much as $500 per month, and enabled the smaller lumber companies to expand their businesses. (c. 1930.)

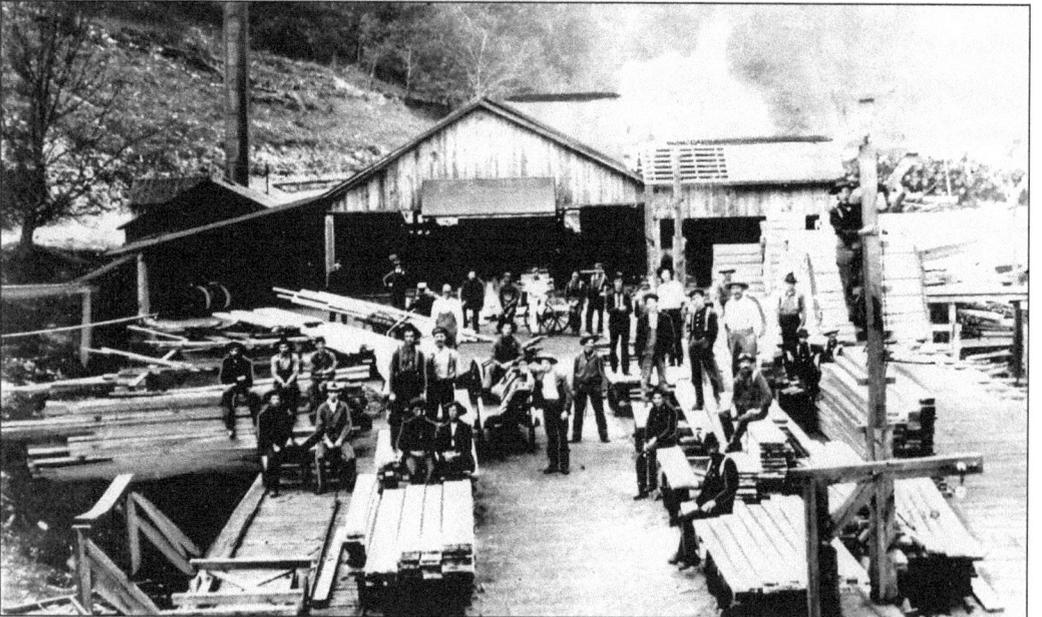

Workers gather at the Sones sawmill at Masten during the lumbering era. Mills like this ringed the greater Williamsport area, particularly near the Susquehanna River. A mill was usually a family business, as the father built the mill and his sons worked in it. The wife and daughters usually stayed home, prepared the meals, and cleaned the clothes and rooms of the employees. (c. 1915.)

18

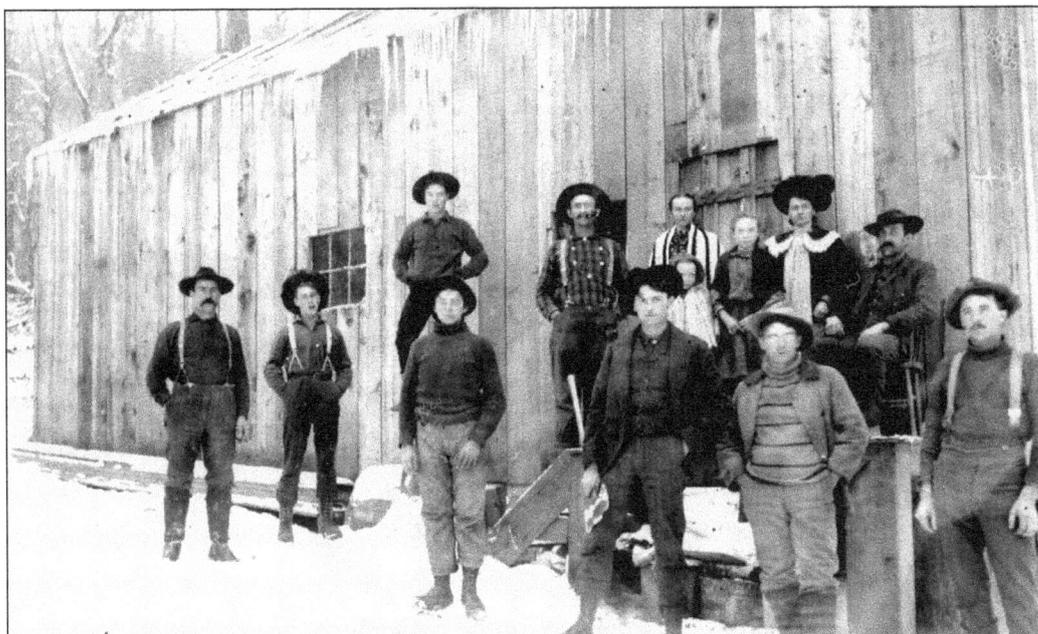

Many people were needed to run the winter operation at a log camp, including swampers, teamsters, cooks, managers, chickadees, jobbers, and operators. The jobber seldom made a profit, but he did obtain winter housing and food for his family, horses, and oxen. Everyone worked 12-hour days, 6 days a week, and generally ate meals of pork fried beans. (July 16, 1916.)

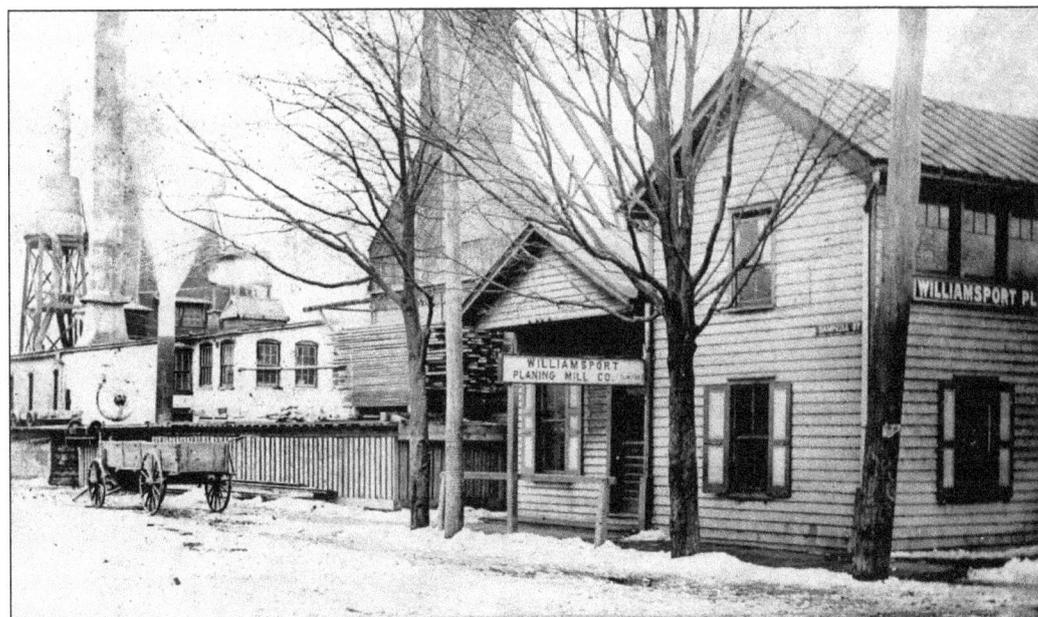

The Williamsport planing mill was a major source for windows and sashes, doors, and lumber in the region in the late 19th century. Most houses built before 1920 used some of the materials from the operation. The mill's officers were Thomas Deutschle, chairman; Andrew Birkle, secretary; Henry J. Weasner, treasurer; and Charles R. Krimm, superintendent. The company employed 75 men. (c. 1900.)

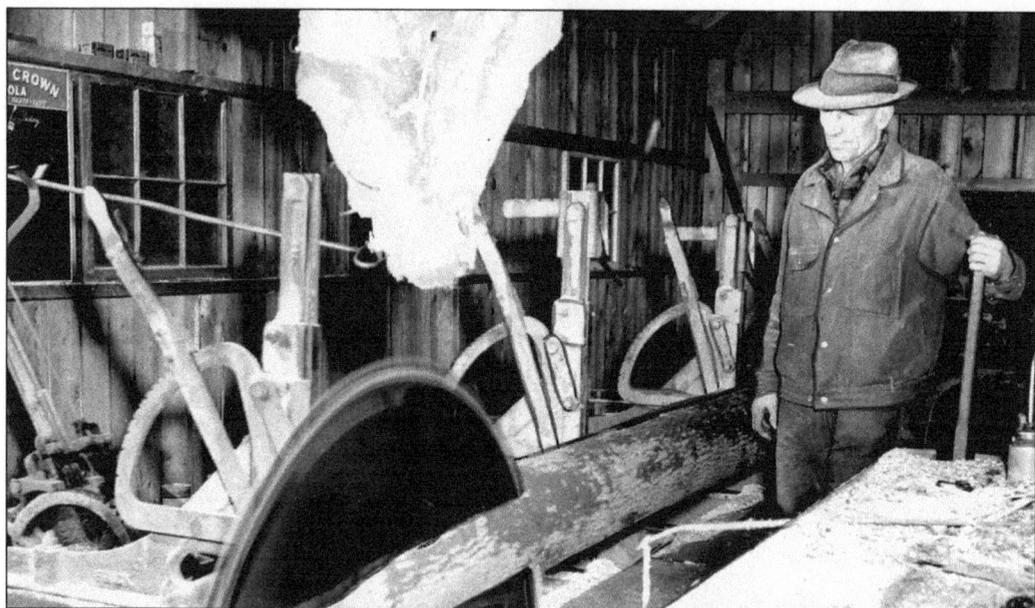

A worker operates a saw at the Blair sawmill in Barbours, a family operation for three generations when this photograph was taken. Fire destroyed the business in 1941, but the founder's grandson, Joseph Blair, rebuilt the enterprise using steel reinforcements and concrete to protect against future fires. He kept an eye on his timber by taking regular airplane rides. (October 14, 1948.)

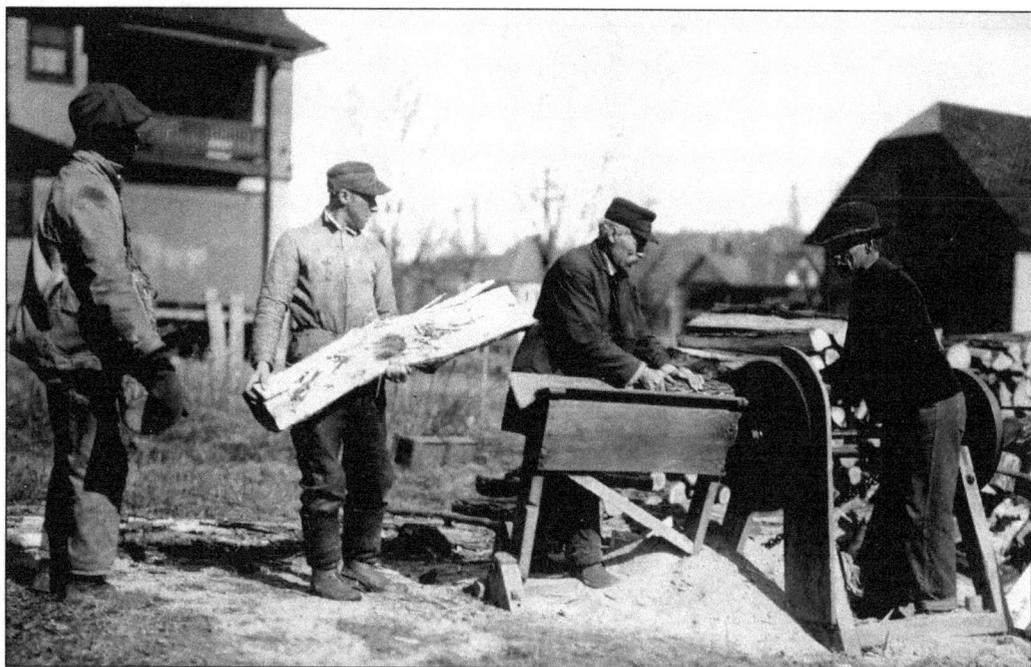

Workers from the Vallamont Land Company cut and saw cordwood. Each year, the men kept the trees at bay through a scientific method that prevented the spread of disease. The company hired the men in order to keep lumber crews employed during the winter. More than 400 cords of deadwood were removed from the area west of the city. (February 21, 1915.)

The *Grit* newspaper reported that this Williamsport harness maker was "as rare as a dodo bird. These old-time trades are being shoved aside like cigar store Indians by the march of progress." The harness maker pictured here is 72-year-old James Blaker, who plied his trade for almost 50 years. In 1930, he made just 29 harness sets. By August 1931, he had produced only 10. (August 23, 1931.)

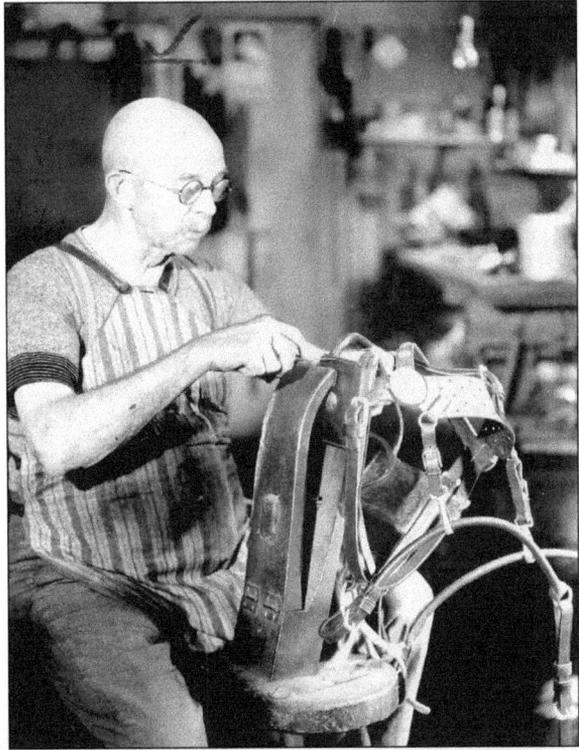

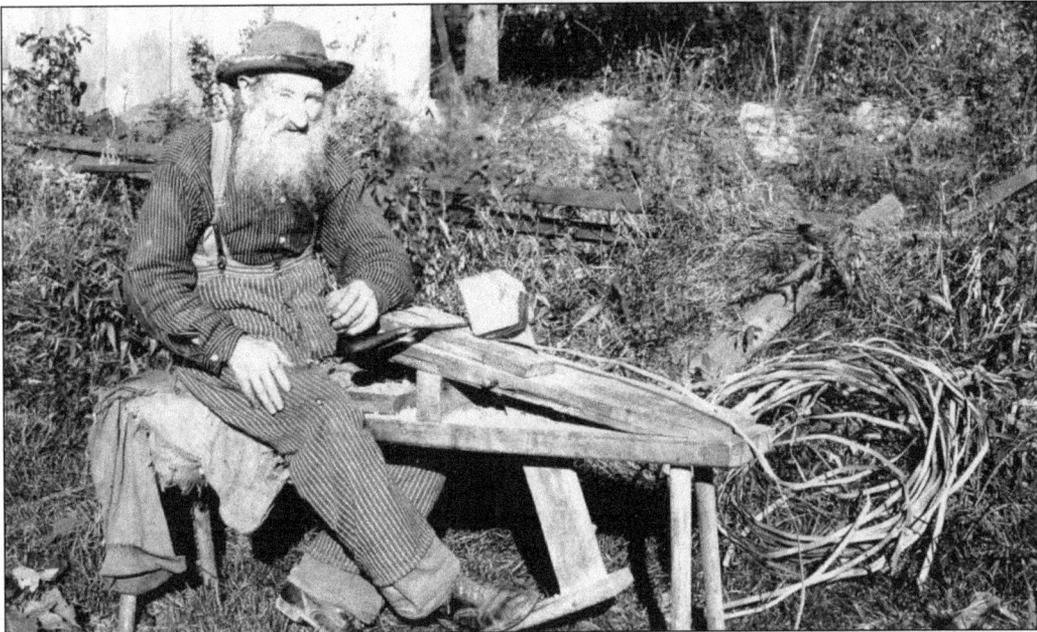

John Tule, 80 years old, was a basket maker who lived in Hepburn Township near Balls Mills. Tule occupied a shanty on his property during the spring, summer, and fall, after his house burned in 1915. During the cold winter months, he resided with relatives on Montoursville Road. Here, on his "horse," Tule creates a basket with white oak, which he claims is as "pliable as cloth when worked." (October 8, 1916.)

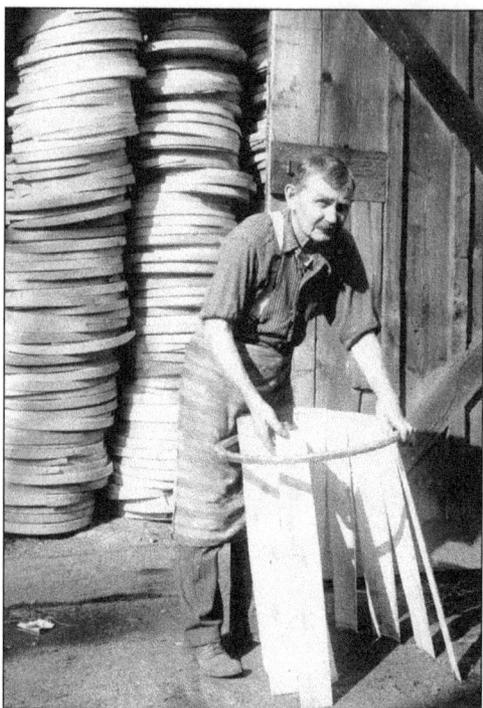

Eustace Case sets barrel staves at his cooper shop at the rear of 419 Fifth Avenue, in operation from 1913 to 1923. Huge quantities of barrels were turned out in Williamsport in the late 1800s and early 1900s because of the number of distilleries. Case's cooper shop, the largest manufacturer in the area, produced barrels, casks, and kegs. There was such a local demand for barrels that many never left north-central Pennsylvania. (October 18, 1914.)

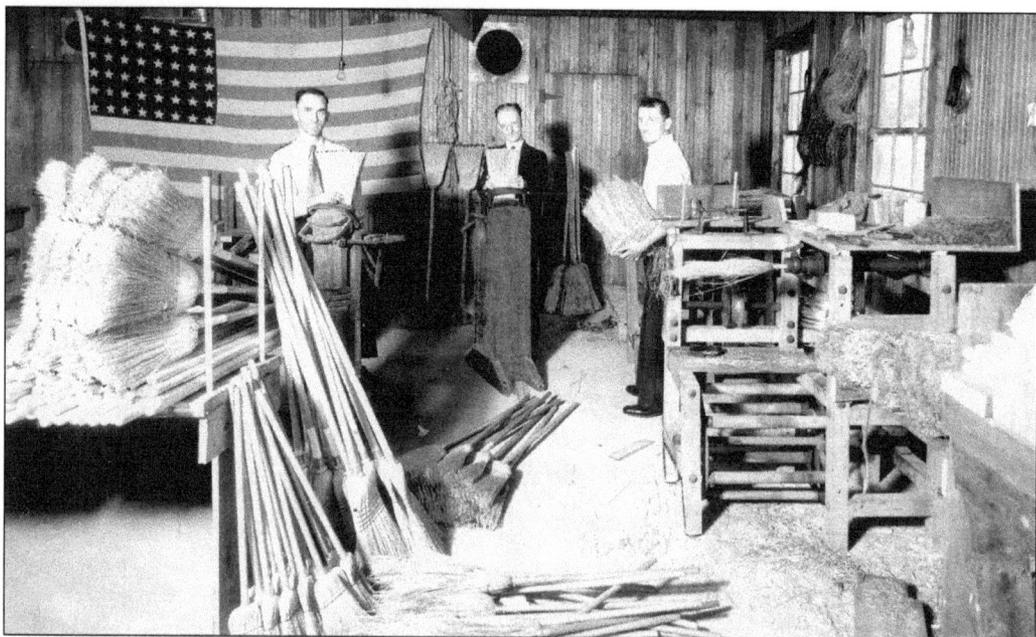

Due to the great demand from the United States Broom Works on Germania Street, Lycoming farmers tripled the price of their broom corn. The company's production rate was 30 dozen brooms per day, having sold several thousand brooms when this photograph was taken. The broom works offered 10 grades of handles in eight colors but had to import the wooden handles. No local lumberyard was able to supply the business. (October 15, 1933.)

Two

MINING AND CONSTRUCTION

Coal mining in Pennsylvania began in the mid-1700s, fueling the Industrial Revolution and providing small, Colonial foundries with iron, then steel mills of the 1800s. Two kinds of coal are mined in Pennsylvania: anthracite, or hard coal, and bituminous, softer coal. The mountains of north-central Pennsylvania, however, do not produce coal in sufficient quantities for a viable industry. Instead, the residents of the newly formed Lycoming County concentrated on the resources at hand—lumber for building houses and furniture, and limestone, shale, and sandstone for roads and buildings. The river also yielded sand and gravel. Sand, the all-important ingredient in sandpaper, was mighty useful in the "Lumber Capital of the World."

Major limestone quarries were located in Loyalsock, two miles east of Williamsport. Loyalsock is derived from the Native American word *Lawi-Saquick*, meaning "Middle Creek," because of its location midway between Muncy and Lycoming Creeks. Geologically, Loyalsock consists of Clinton shale and Lower Helderberg limestone.

A settlement grew at the base of Sand Hill, where industrious families built kilns to burn lime to use for construction and agriculture purposes. A small, profitable business, the Sand Hill lime kiln was built in the side of a hill with stones stacked in an upright, bottle-shaped furnace with an opening at the base and at the top. The walls were several feet thick and would have been either dry laid or laid with a mud mortar. Limestone was burned in kilns for at least 72 hours at temperatures high enough to drive off the carbon dioxide. Powdered lime could then be scraped out of the bottom of the kiln and packed in wooden barrels for shipping.

Marketed as an agricultural additive and for chemical and manufacturing processes, lime was used in the production of mortar. Mortar bound stone and bricks together and was used to chink between logs of a cabin. Lime was also used in the production of plaster then smoothed over wooden laths for flat walls or ceilings in most 19th-century homes and buildings. Historic log cabins lacked plaster walls, but owners employed lime in a whitewash applied on the inside walls.

In addition to limestone, quarries in Loyalsock and Montoursville yielded shale and sandstone for a variety of uses, including stone blocks for canal locks and building foundations and grind and pulp stones for papermaking and grain milling.

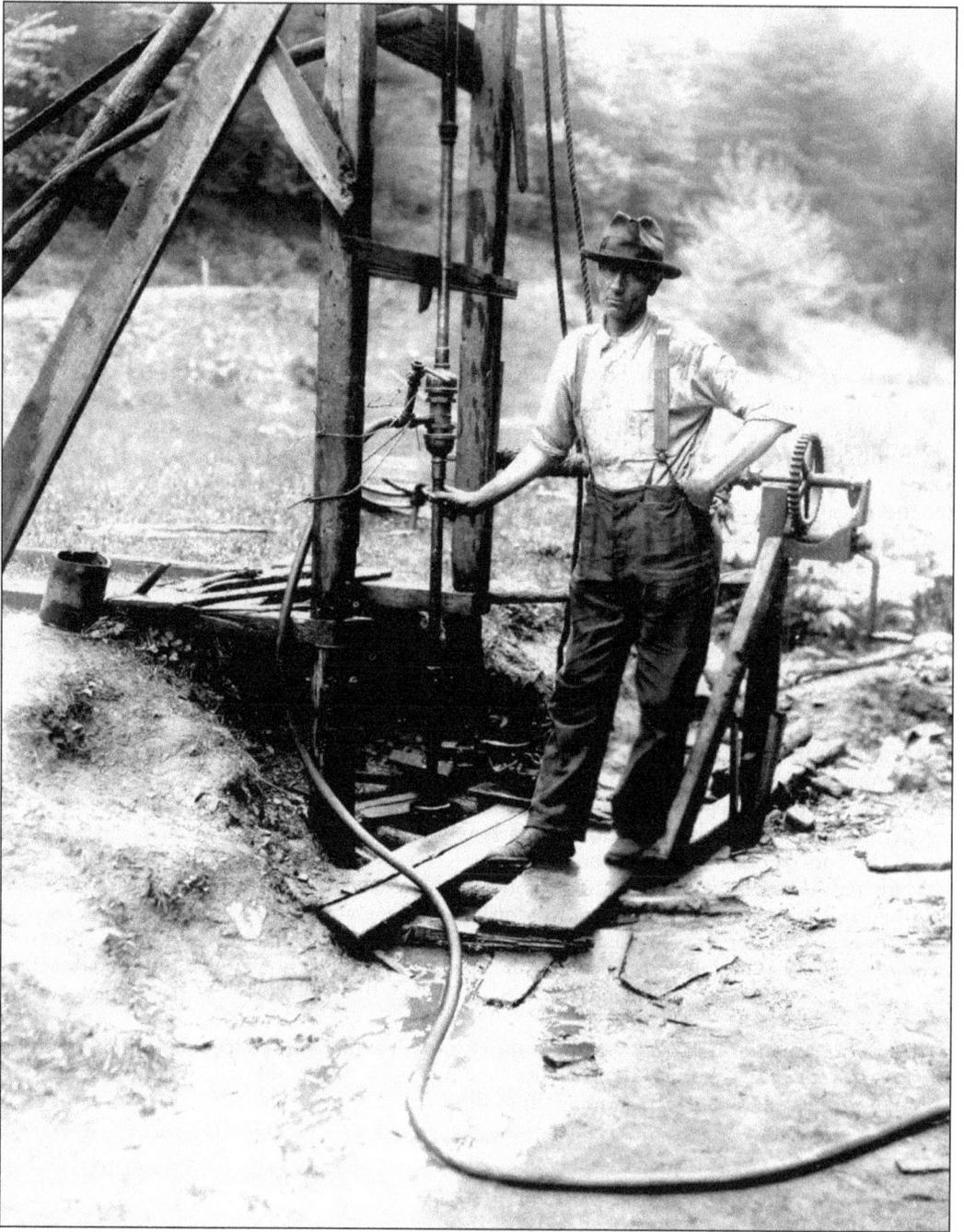

A determined entrepreneur has staked out a claim, a parcel of land on the Loyalsock Creek, and built a sluice to pan for gold. A claim was a gold field that a person was legally entitled to mine. During the California gold rush, a miner might find $10 in gold a day—10 times more than a Pennsylvania coal miner made at the time. Gold has been found in Pennsylvania because of Ice Age glacier drifts. Few people know that gold was discovered on the East Coast before the 1849 gold rush. Reed Gold Mine, near the town of Concord, North Carolina, was the first commercial gold mine. (c. April 1920.)

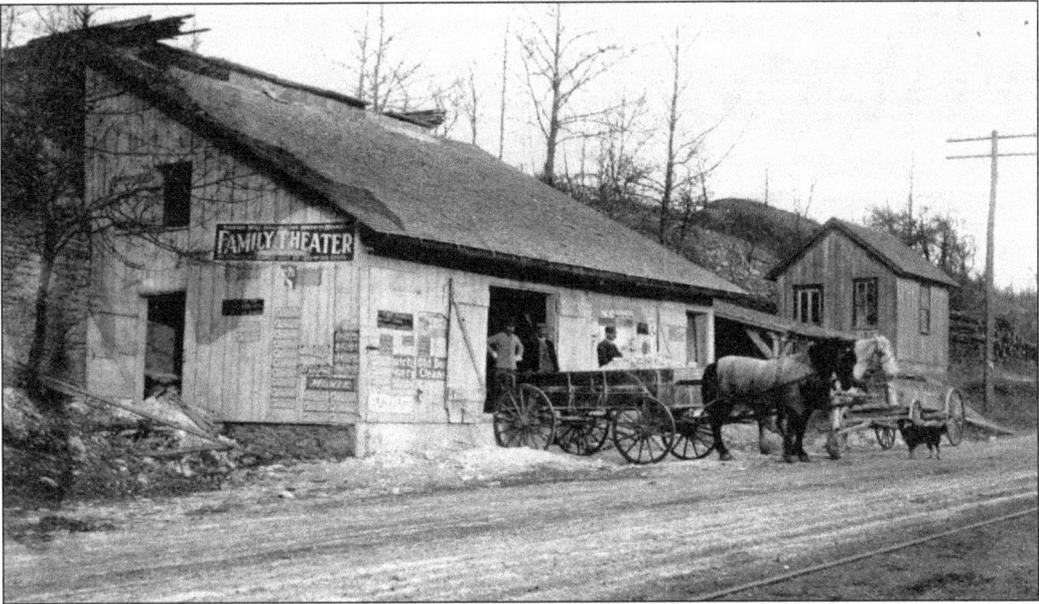

The old lime kiln near Montoursville Road is pictured here. As late as 1959, the furnace building and most of the structures around it were still standing. The tracks in the photograph are part of the now defunct Montoursville trolley line. During the 19th century, lime was used to make mortar and plaster for building construction. Mortar also helped to bind stone or bricks together in building walls and to secure the logs of a house. (*c.* December 1912.)

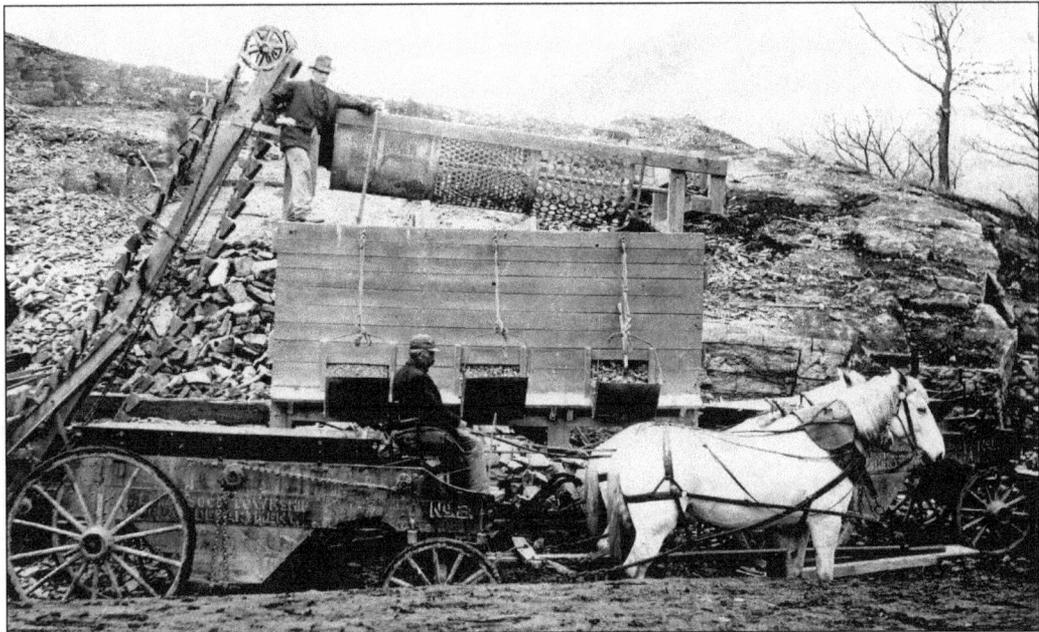

A wagon pulled by a team of white horses is filled with crushed stone. A conveyor belt equipped with buckets lifts the stones to a shaker, where varying sizes of gravel are automatically separated into wooden bins. Around the beginning of the 20th century, Loyalsock Township was using gravel on roads. Spring thaws turned dirt roads into quagmires, whereas gravel roads had both strength and drainage capabilities. (*c.* April 1920.)

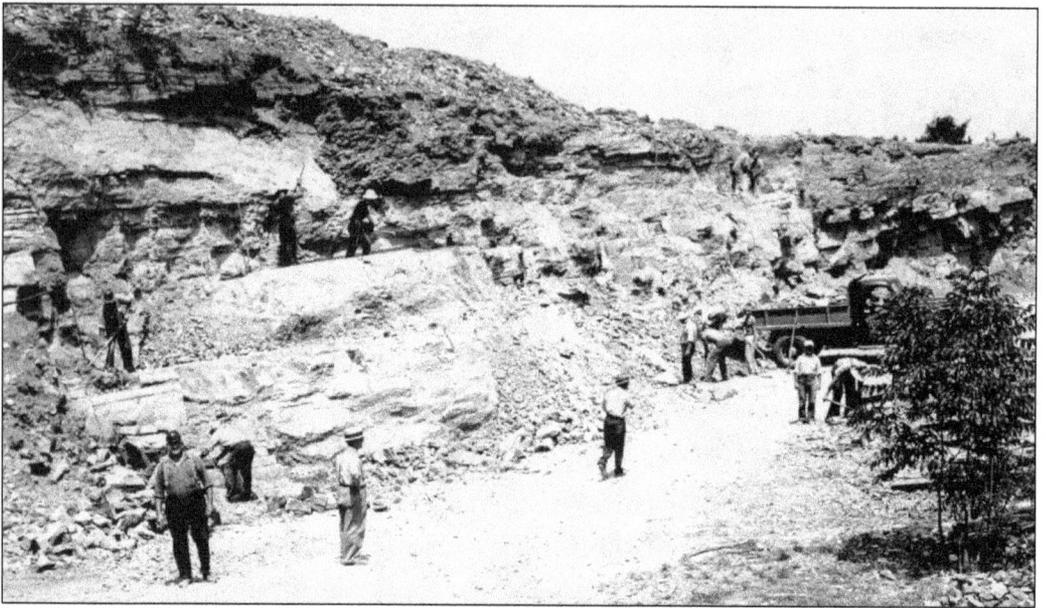

Workmen mine stone at a Loyalsock quarry for two new lanes to be added to the road over Sand Hill. Work on the new road progressed rapidly, though the federal aid highway program had felt the impact of the Great Depression. The system was "completed" by the late 1930s, and while many segments of the rural network had not been paved, virtually all had received initial treatment. (July 16, 1939.)

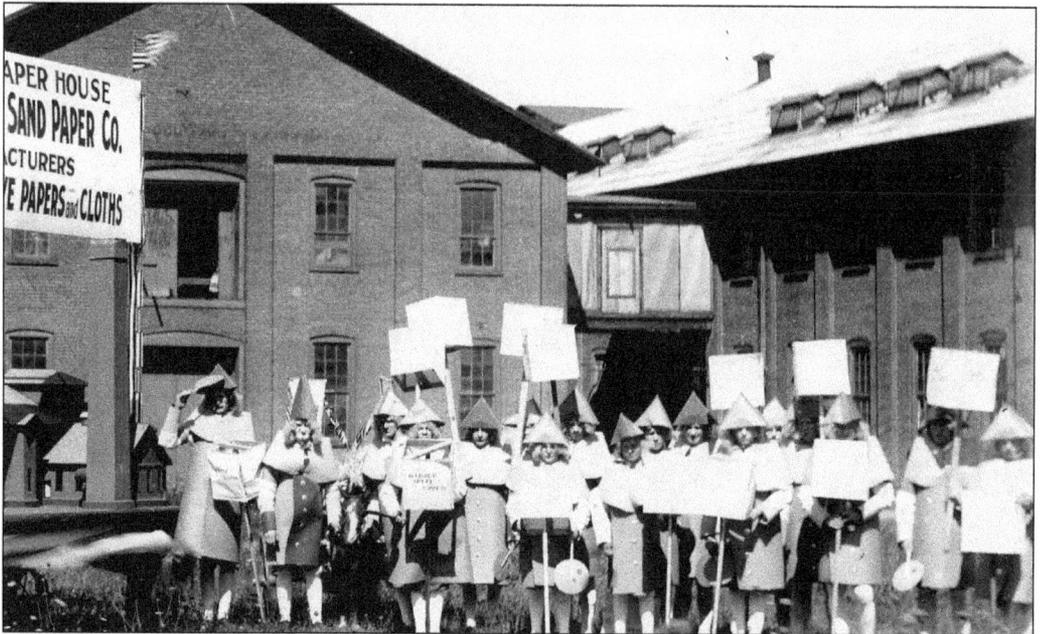

Employees of the United States Sandpaper Company line up to participate in a "Made in Williamsport" industrial parade at the National Guard Armory of the 12th Regiment. The parade, witnessed by more than 50,000 people, concluded the celebration of Old Home Week, the "most extensive, varied and remarkable celebration ever held in the city of Williamsport," according to the *Grit*. (September 14, 1913.)

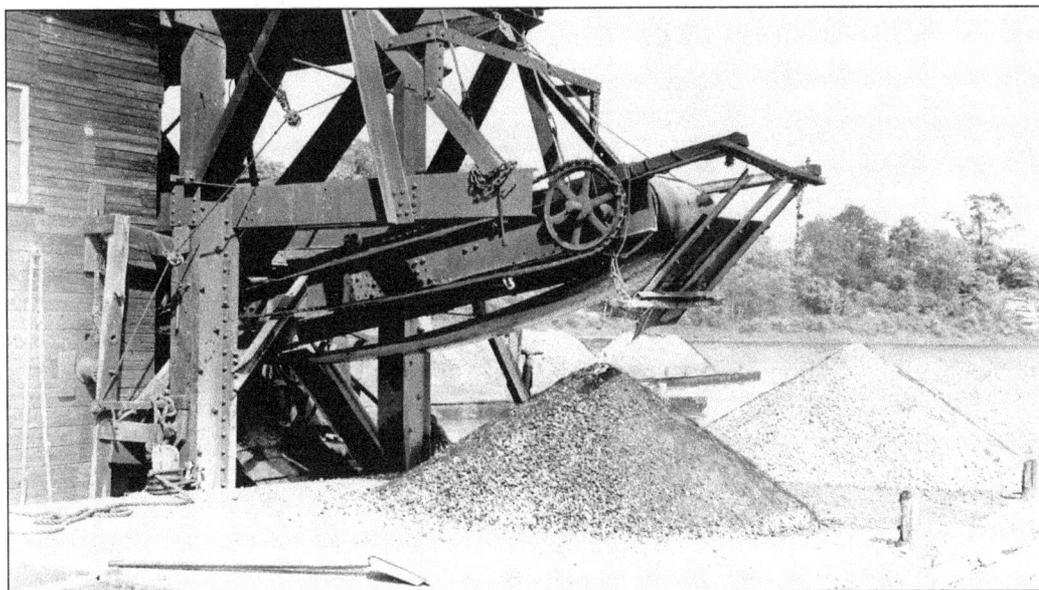

When gravel and sand is scraped from the riverbed, it is carried in a series of buckets to a bin on the dredge, where the material is separated mechanically. At left, gravel comes from one side of the machine on an endless belt. Prized for its clean sand and gravel, the West Branch of the Susquehanna River was mined to provide construction materials and grit for local sandpaper factories. (September 21, 1941.)

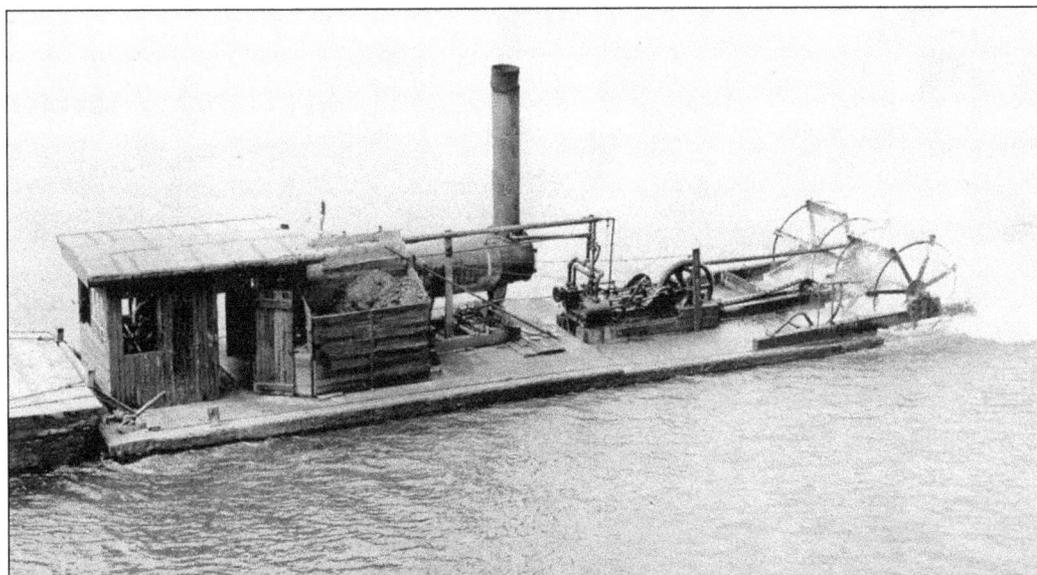

The boom in housing and construction, which was part of the nation's defense preparations, had its effect on the Williamsport firms that supplied needed materials. Chief among them were sand and gravel companies. Here, a barge scours the bottom of the West Branch of the Susquehanna River for the necessary materials. (September 21, 1941.)

In the spring of 1914, building and construction work in the Williamsport area consisted of more than $250,000 in projects. Builders declared that the season would approach the record mark set in 1913. Here, workers haul sand from a railcar to the riverbank for one of the building projects. The biggest project that spring was at the National Silk Dying Company. (April 19, 1914.)

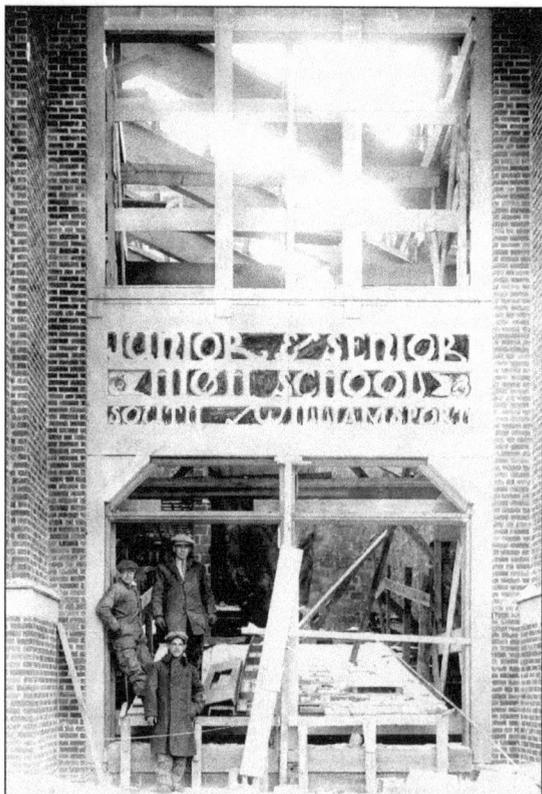

Work on South Williamsport High School continues as men finish the rooms. A new, five-room unit and corridor completed work on the building. Funds for the job came from the Works Progress Administration. An enclosed fire escape was also part of the project. In 1935, six hundred students were enrolled at the school. (October 13, 1935.)

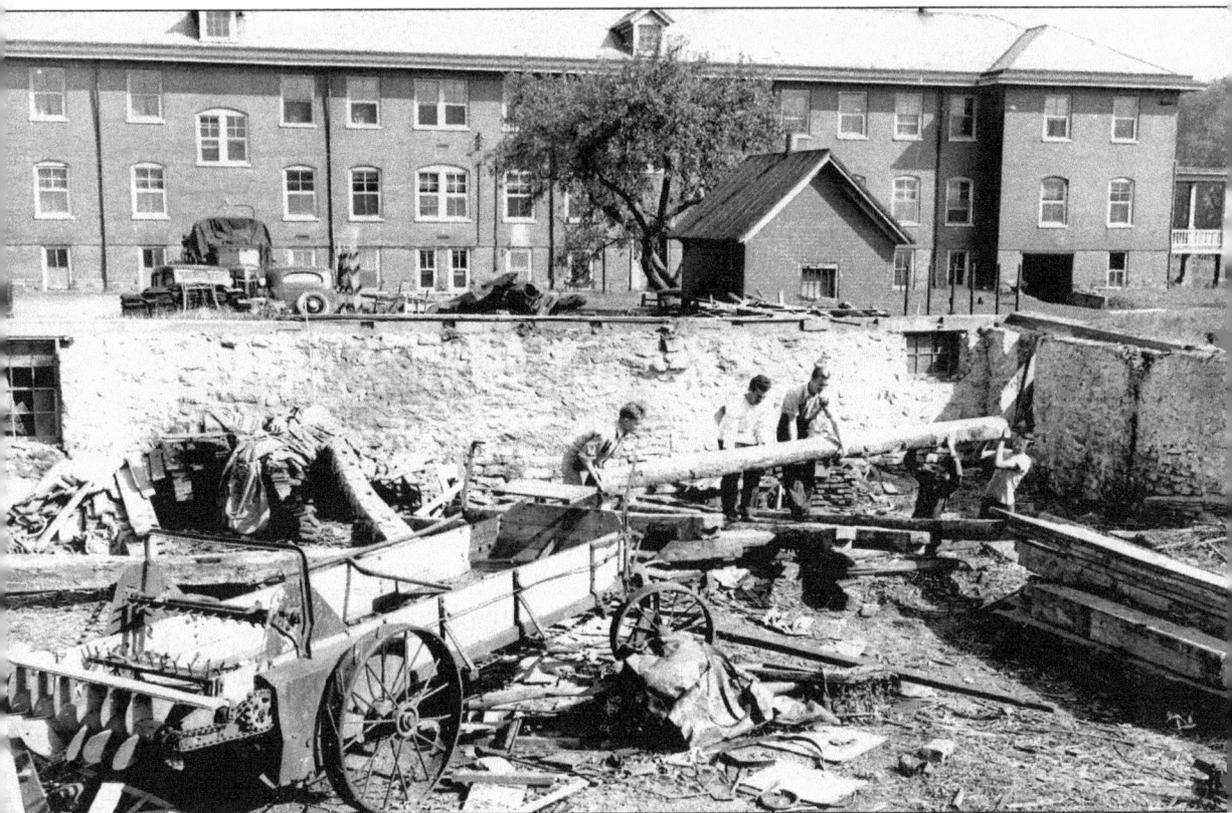

Members of the National Youth Administration (NYA) in South Williamsport raze an old barn on the former city poorhouse property to make way for improvements. Materials from the old barn were used in the construction of workrooms and shops in the basement of the new building. The site was expected to be made into a youth regional training center. The NYA was a New Deal program to provide work for unemployed youth. (September 14, 1941.)

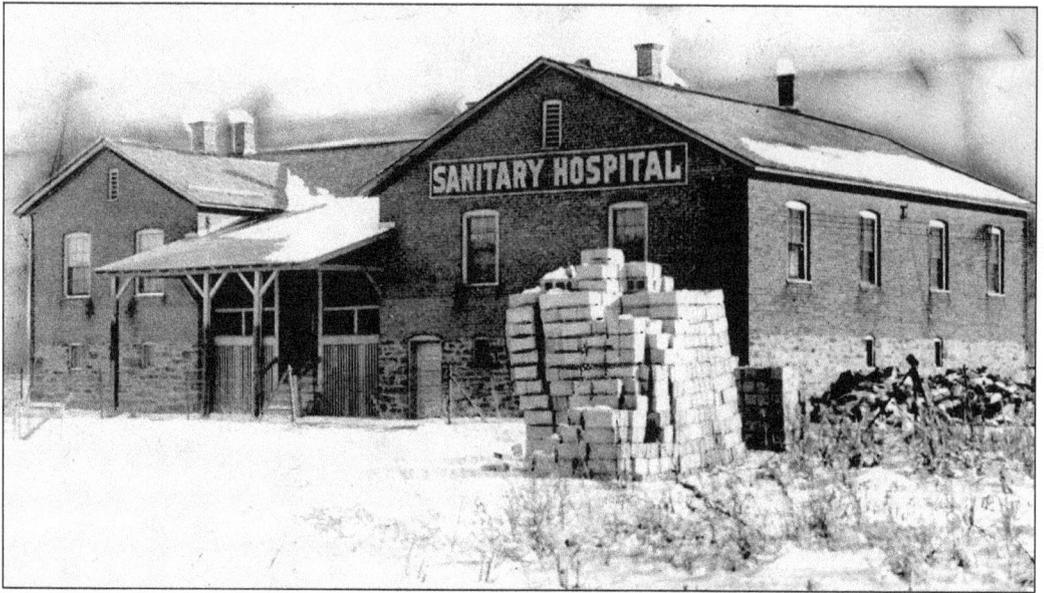

The NYA converted the old city sanitary hospital in the Sylvan Dell neighborhood of South Williamsport into additional dormitory space for residents of the youth training center. Additional facilities were necessary to accommodate the 120 boys. This program helped those who were between the ages of 16 and 25 with part-time jobs. More than 700,000 students enrolled. (January 18, 1942.)

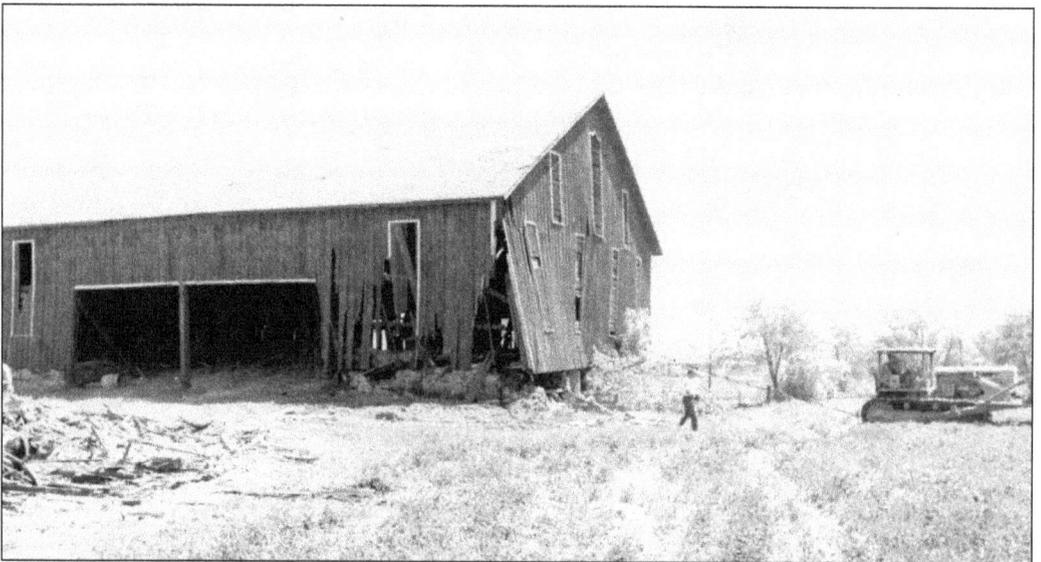

The old must give way to the new, as illustrated in the destruction of this old barn on Industrial Properties Corporation land along Reach Road. At right, Alfred Kaufman of the Lycoming Supply Company returns to his bulldozer after wrapping a chain to the barn's beams. The barn was reportedly built c. 1860–1870 by James B. Reighard. The Industrial Properties Corporation then sold the land to Precision Metal Fabrication in the summer of 1964. (May 24, 1964.)

Three

FOOD, BEVERAGES, AND TOBACCO

Since the advent of agriculture nearly 15,000 years ago, humans have sought ways to prepare and preserve food and drink. Grain was the first domesticated crop that started the farming process. Reliance upon annual harvests and the domestication of animals eliminated the need for continual hunting and gathering. Agriculture left time for leisure, the development of luxuries, and the refinement of food and beverages.

One of the oldest and most important beverages created (or discovered) was beer. The first record of alcohol dates back 6,000 years, when the Sumerians began brewing grain to create beer. The 4,000-year-old Sumerian "Hymn to Ninkasi," the goddess of brewing, is even a recipe for making beer.

Another extravagance crop was tobacco, a product of the New World. Tobacco was first introduced to Europeans when Native Americans offered dried leaves to Christopher Columbus as a gift on October 15, 1492. Spanish sailors brought tobacco back to Europe, and soon the plant was being grown commercially.

Lycoming County's earliest buildings were "tippling houses," or taverns. George Slone opened the first tavern in Newberry in 1795. The first house in Williamsport was a log tavern erected by James Russell in March 1796. His inn stood on the corner of Third and Mulberry Streets and was also used as the first county courthouse. Unfortunately, Russell was brought before the court (in his own tavern!) and charged with operating a tippling house. He soon evicted the court. This log building remained a landmark until it was destroyed by the great fire of 1871.

As early as 1796, Jacob Grafius built a distillery on the southwest corner of Market Square. The City Brewery was established by a Mr. Huffman in 1854. In June 1865, Henry Jacob Flock purchased it and operated it until his death in 1884.

Another favorite beverage in the county was tea, and the famous Tetley Tea Company even established a local plant. The story of tea began in ancient China 5,000 years ago. According to legend, Emperor Shen Nung was a skilled ruler and a creative scientist who insisted that servants boil his drinking water. One day, leaves fell into the water and when Shen Nung drank it, he felt refreshed. Both China and Japan consumed tea for thousands of years, but Europeans did not know about the beverage until the Portuguese Jesuit missionary Jasper de Cruz introduced it in 1560. Tea became very fashionable in Europe, in part because of its high cost ($100 per pound). It immediately became the domain of the wealthy. Tea imports increased; the price fell.

In 1650, Peter Stuyvesant brought tea to the colonists of New Amsterdam (later renamed New York). America drank more tea at that time than all of England.

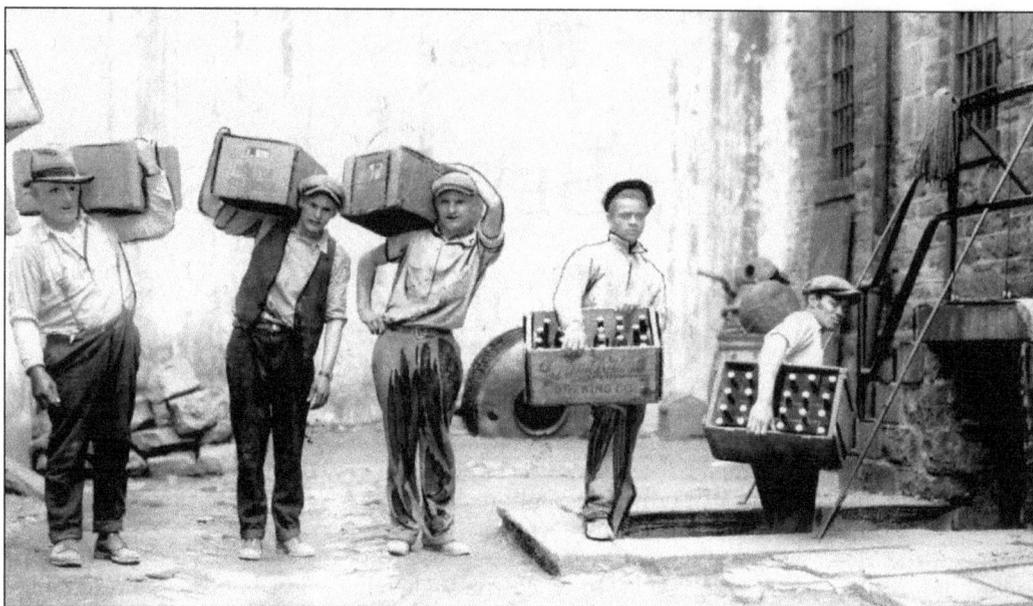

The 18th Amendment banning alcohol became law in 1920. Here, men in a federal liquor raid confiscate 245 cases of home-brewed beer and store it in the county jail. The Motor Car Pioneering Society, Basin Street, and the Fraternal Order of Eagles, East Third Street, were caught with the alcohol. In Milton the next day, officers confiscated 274 cases of beer at the Loyal Order of Moose and 280 cases at the Fraternal Order of Eagles. (June 12, 1927.)

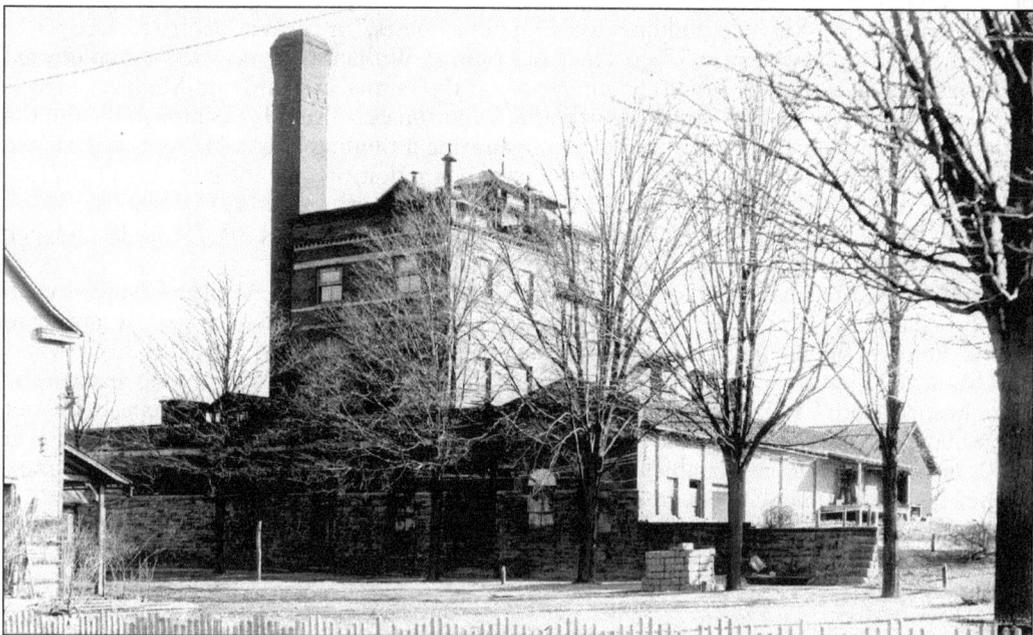

Koch's Brewery in South Williamsport prepares to brew beer after the Volstead Act legalized the manufacture and sale of beer. At 12:01 a.m. on April 7, 1933, beer containing 3.2 percent alcohol became legal for the first time in more than 13 years. Officials at Flock Brewery, who also operated Koch Brewery, said the company could produce about 50,000 31-gallon barrels a year. (April 2, 1933.)

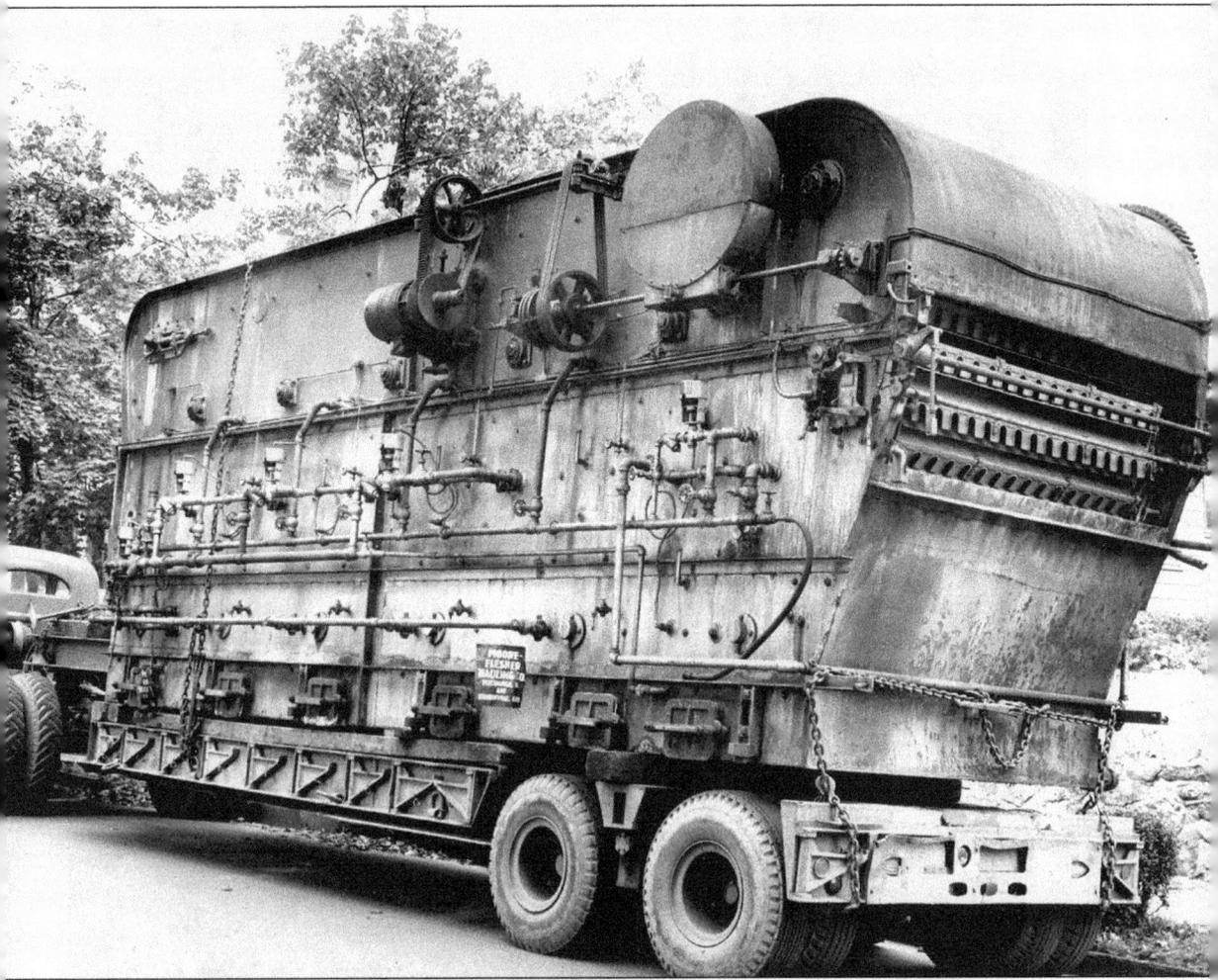

Arriving for installation at the Flock Brewing Company is a new $28,000 bottle washer. Each bottle was soaked in six different solutions, brushed out with high-pressure hydro action, and rinsed six times. The complete cleansing cycle of the washer required 45 minutes. The new washer was another step in Flock's equipment modernization program. The company had recently installed new filters and modern keg-filling equipment at the brewery. In 1865, Henry Jacob Flock bought the City Brewery at 601 Franklin Street, begun by Jacob Hoffman in 1854. Flock, a native of Prussia, came to the United States in 1853 and worked as a stonemason. He operated his brewery until his death in 1884, then his widow and family ran it until 1943. (October 8, 1950.)

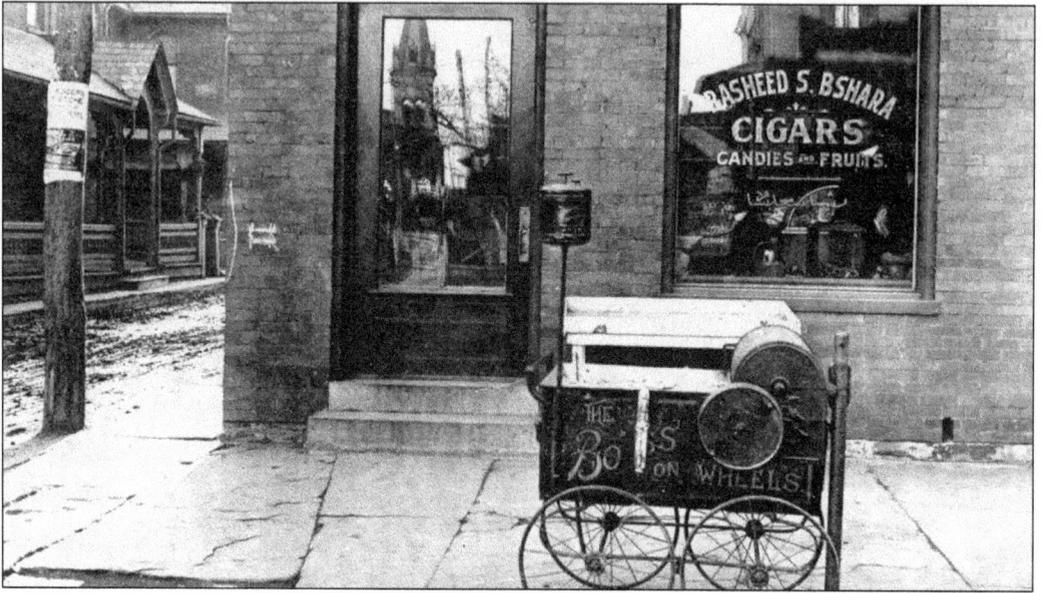

Rasheed S. Bshara operated a cigar shop in Williamsport early in the 20th century. All cigars were made by hand around the turn of the century, and there were 40,000 cigar factories nationwide. It took very little money to get into the cigar business, and Bshara, an immigrant from the Middle East, could have gone into manufacturing cigars with as little as $10 capital. (c. January 1915.)

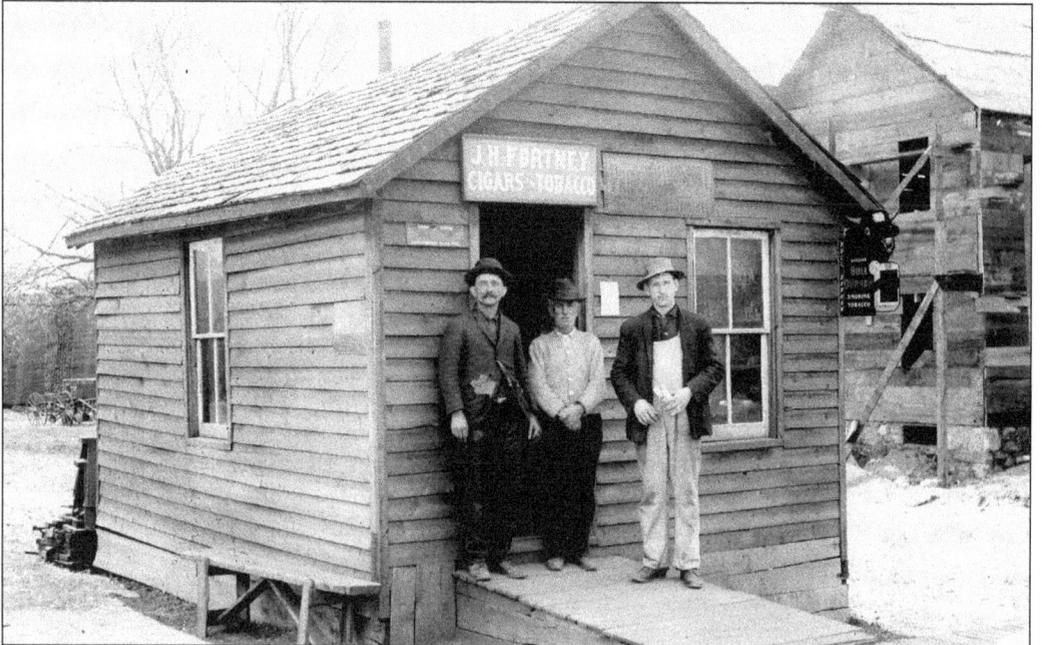

Three men are pictured in front of the J. H. Fortney cigar and tobacco shop, at 1101 West Third Street. A sign to the right advertises "Pride of Williamsport, Quality Smoke," sold by Henry Lundy for 5¢. After the country entered World War I, tobacco companies sent millions of free cigarettes to Americans fighting in France. In 1910, less than 10 billion cigarettes were produced. By 1919, the industry was worth $70 billion. (c. January 1920.)

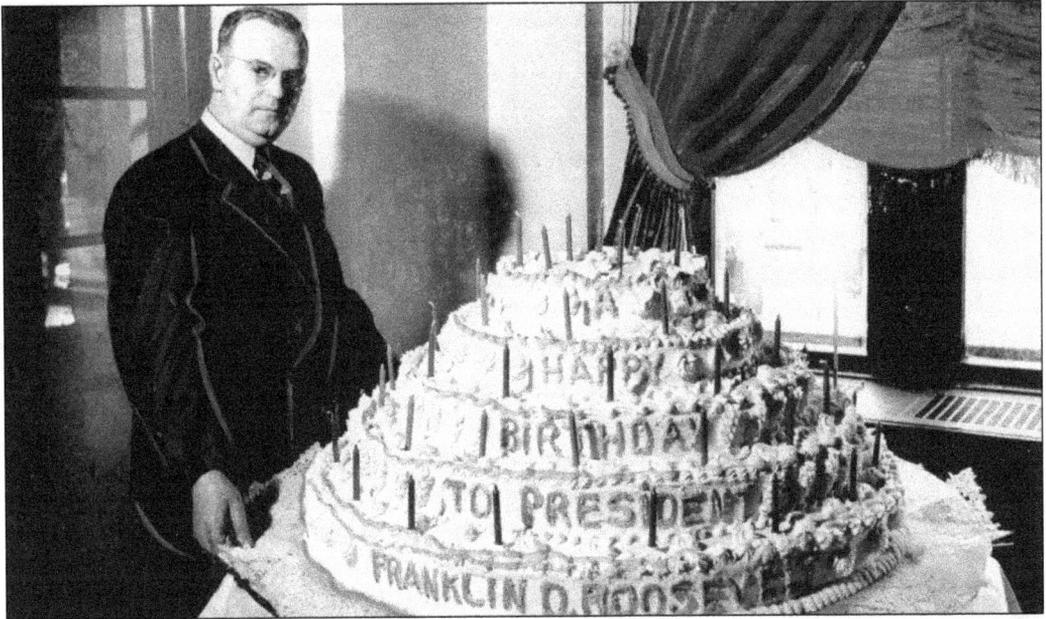

J. Frank Slack of Capital Bakery contributed a cake for a Pres. Franklin D. Roosevelt birthday celebration. About 2,500 people danced at local birthday balls used to raise money to benefit crippled children. The Lycoming County Crippled Children's Society received 70 percent, and the Warm Springs Foundation received 30 percent, of the proceeds derived from dances held at the Elks Club, the Lycoming Hotel, and the Ex-Servicemen's Club. (January 31, 1935.)

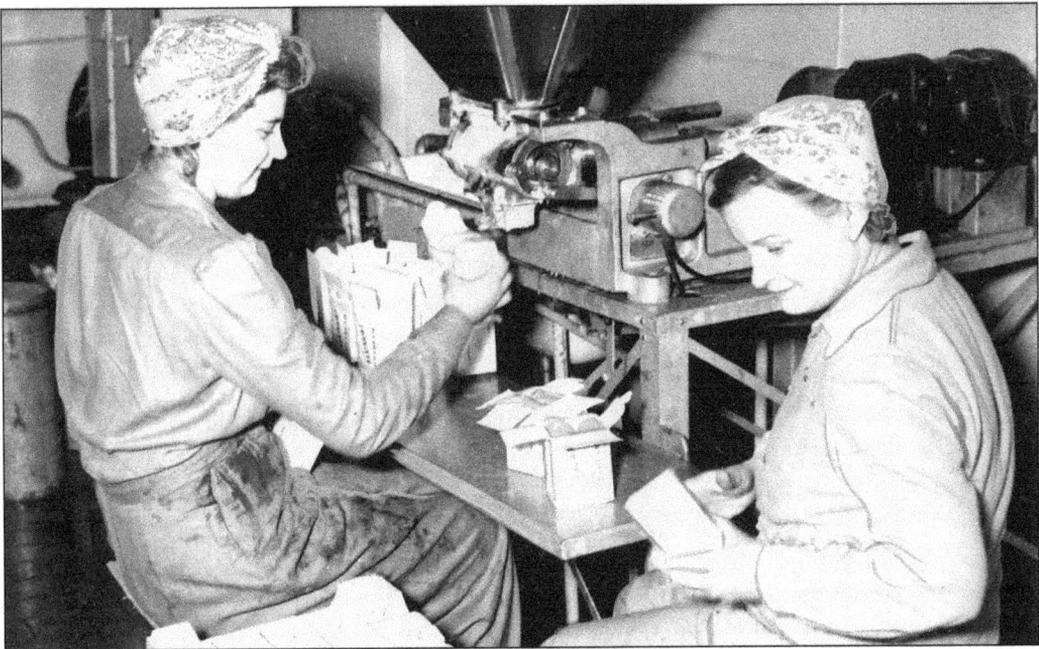

Laboring in an ice-cream plant, two women fill packages for three companies in February 1943. As a war measure, the government ordered a reduction in the production of ice cream. To conform, plants used new equipment and converted to making hand-held confections. More of these products, which targeted children, began to appear after World War II. (February 7, 1943.)

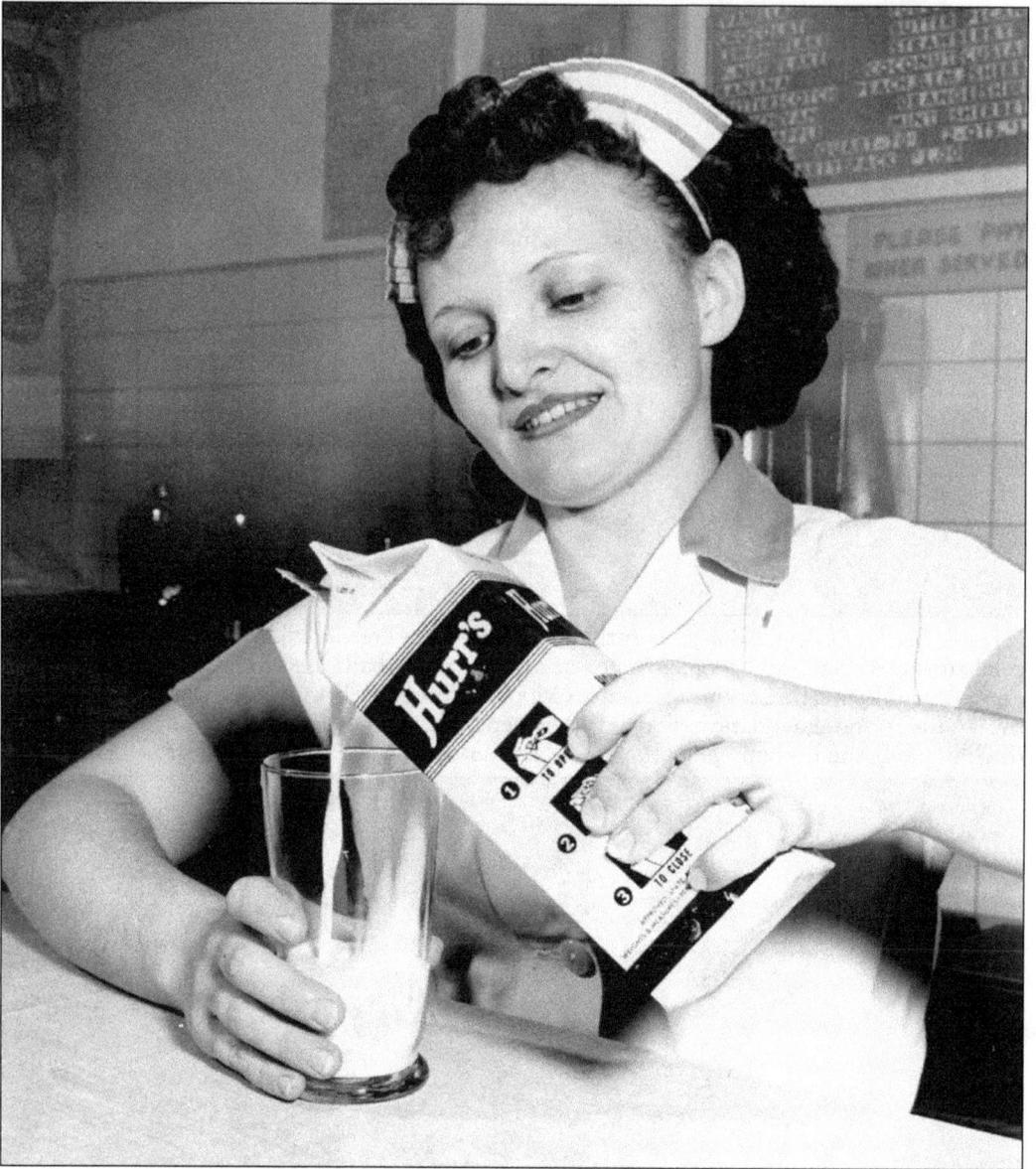

Hurr's Dairy introduced a new type of milk container made of paraffin-covered fiberboard in all of its Williamsport retail outlets. Research in dairy technology had begun at the University of Illinois-Urbana in 1896, and in the 1940s, faculty member Martin Prucha demonstrated the safety of paper containers for milk. Studies by Prucha and Harry A. Harding showed that dairy equipment and utensils were the major source of contamination of milk, and that chlorine was an effective sanitizer. Locally, the Williamsport Milk Products Company installed an automatic milk-packing machine, which had a profound effect on the dairy industry, since milk was delivered daily in glass bottles until then. (November 13, 1949.)

36

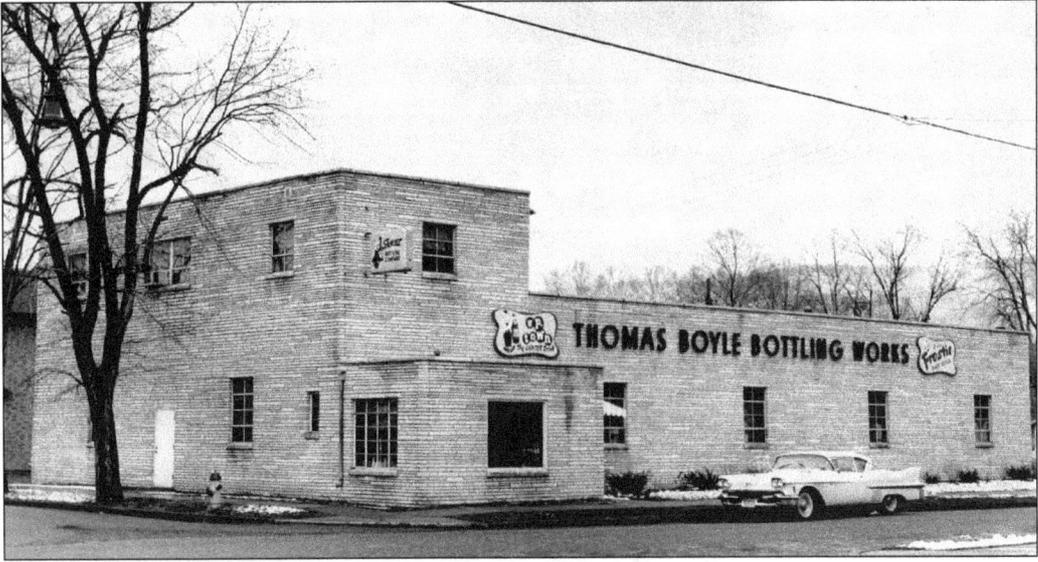

The former Thomas Boyle Bottling Works, at 316 Rose Street in Williamsport, was the local distributor of Royal Crown, Frostie Root Beer, Uptown Cola, Diet-Rite, and Squirt soft drinks. The bottling works was out of business by the mid-1970s, the building then housing the Jesco Athletic Clothing Company. (March 20, 1958.)

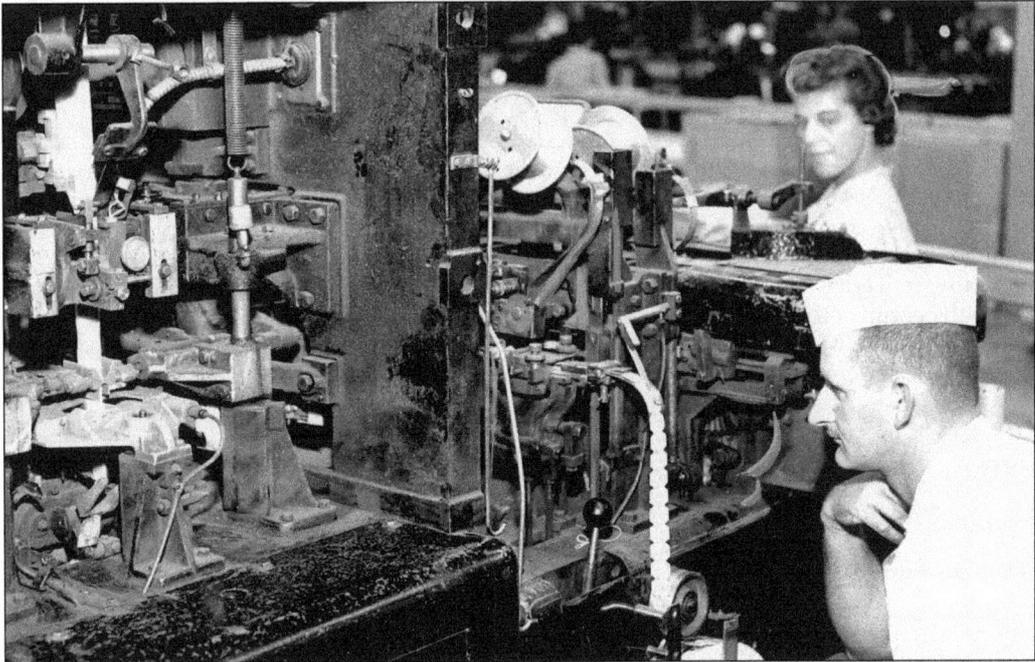

James Robinson, a machinist at the Tetley Tea Company, watches the operation of an automatic loader as it pours tea into small bags, seals them closed, and inserts strings, staples, and tags. The tea bags are then pushed on to Patricia Schon of Montoursville, who inspects them and places them into a larger cardboard box. The Williamsport Tetley Tea plant was built in 1958 as the New York facility was phased out. (November 1, 1964.)

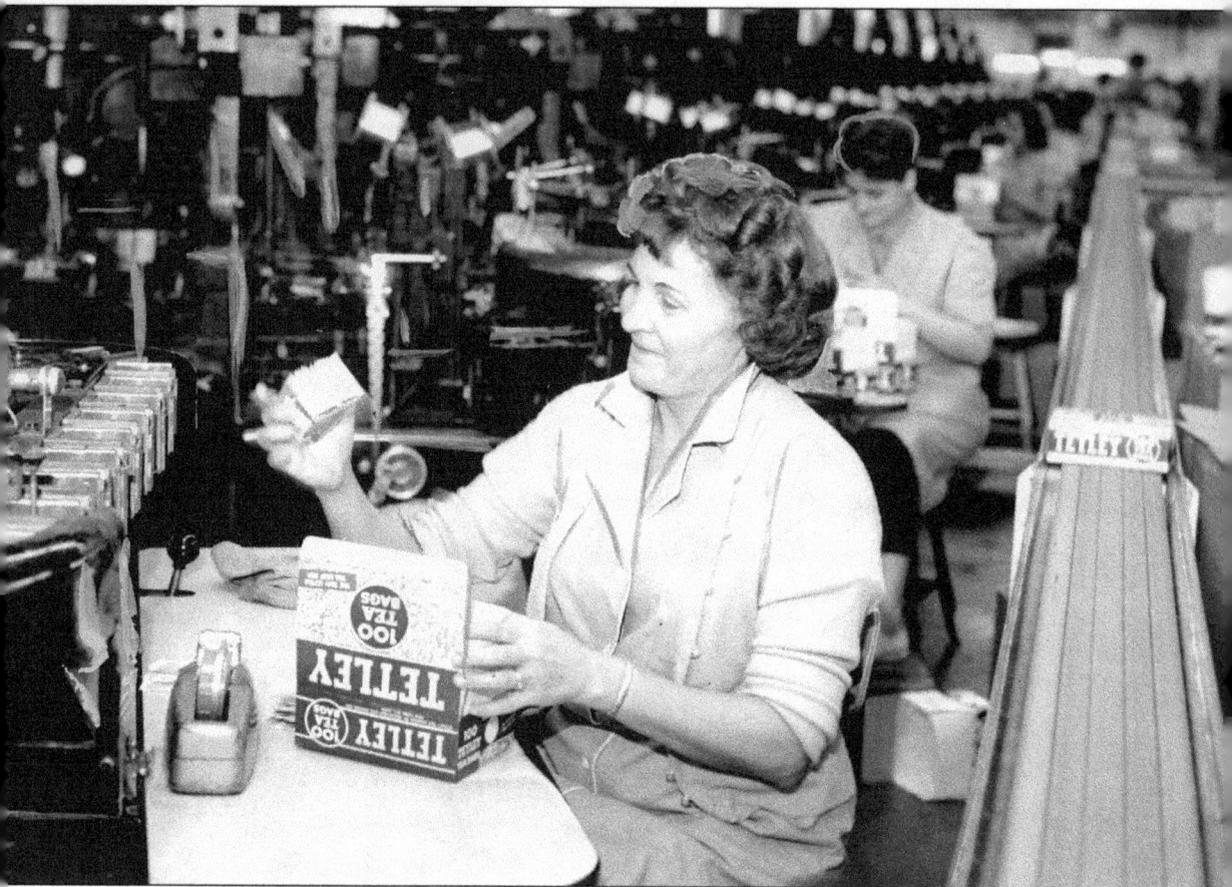

Mary Mundell inspects a lot of 16 tea bags as it exits the automatic loader at the Tetley Tea Company. Tea's worldwide significance began with the founding of the East India Company in England. Chartered in 1600, the company had a monopoly on all goods entering Britain. This resulted in expensive tea. Sailors and smugglers avoided the monopoly and tariffs by illegally importing it. Tetley Tea began more than 160 years ago in England when, at the beginning of the 19th century, brothers Joseph and Edward Tetley peddled salt from the back of a pack horse on the Yorkshire Moors. In time, they added tea to their supplies. By 1888, the company was distributing Tetley's teas throughout the United States. (November 1, 1964.)

Four

THE TEXTILE INDUSTRY

The American textile industry is rooted in the British factory system. The first American cotton-spinning mill was developed in 1790 by Samuel Slater, a British mechanic. This mill began the transformation of New England from an agricultural region to an industrial one.

In 1813, Francis Cabot Lowell of Boston launched a mill in Waltham, Massachusetts, that used power looms, spinning yarn, and weaving cloth. He hired only young women between the ages of 12 and 25, who lived in boardinghouses on his property. Big business had arrived.

The Lowell system experienced its first setback when management, responding to a financial crisis, sought to cut wages. The young women went on strike in 1834 and 1836, formed the Factory Girls' Association, and joined the 10-hour workday movement. Mill owners around the nation turned to "scabs" and immigrants to replace the native-born workers. Conditions in the textile industry continued to decline in the North. After the organization of the Industrial Workers of the World in 1912, many firms moved to the South, or once tariffs were lowered, moved offshore.

After World War II, the American textile industry continued to lose ground. Communities that once relied upon textiles had to evolve. For example, Lowell became a center of high technology. Many textile towns, however, languished.

Lycoming County had many manufacturers of textiles and companies that processed leather. The first boot and shoemaker in Williamsport was Jeremiah Tallman, who, as early as 1799, opened a shop at Third and Pine Streets. In 1873, J. E. Dayton and Company established the first boot and shoe factory. Founded in 1882, Lycoming Rubber was also a great shoe industry in the city. The first hatter was Robert McElrath, who, in 1795, set up shop on Third Street between Pine and William, the site of the jail. Subsequently, he was made jailor and lived there, where he practiced his trade on a small scale.

Samuel and Jonathan Rogers bought the Willow Grove Mills in Clarkestown and erected a frame woolen mill there in 1817. It was destroyed by fire in 1826. In 1812, John Opp, the son of Philip Opp, a pioneer of Moreland Township, built a wool-carding and cloth-dressing mill at Little Muncy Creek. The Muncy Woolen Mills Company began in 1882. In 1891, the brick mills on Market Street sold 30,000 blankets.

Thomas Updegraff was the first man to establish a tannery in Williamsport, shortly after his arrival in 1799. He first worked at Daniel Tallman's tan yard and, in his spare time, built a log cabin at the corner of Market Street and Black Horse Alley for a dwelling and shop.

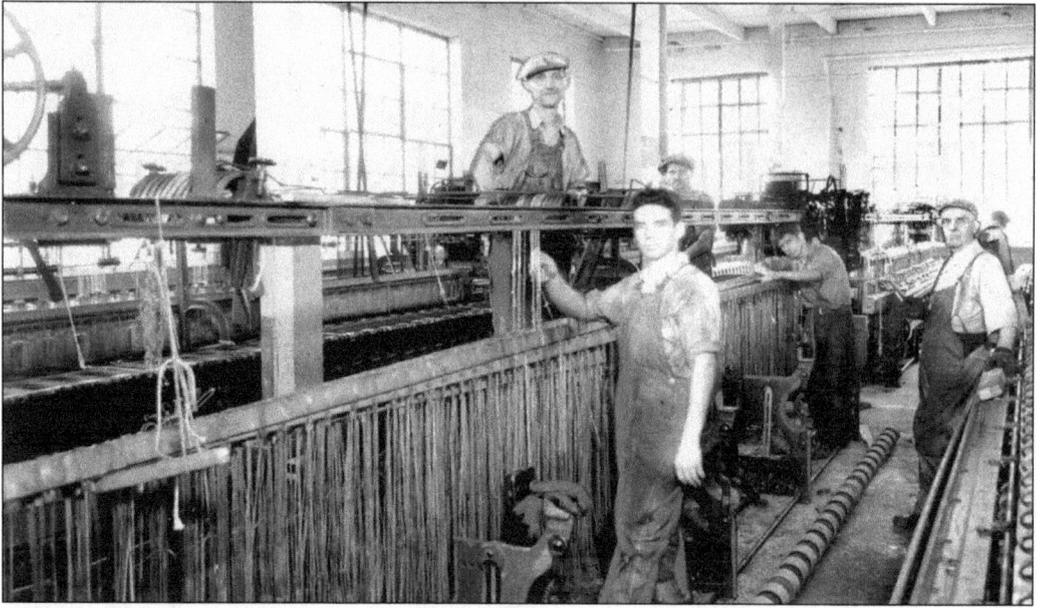

Workers operate looms and machinery at the Mountain Textile Company, at 200 East Street in Williamsport. Originally housed in the National Paintworks, work continued uninterrupted as Mountain Textile moved. It was lucky to be in business despite competition from Southern mills, labor conflicts, and the collapse of cotton. Two years earlier, the Independent Textile Union had formed. (August 6, 1933.)

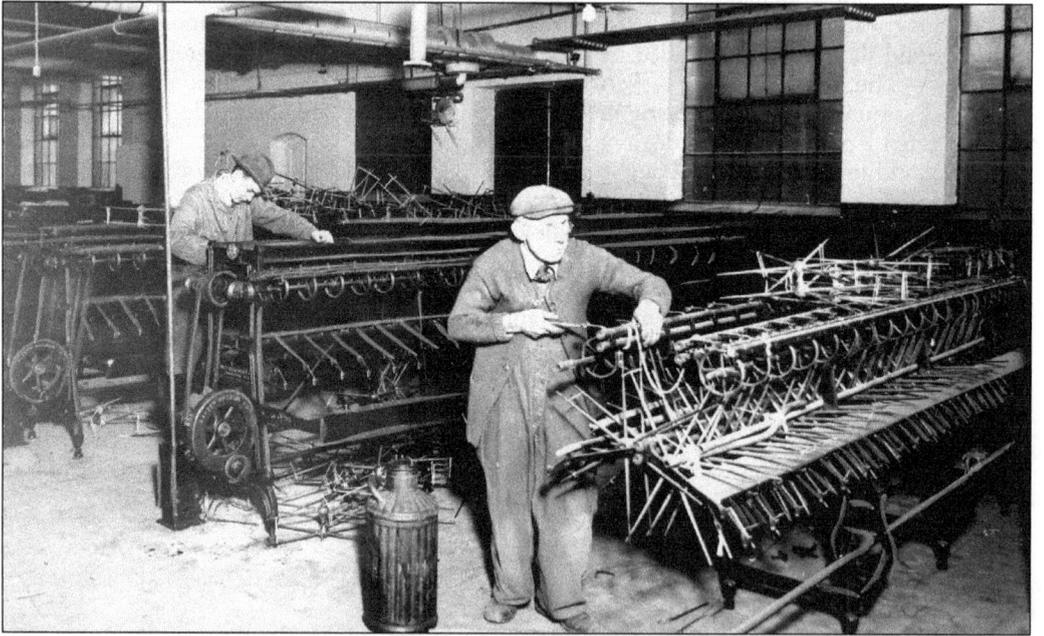

The Faxon Fabric Company had added $80,000 worth of new machinery by March 31, 1935. The company also increased its floor space from 13,000 to 43,000 square feet. After the new machinery was installed and the plant expanded, 85 additional employees were needed. The plant was located on the fourth floor of the United States Rubber Company building. (January 13, 1935.)

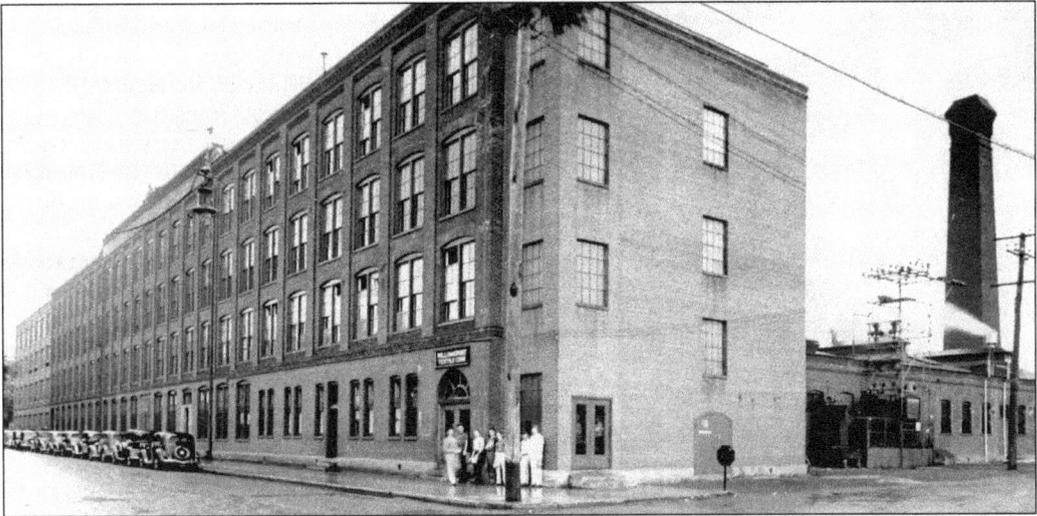

The Williamsport Textile Corporation building stood at the corner of Memorial Avenue and Oliver Street. Williamsport Textile began operations in November 1933, becoming one of Lycoming County's largest employers. The post–World War II years, however, brought a decline in union strength among textile workers, and production shifted overseas or to unorganized Southern mills. Williamsport Textile closed its doors in 1951. (June 27, 1937.)

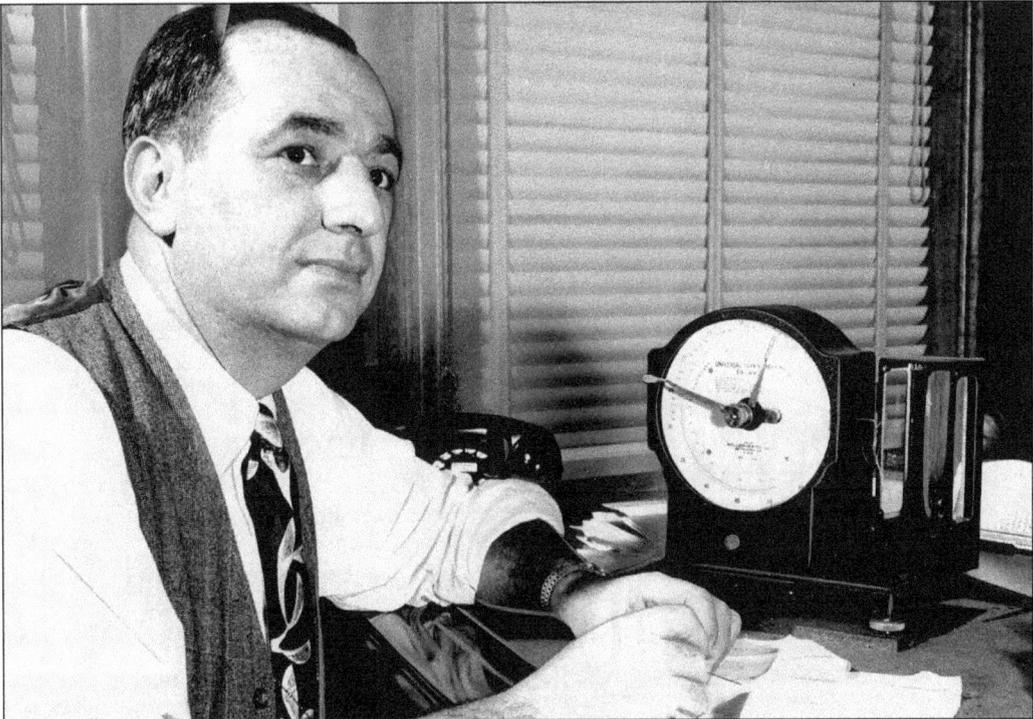

Alfred A. DiCenso of Syntex Fabrics, at 600 Railway Street, analyzes cloth with precision scales. The company's 360 looms ran 140 hours per week. DiCenso became a textile factory worker at the age of 10, climbing to the position of president of an "ultra-modern local factory" that made 11 million yards of cloth each year. Today, Syntex fabric, which looks like Olefin, is a material with Kevlar-like properties and has one of the highest strength-to-weight ratios. (January 22, 1950.)

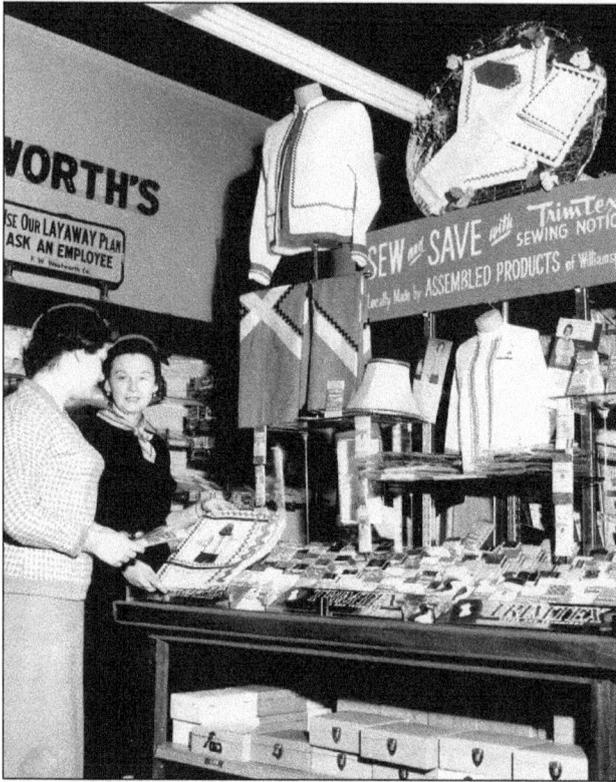

Sally Doane (left) and Mrs. John Whiting Jr. examine a local display of products from the Trimtex Company. This Williamsport industry received national publicity in the February 25, 1957, issue of *Life* when the magazine devoted a full page to the national home-sewing craze, which involved adding rick-rack and tape trim to clothing for a colorful effect. Trimtex's packaged trimmings were sold in some of the nation's leading stores, including F. W. Woolworth. (March 3, 1957.)

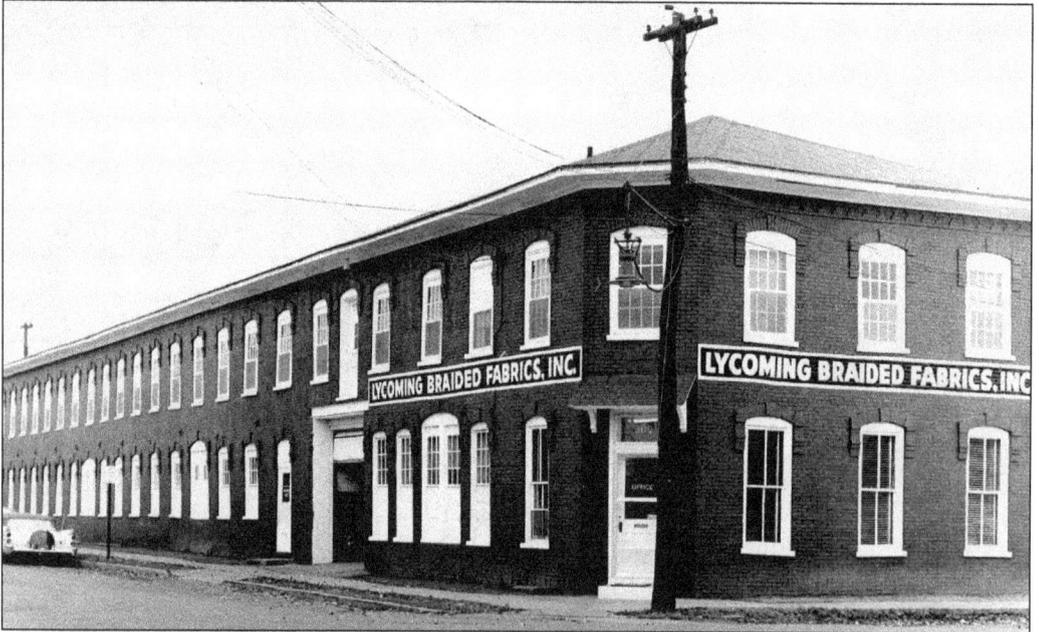

Lycoming Braided Fabrics, at the corner of Church and Basin Streets in Williamsport, was founded in 1947 and became Lending Textile in the mid-1980s. At one time, it employed about 80 people and held 1,500 machines. The company made rick-rack, a favorite trim of late-19th- and early-20th-century seamstresses, who used it to embellish garments. (November 10, 1957.)

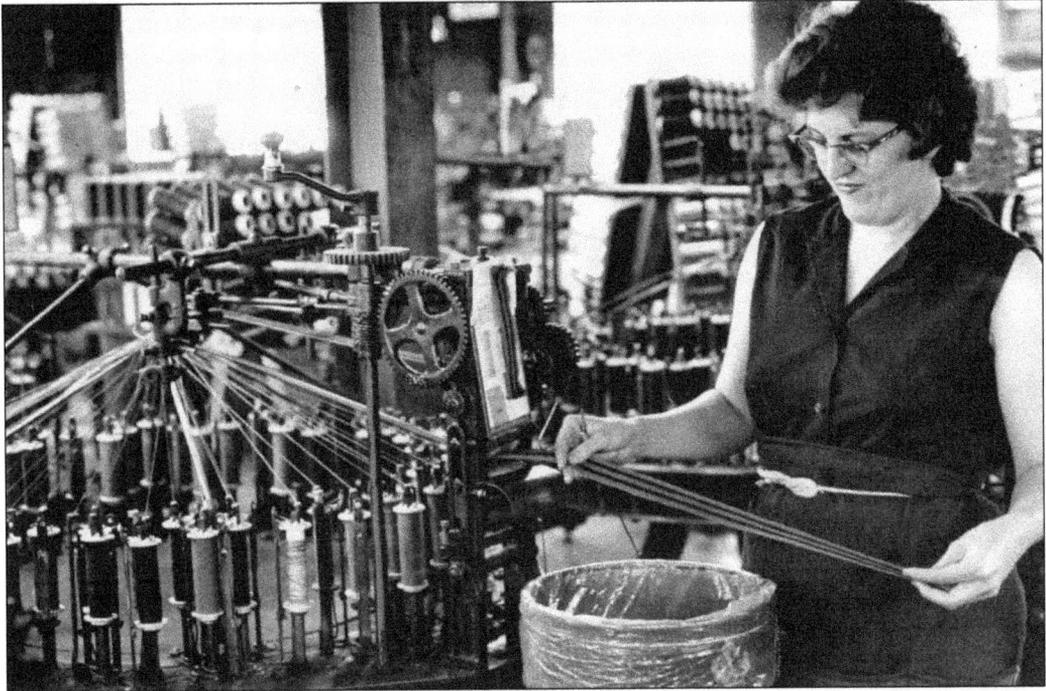

Fancy, novelty, and functional braids and tapes of all descriptions were manufactured by Trimtex, at 400 Park Avenue. General Electric purchased Trimtex's Kappa Tape and used it in the fuel cell of NASA's Gemini 7. Founded in 1919 with seven employees and known as the Leonard W. Wood Silk Mill, Trimtex later became known as the Williamsport Narrow Fabric Company. (July 9, 1966.)

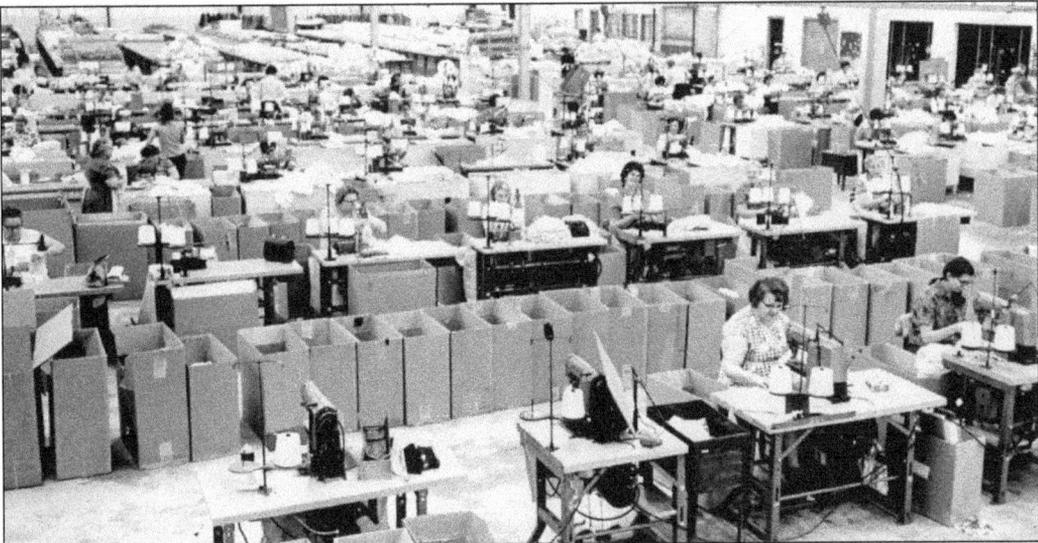

The seamstresses of the Sybil Manufacturing Company work in roomy new facilities at Elm Park. The firm had almost completed its move from the old quarters at Rose Street at the time of this photograph. The old facilities, however, continued to house company offices. The 125,000-square-foot plant in Elm Park was built at a cost of $1,400,000 by the Lycoming County Industrial Development Authority. (January 17, 1971.)

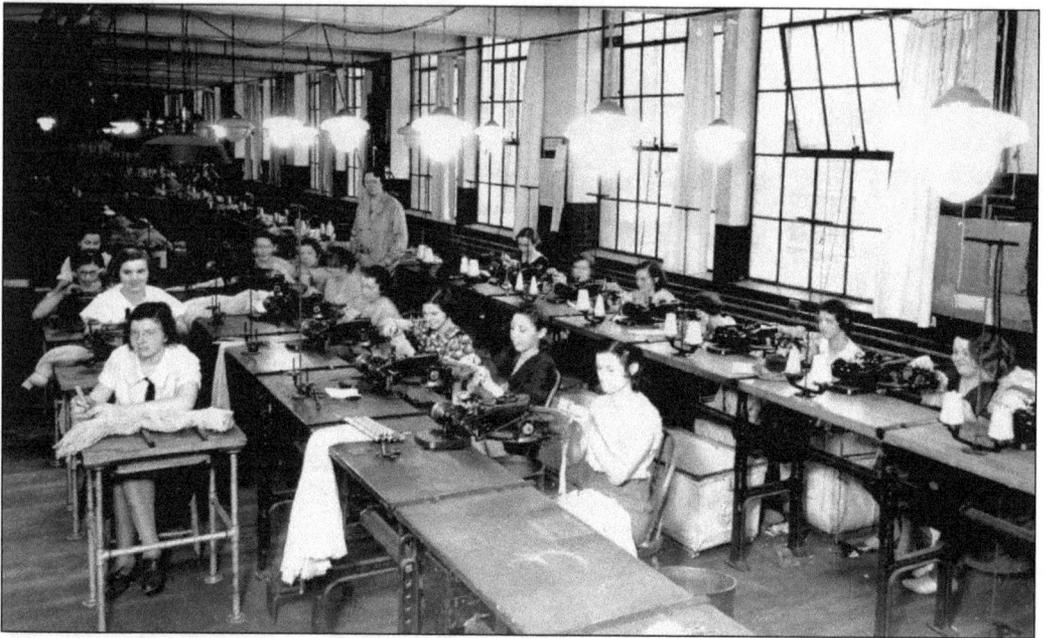

Girls learn hosiery weaving at the Franklin Hosiery Mill, located on the third floor of the Lycoming Rubber Company building. The special class was conducted by the Williamsport School District in conjunction with the employment committee of the local chamber of commerce. More than 40 young women were enrolled in the class; 25 were later hired as employees of Franklin. (December 17, 1933.)

Members of the Mutual Welfare Association of the Williamsport Silk Company held their annual picnic on July 28, 1934. About 120 members and their families were present. A rainstorm did not daunt picnic goers in their food, fun, and games. Music was provided by the Joe Vannucci Orchestra, and dancing was held at the pavilion of Memorial Park. (July 29, 1934.)

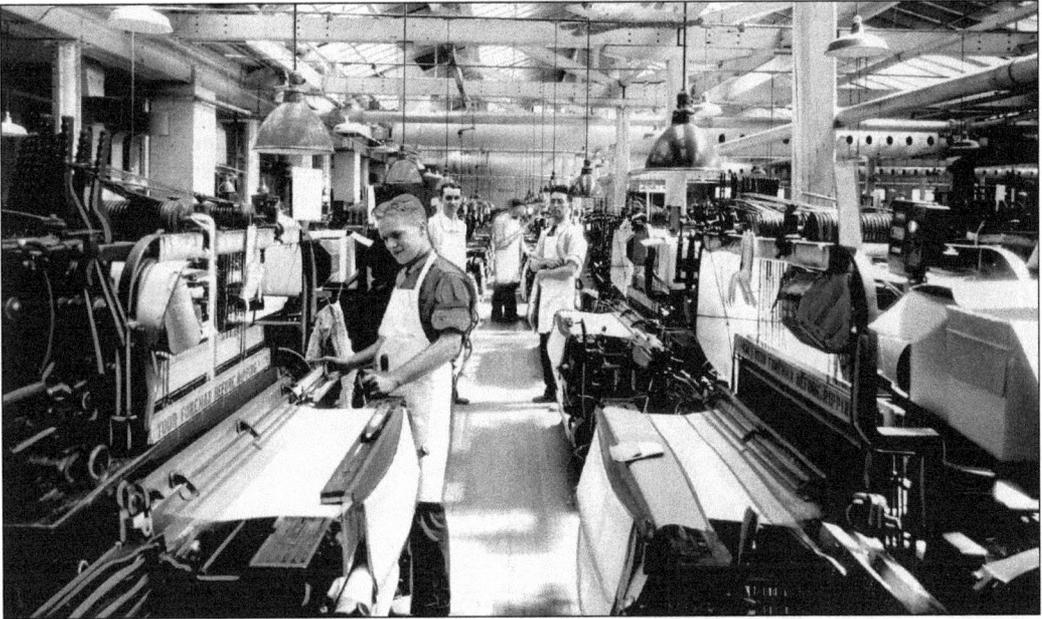

An additional 100 workers were employed for the night shift in the weaving department of the Williamsport Silk Company on Memorial Avenue. In April 1935, despite the Great Depression, the plant employed 500 people. At the turn of the century, manufacturers of silk and silk goods in Williamsport generated an income of $1,191,273. (April 14, 1935.)

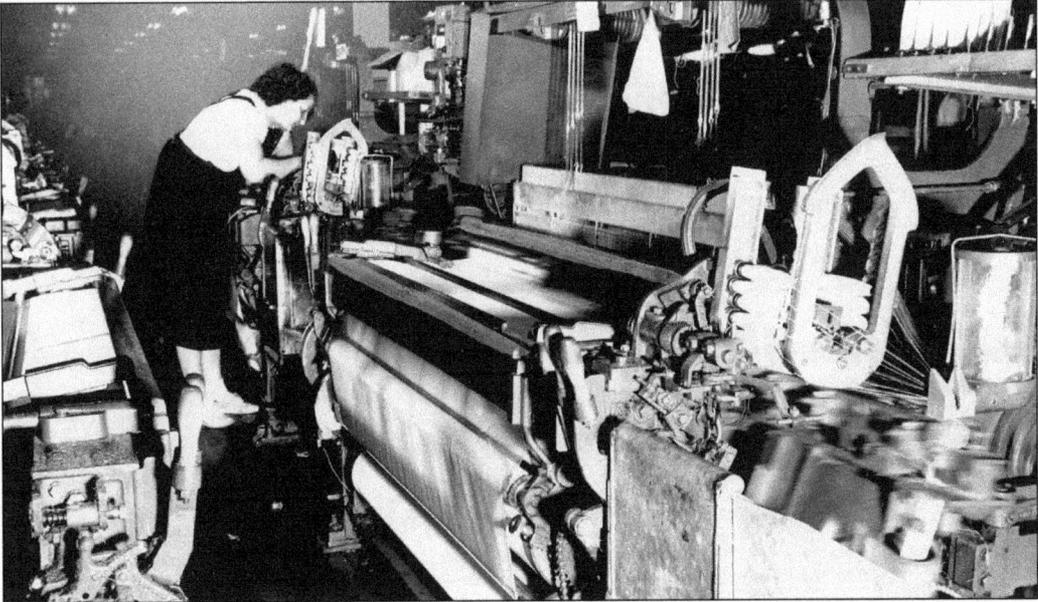

An employee monitors one of the numerous machines used at the Williamsport Textile Corporation. Greige fabric, the company's specialty, came directly from the loom, not requiring any process to convert it into a finished, dyed fabric. Of the 615 employees, 230 were women, who worked only on the first and second shifts. Three 40-hour shifts were required to maintain production at the plant, valued at $1,250,000 in 1950. (November 5, 1950.)

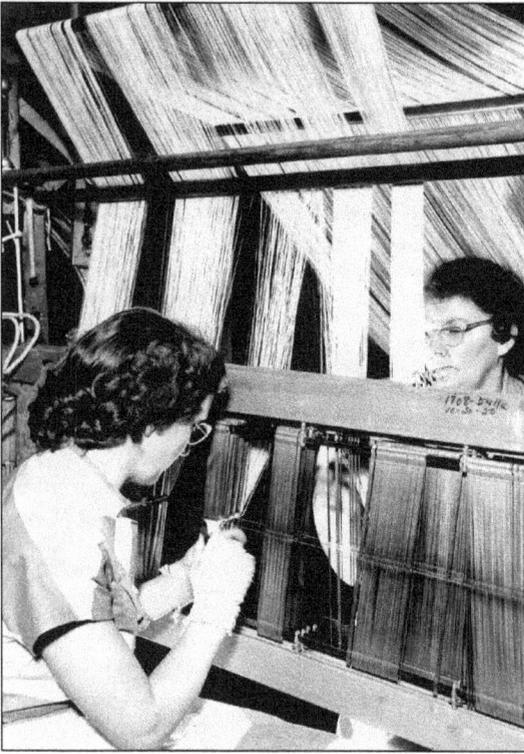

Women enter yarn into a harness before weaving begins at the Williamsport Textile Corporation. There were 592 automatic looms at the plant. Young women also handled a quilling operation separate from the other stages of making greige fabric. The quilling department employed several thousand spindles, and yarn was transferred from cones to loom bobbins to be used with the warps in the weaving operation. (November 5, 1950.)

The former Holmes Silk Mill, located at Dewey and Memorial Avenues, was purchased in 1959 by Investor's Properties, a group of local businessmen. The 54,000-square-foot building was standing empty when the silk mill company ceased operations in 1958. Silk mills nationwide declined because of antiquated mills, the increase in small, family-operated shops, and the introduction of rayon. (May 3, 1959.)

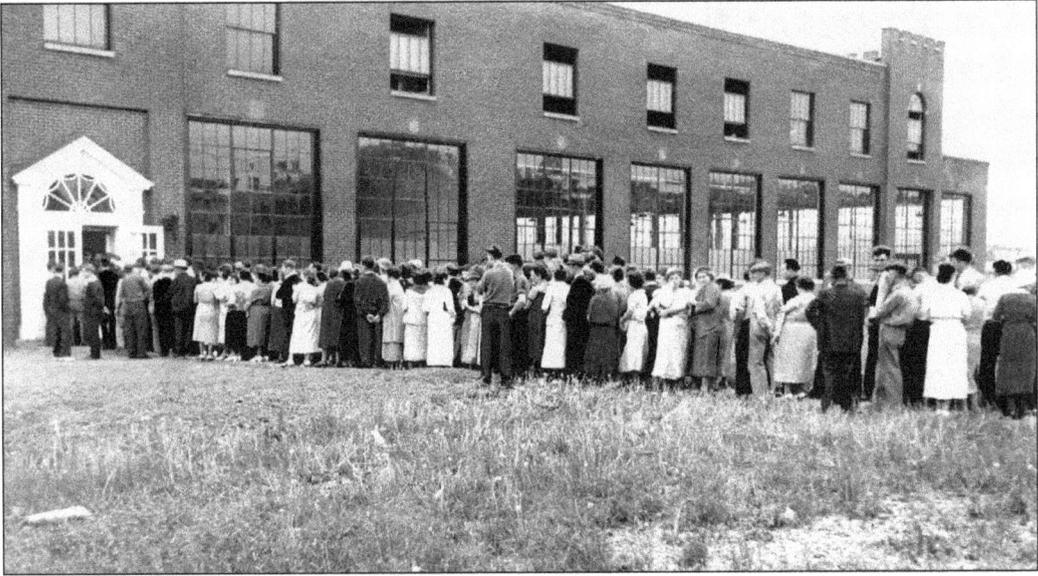

Several hundred people line up to seek work at the R&G Knitting Company, Williamsport, after opening amid the Great Depression in 1936. The factory, employing 150 persons and expecting to hire more, was located in a former car barn on West Third Street. R&G was brought to Williamsport through the efforts of the Committee of 100, the industrial recruitment arm of the local chamber of commerce. (May 24, 1936.)

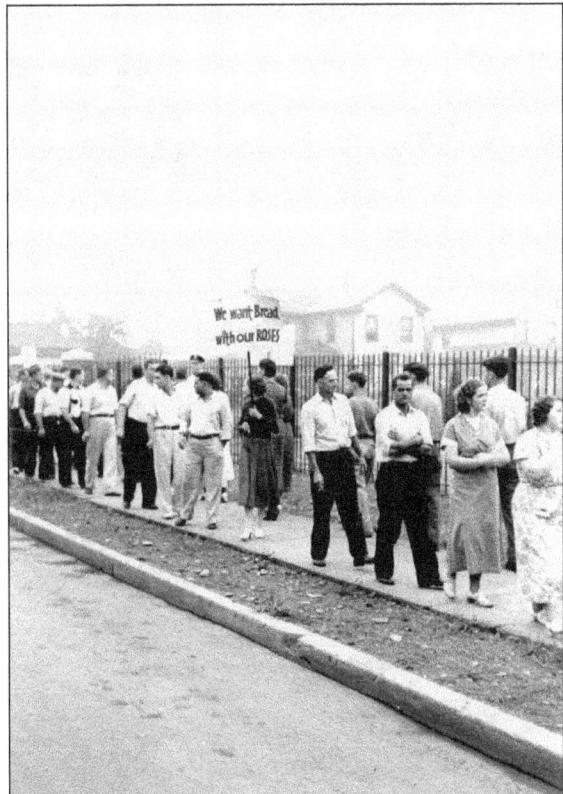

By 1937, it seemed like the world was falling apart, with labor a big part of the problem—or solution, depending on one's point of view. Almost everyone was striking, and in this October 1937 photograph, workers form a picket line at the R&G Knitting Company, carrying signs that read, "We want Bread with our Roses." The employees were striking for a closed shop and the disbanding of the company union. The strike lasted two months, from August to October 1937. (October 5, 1937.)

47

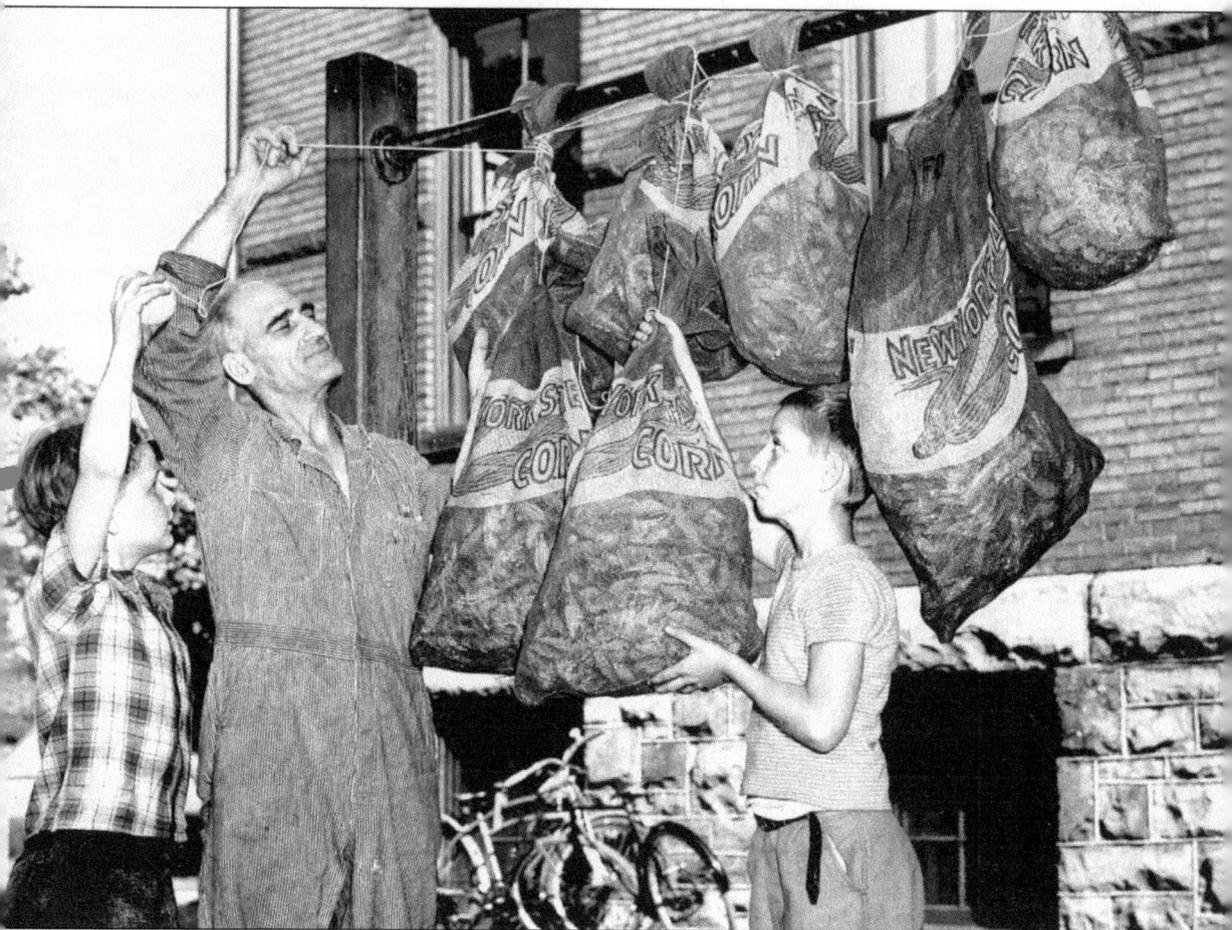

An adult helps boys hang milkweed pods to dry at Clay School, Williamsport. Before World War II, the United States imported kapok for filling life jackets. When the Japanese captured the East Indies, the supply of kapok was cut off. People—particularly schoolchildren—were directed to find and collect milkweed pods. The silk was especially good because of its exceptional buoyancy and light weight. Also in World War II, because of the shortage of natural rubber, scientists in the United States tried to turn common milkweed's latex into a rubberlike substitute. Lycoming County's schoolchildren nearly doubled their quota during the fall of 1944, filling 1,521 bags with pods. (October 15, 1944.)

Sara Eiswerth, an employee in the pressing department at the Vogue Lingerie Company, hangs slips on pressure forms that emit about 80 pounds of live steam. Of the 250 employees at Vogue, all but 12 were women. There were eight different sewing operations on the garments in the slip-sewing section. In the 1950s, strapless bras appeared. (February 3, 1952.)

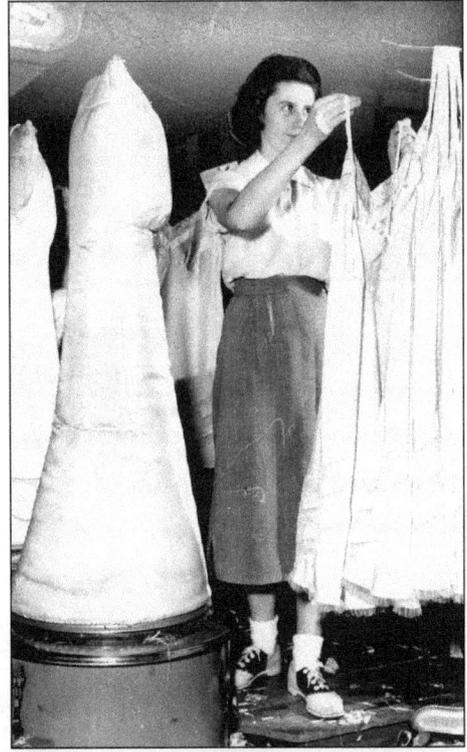

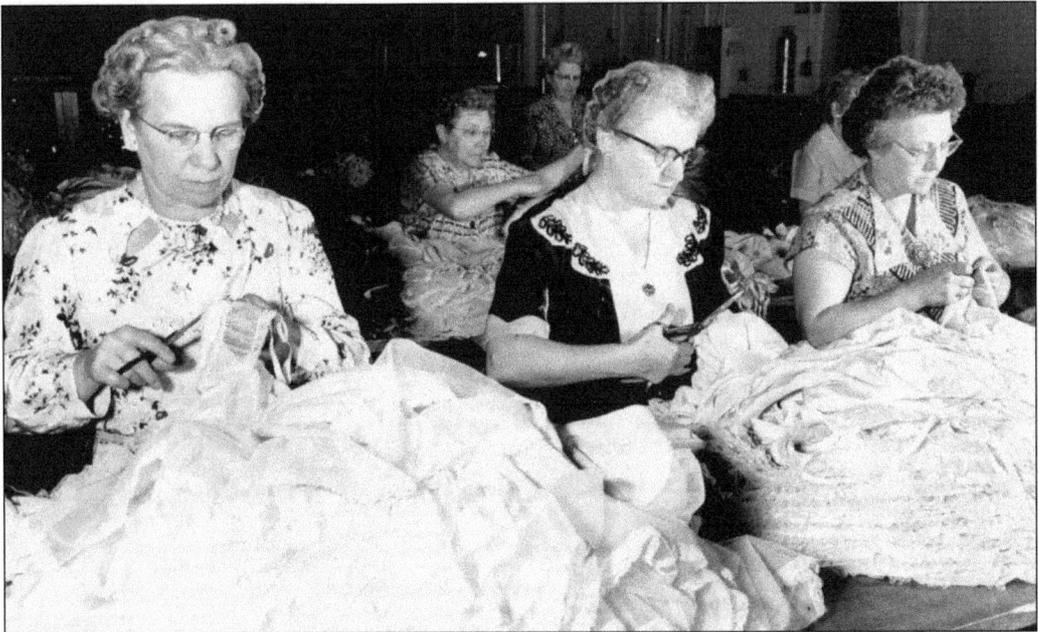

Employees trim threads from slips in the inspection department of the Vogue Lingerie Company in February 1952. Pictured here are Nellie Smith (left), Mrs. Shire (center), and Hazel Smith. As many as 180 women worked in the slip-sewing section at the Vogue Lingerie Company, at 2928 West Fourth Street in Williamsport. The identification tag of "Style by Vogue" was found inside garments sold all over the country. (February 3, 1952.)

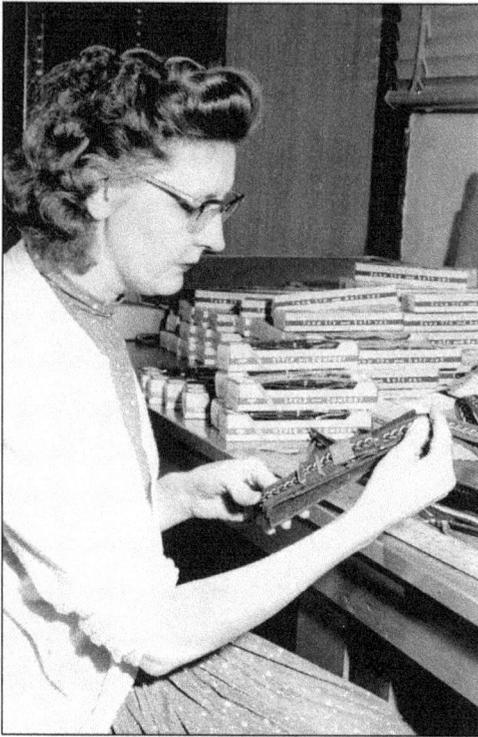

The Billtown Belt and Trimming Company began manufacturing in Williamsport with high hopes in 1957. The company lasted about four years before fading out because of constant fires. Billtown was organized through the efforts of Angelo Infantino as a side business of Lycoming Braided Fabrics. Infantino designed and built the fast-braiding machines from leftover parts of an automobile transmission. (September 29, 1957.)

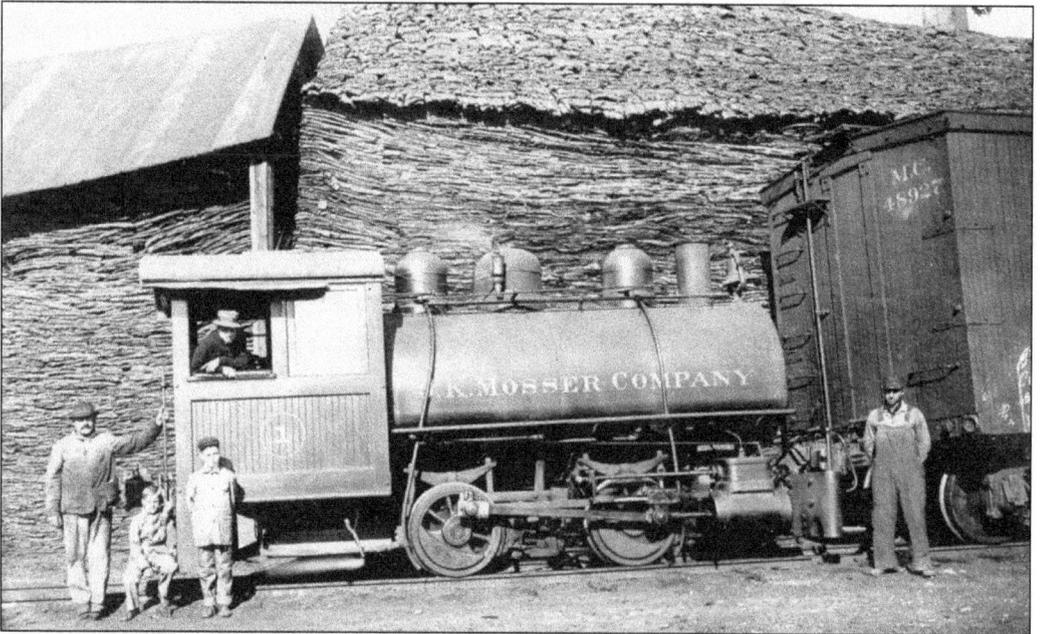

Tannery pushers at Mosser handled railcars that transported hides, both finished and unfinished, from the tannery. Although small, this locomotive handled freight cars with ease. These trains ran on tracks about 24 inches wide, less than half the size of standard tracks. Cars attached to the engine were the forerunners of cattle cars. (March 15, 1914.)

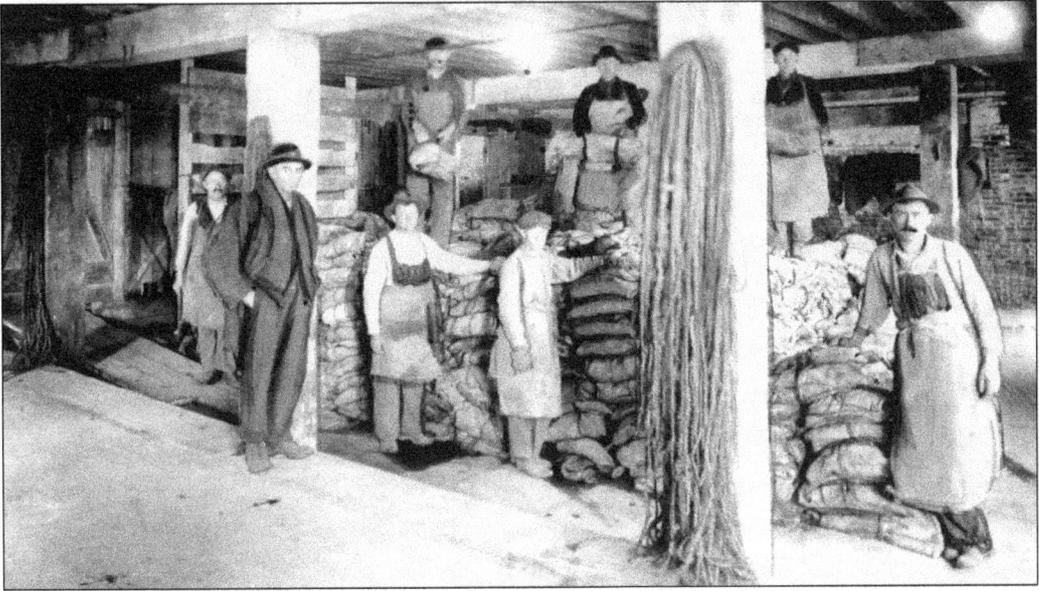

Laborers process green hides as they are received at the J. K. Mosser Tannery, on Arch Street in Newberry. The family fortune began in 1763, when Phillip Mosser built a log gristmill on the Antelaunee Creek. In 1838, he built a tannery and sawmill there. In 1854, his son Jacob turned over his tannery business to his two sons, William K. and James K. Mosser. In 1876, the firm established a local tannery at 500 Arch Street. (December 11, 1921.)

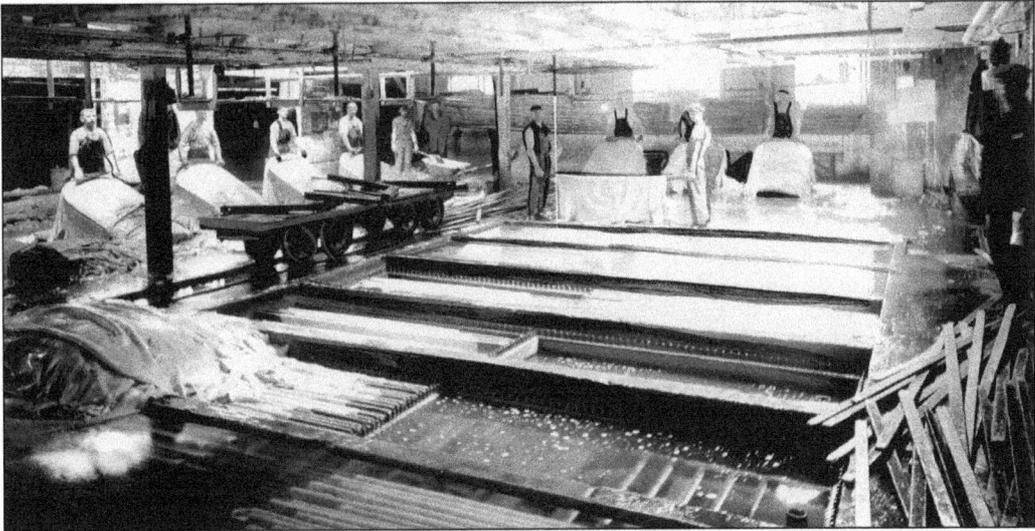

These men work in the trimming and washing room of the J. K. Mosser Tannery. There is little waste material in a hide, and Mosser's used every part for some purpose or other. Each of Mosser's sons managed a department in the company, which was one of the largest producers of leather in the country. (December 11, 1921.)

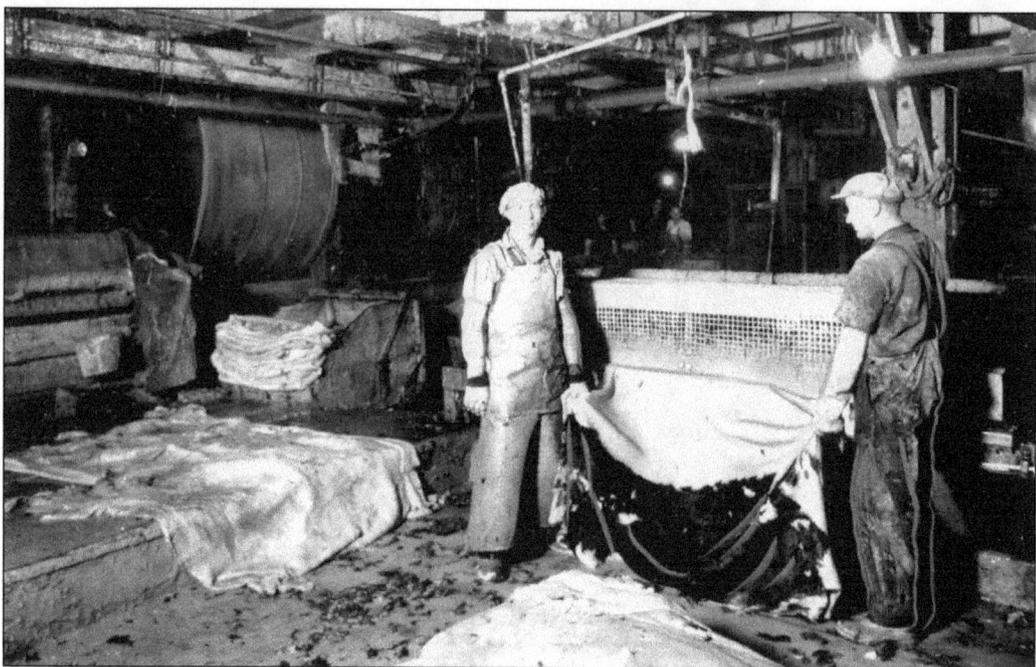

Workers use the "unhairing and fleshing" machine at the J. K. Mosser Tannery. The plant encompassed 2,300 acres in the Newberry section of Williamsport, with 1,200 feet on West Third Street and 1,600 feet along the Philadelphia and Reading Railroad tracks to the south. Mosser's 58 buildings contained 600,000 square feet, equally divided between tanning and manufacturing. (December 11, 1921.)

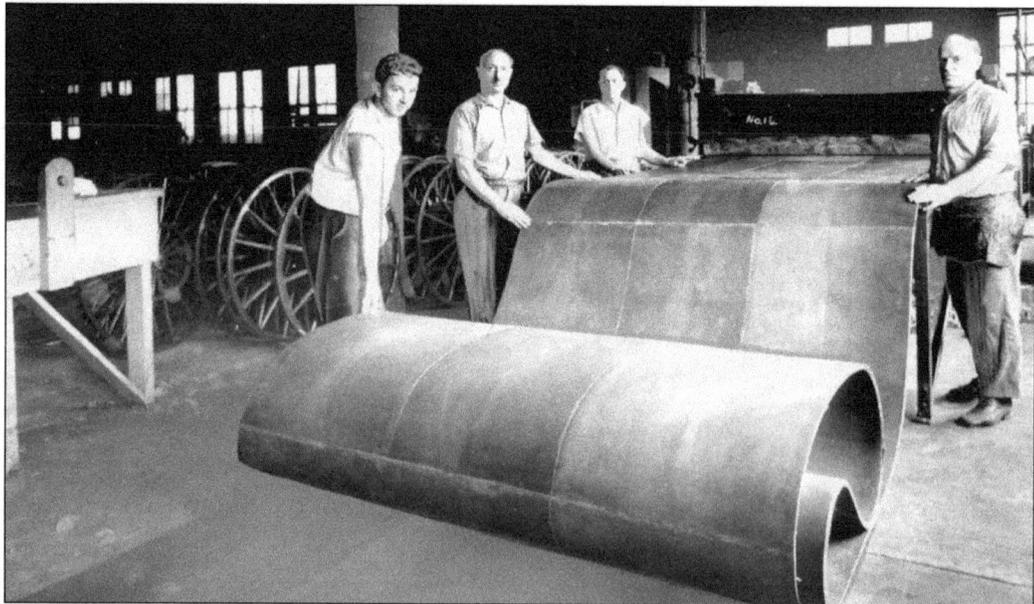

A belt 86 feet long, 6 feet wide, and five-eighths of an inch thick was made by Alex Brothers, a subsidiary of the Armour Leather Company, at the plant in the west end of Williamsport. The belt contained 285 hides put together with special cement. It weighed 2,100 pounds and generated 2,500 horsepower at the plant for which it was intended. (July 16, 1933.)

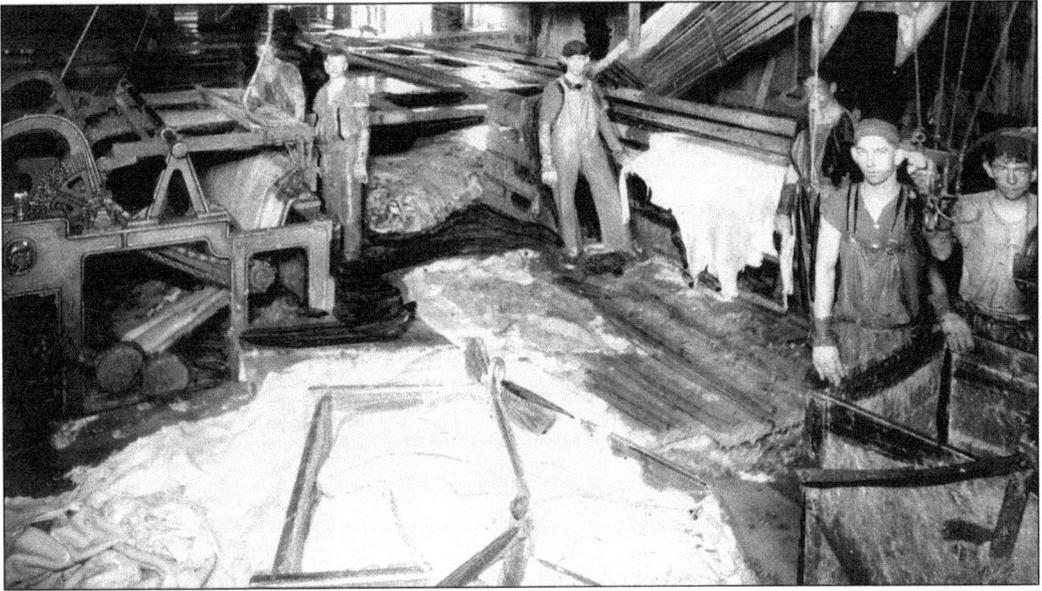

Hides are processed at the Armour Leather Company, formerly the J. K. Mosser Company. Williamsport residents nicknamed it "the Tannery." At its height of operation, Armour employed 700 workers and had an annual payroll of $2.5 million. It maintained its own railroad, using locomotives to move tons of unprocessed hides. (November 30, 1952.)

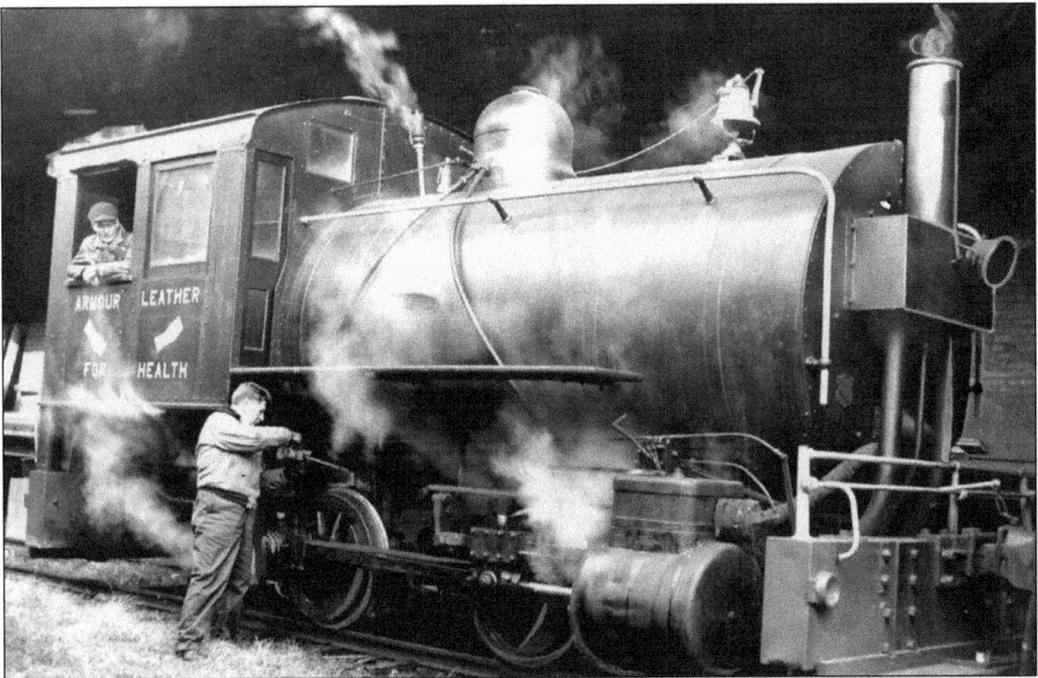

This tiny engine was owned by the Armour Leather Company, one of the city's largest industries. Armour operated its own railroad with the help of brakeman Elwood Ripka and engineer Henry Derr. In addition to the pint-sized engine, the company had four cars and about one mile of tracks, which wound about the company's vast grounds. The tracks connected with the side switches of the Pennsylvania Railroad and the Reading Company. (January 3, 1954.)

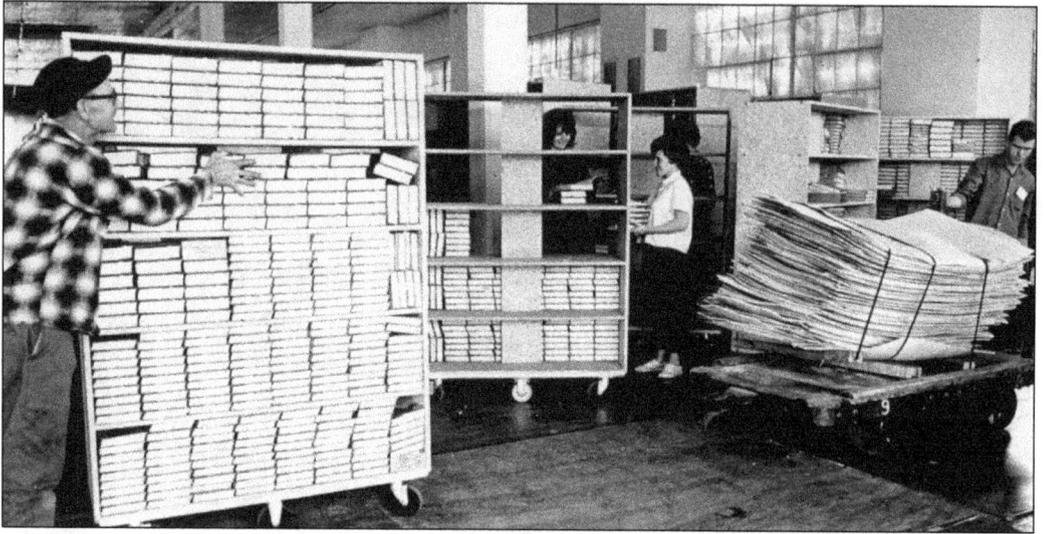

During a time of transition, the last of the leather was removed from the Armour Leather Company building, and books by the thousands were moved into the facility at 500 Arch Street. A tannery had been at that location for more than 90 years before Brodart moved into the plant. Brodart would become one of Williamsport's leading employers. (November 21, 1965.)

Byron S. Ames, a cutter for many years, works at his machine at the Lycoming Rubber Company. In 1916, Converse, an eight-year-old Massachusetts company, introduced canvas shoes with rubber soles specifically for playing basketball. Sneakers had been available since the late 1860s, but brand names were almost nonexistent. The United States Rubber Company followed with its own canvas and rubber shoes, Keds, manufactured in Williamsport. (July 23, 1916.)

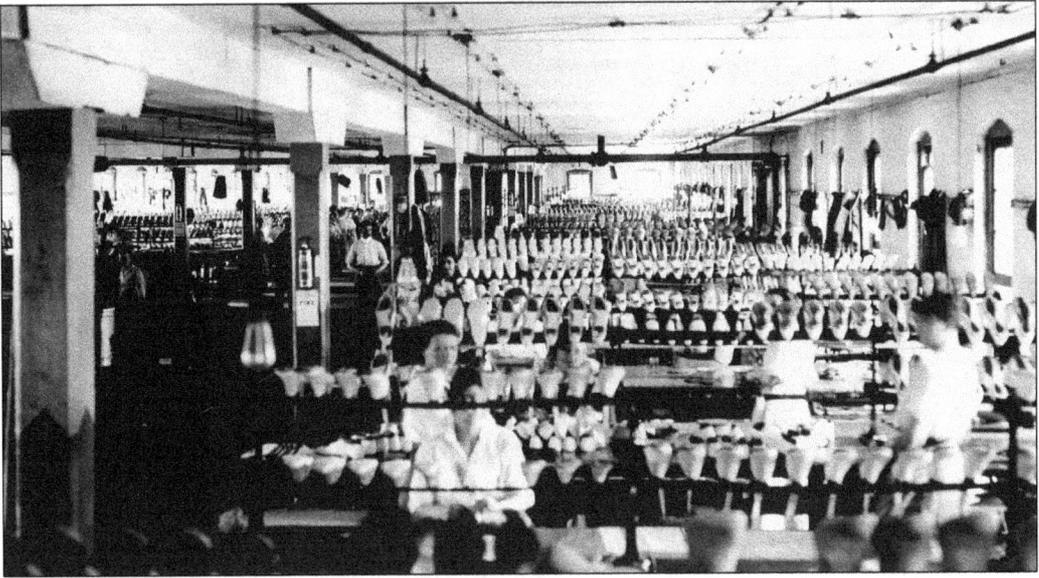

More than 200 women toiled in the shoemaking room at the Lycoming Rubber Company plant. (July 23, 1916.)

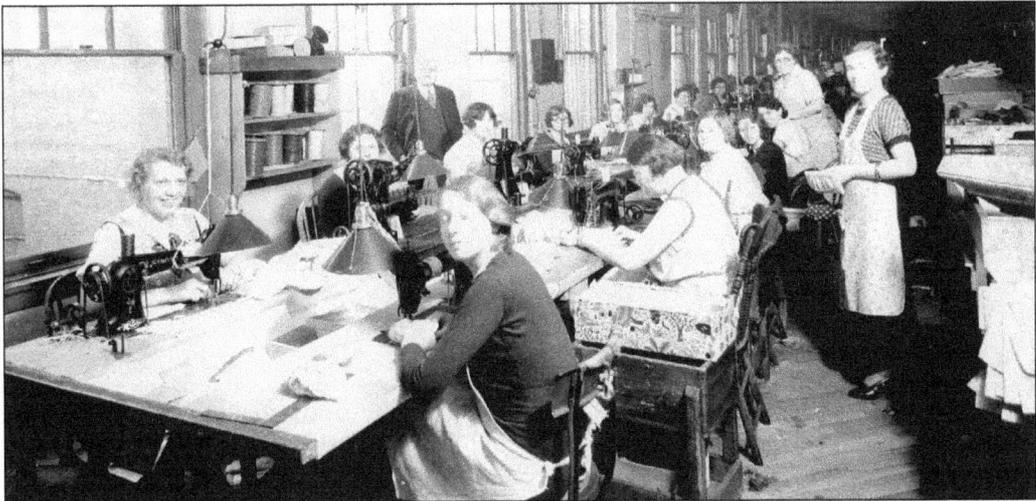

The Herz and Kory Manufacturing Company was a purse and pocketbook plant. Here, women work in the machine stitching department. The earliest handbags mentioned in historic literature were little sacks that contained pomanders, flint, and money. Gentlemen's "pockets" were hung by thongs from the back of the belt. Pockets were often cut from behind by thieves who knew how to capitalize on a friendly pat on the back. (March 5, 1933.)

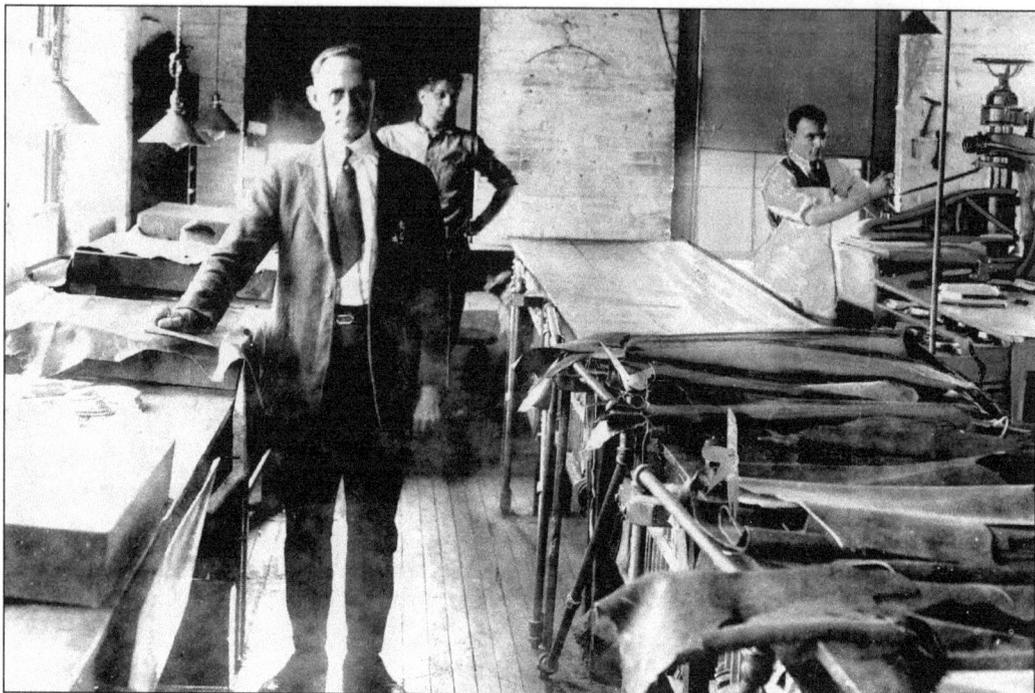

The Dayton Shoe Company experienced steady growth from its formation by J. E. Dayton, J. O. Crawford, and George Bubb in 1871, to its first shop at 37 West Third Street in 1873, then to its "magnificent factory" in the 300 block of West Fourth Street in 1922. From only $64,000 at incorporation, the company's worth had grown to nearly $500,000 by 1922. There were 185 men and women employed at Dayton, collectively producing nearly 1,000 pairs of shoes each day. (January 15, 1922.)

Members of the Keds team of the Lycoming Rubber Company had a record production of 19,000 pairs of shoes per day, or 40 pairs per minute. L. A. Trull was superintendent of the Keds division, Bernard L. Sullivan was foreman, and George Felix was assistant foreman. The rubber-soled shoes were created with a process called vulcanization, still done today, which used heat to meld rubber and cloth together. (August 25, 1929.)

56

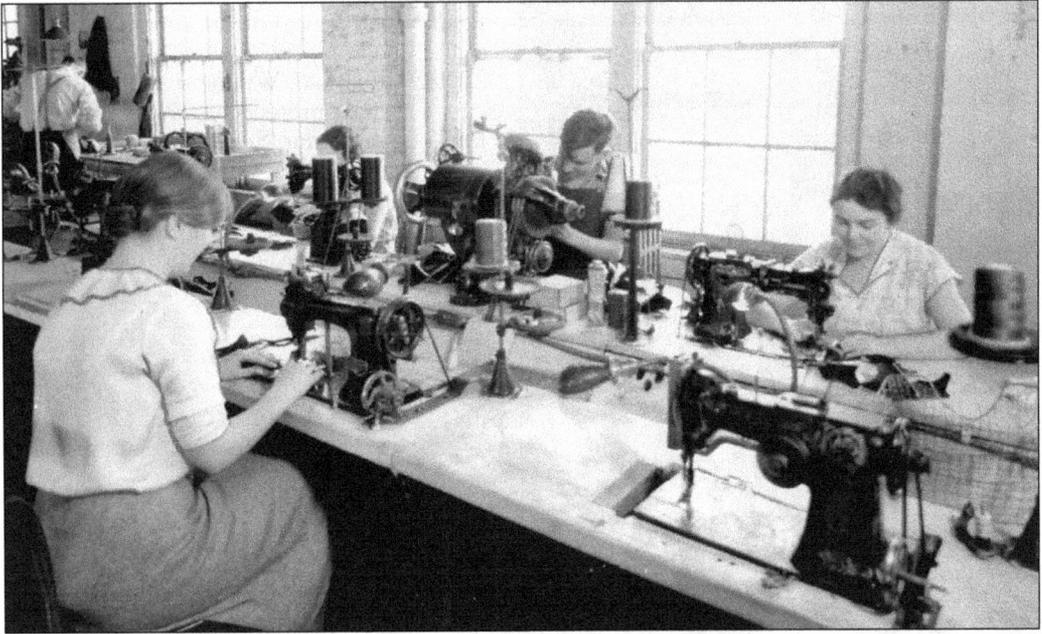

Women work among a battery of sewing machines at the Williamsport Shoe Manufacturing Company in the winter of 1933. The factory employed 10 workers and turned out 100 shoes per day when it initially opened at 643 Elmira Street. The two main operations of shoemaking were "lasting," in which the upper sections were shaped to the last and insole, followed by "bottoming," or the attaching of the sole to the upper. (February 19, 1933.)

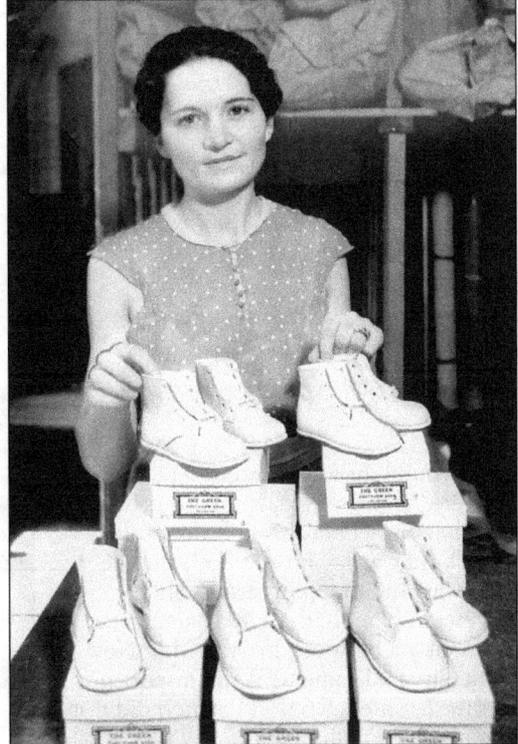

The W. S. Greene Company of Williamsport sent shoes to the Dionne quintuplets, the first known to have survived infancy, born on May 28, 1934, in Ontario to Olivia and Ernest Dionne. The babies' first steps, as they toddled around in their Corbell home, were in shoes made locally. The linings of the white, kid-leather shoes were hand embroidered with the names of each child: Annette, Cecile, Emilie, Marie, and Yvonne. (July 1, 1934.)

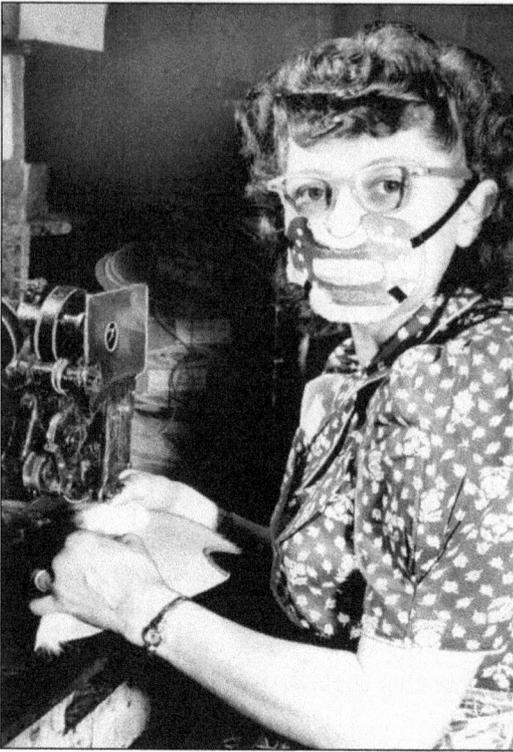

Pearl Mayer dons protection while working at the Lucille Footwear plant, located at 2000 Mill Lane in Williamsport. While she cuts, her mask protects her throat and lungs from the rabbit fur. Stepping Stone Shoes, a subsidiary at 1306 Memorial Avenue, provided the shoes. More than one million pairs emerged yearly from Lucille and Stepping Stone. (May 7, 1950.)

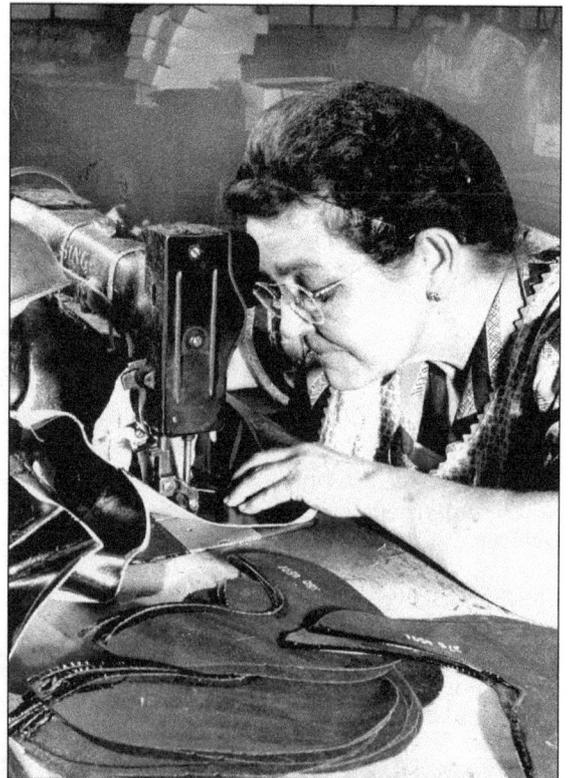

Leah Tompkins works intently at her machine as she sews parts of a shoe together on her automatic stitcher. Leo Goodkind was the boss at both Lucille Footwear and Stepping Stone Shoes. A veteran of more than 40 years in the shoemaking business, he started in New York City and came to Williamsport just in time for the 1936 flood, which did not endanger the plant. (May 7, 1950.)

Five

THE WOOD AND
PAPER INDUSTRY

The wood and paper industry in Lycoming County was a natural, direct byproduct of its lumber boom.

In 1690, William Rittenhouse and William Bradford built the first American paper mill near Philadelphia. The mill produced 100 pounds of paper daily, recycling old cotton and linen rags. The demand for rags became acute, sparking "rag wars" during the mid-1700s. Nations passed laws forbidding exportation of rags, so smuggling became a lucrative profession.

During the 19th century, contests were held and inventors worked feverishly to develop a new paper source. In the 1840s, experiments in ground-wood pulping spurred the commercial production of paper, and in 1867, the first pulp mill in the United States was established.

To make paper, ground wood chips are combined with water and "cooked" until the cellulose fibers separate. This solution is called pulp, which is then sprayed onto a giant screen. The fibers in the pulp bond to form a watery sheet of paper. As the pulp is carried along the screen, the water drains out and the sheet of paper is pressed between heated rollers to smooth and dry it. By 1900, the United States was manufacturing about 14,000 tons of paper a day. Today, more than 250,0000 tons of paper and paperboard are created daily.

Next to the paper and wood business, the manufacture of furniture is one of the largest byproducts of lumbering. As early as 1859, John A. Otto manufactured lumber in Lycoming County, to which he added a planing mill and sash, door, blind, frame, and molding factory.

In Picture Rocks, the firm of Sprout and Burrows added a sash, door, and blind manufactory in the fall of 1848. This was the first window-sash factory in the county. Carpenters, however, were distressed by the innovation. According to Lycoming County historian John F. Meginness, they argued that the making of sash by machinery would ruin their business and disapproved of its use by builders.

One of the earliest and most extensive companies in the area that benefitted from byproducts of the lumber industry was Rowley and Hermance. Owned by E. A. Rowley and A. D. Hermance, the Williamsport company opened in January 1875 on West Third Street. Its specialty was the manufacture of woodworking machinery to supply furniture factories, sash, doors, and blinds, and all woodworking establishments. Hermance shipped to all parts of the world and employed between 160 and 180 men seasonally.

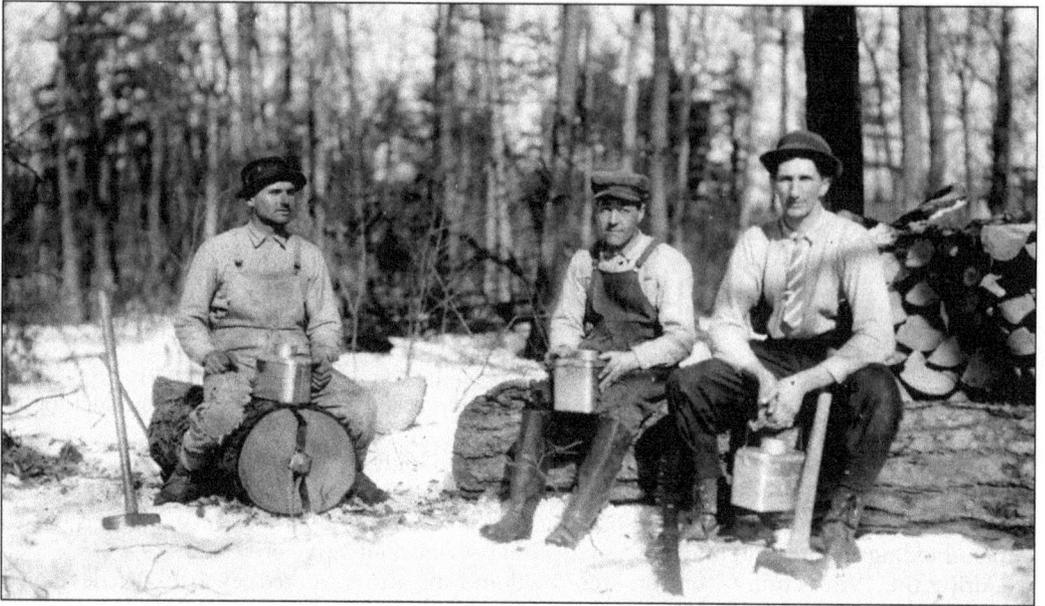

Vallamont woodcutters take a break to eat dinner. Because of the cold weather and the strenuous work, lumbermen ate several times a day. One lumberjack commented, "In most camps the meals were either bacon and beans or beans and bacon and you can imagine what it was like in the bunkhouse after 40 men had dined on beans." (February 21, 1915.)

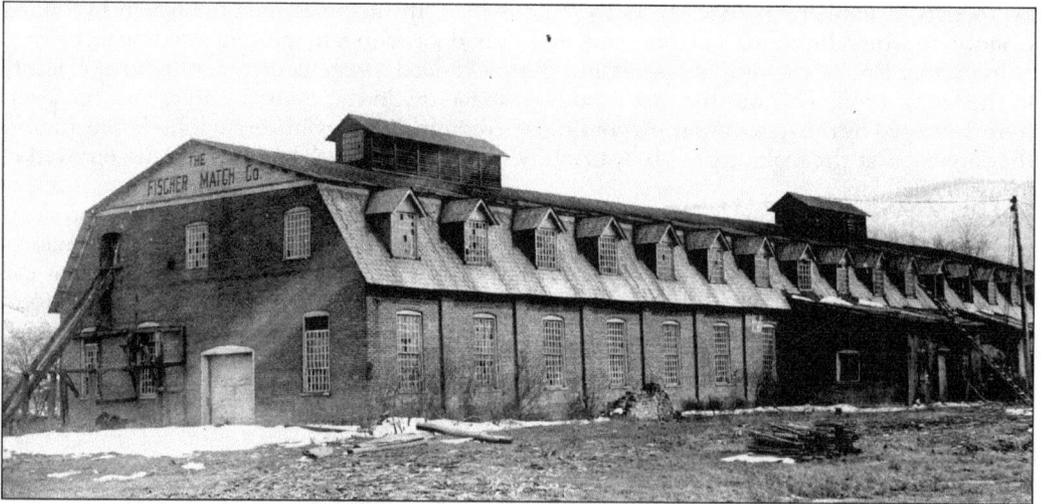

The Fischer Match and Kindling factory, located at the foot of Rose Street in Williamsport, was owned by Jonas Fischer, who became mayor of Williamsport in 1915. A German immigrant, Fischer resigned as mayor when questions arose about whether he was a naturalized citizen. He also owned the Citizens Electric Company, which competed with other suppliers, thereby making electricity available at lower rates than the large companies. He built Fischer's Park. (c. 1916.)

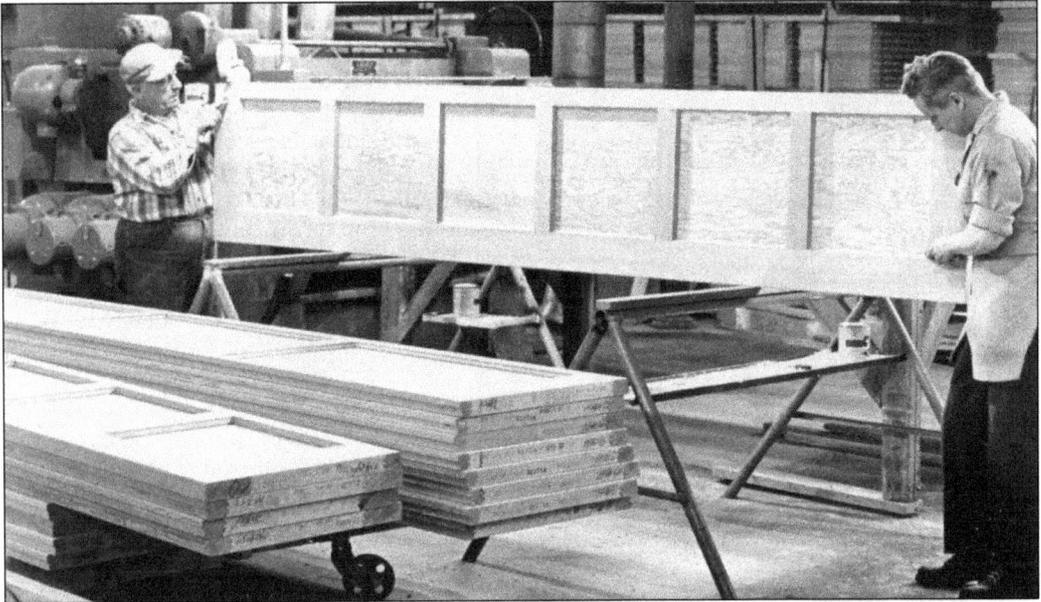

Overhead sectional garage doors for both residential and industrial uses were produced by Wood Parts. The plant, at the foot of River Avenue, made doors up to 32 feet wide and distributed them across the country. The firm came to Williamsport in 1950 and was managed by M. E. Scranton, who employed between 60 and 100 people, depending on the season. Wood Parts was a subsidiary of the Crawford Door Company, owned by Celotex. (April 10, 1966.)

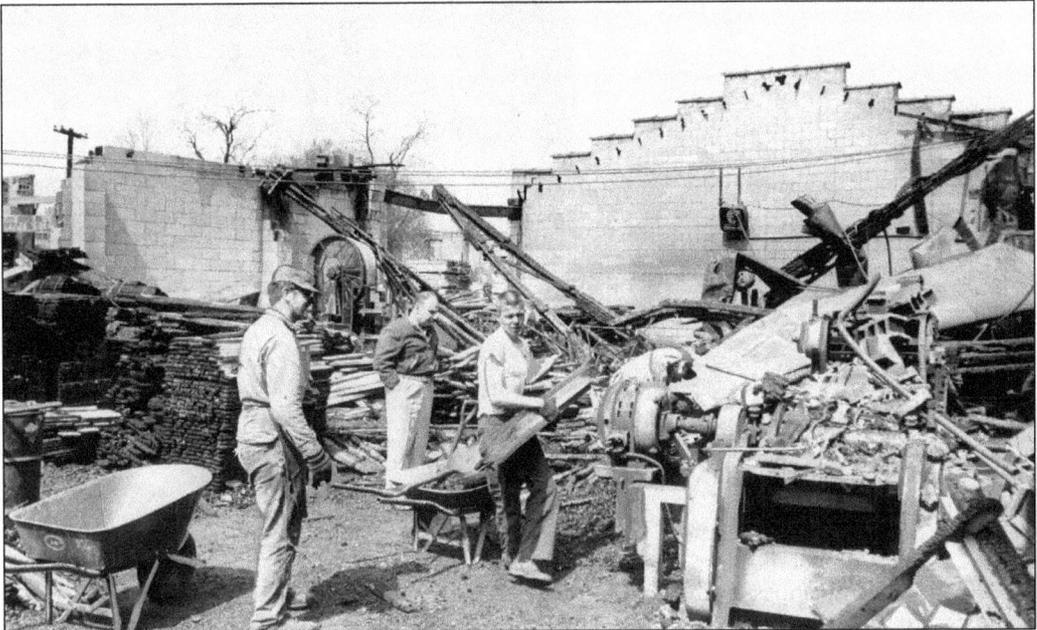

Company cleanup at Eastern Woods, at 549 East Jefferson Street, was a massive task following the $200,000 fire that devastated a section of the plant. Firm president J. John Herz reported that in one day in May 1962, his men took 500 wheelbarrow loads of charcoal out of the ruins. Eastern Wood Products began in Williamsport in 1939, producing hardwood flooring and wood water pipe. The firm employed 115 men throughout the year. (May 6, 1962.)

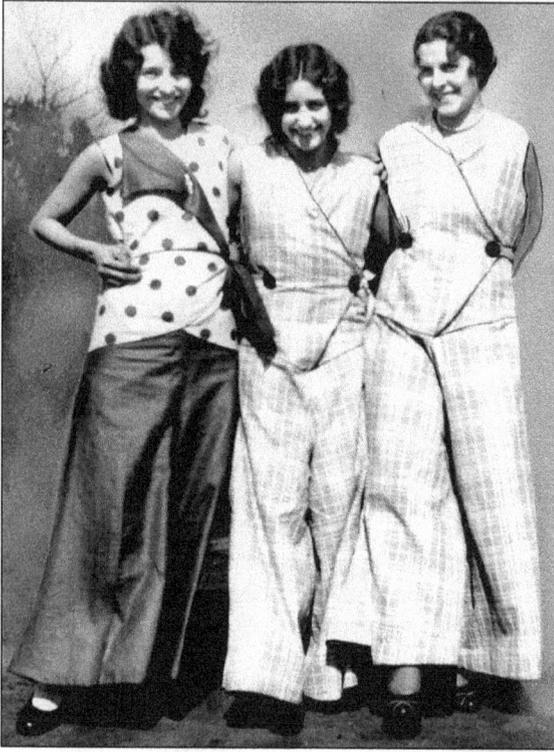

Beach pajamas are the latest craze in Williamsport factory wear, as seen in this 1931 photograph. Lucy Curchoe, Margaret Pedro, and Blanche Newcomer, employees of the Pennsylvania Collapsible Tube Company, enjoy the spring sunshine during the noon hour before answering the call of the one o'clock gong. (May 17, 1931.)

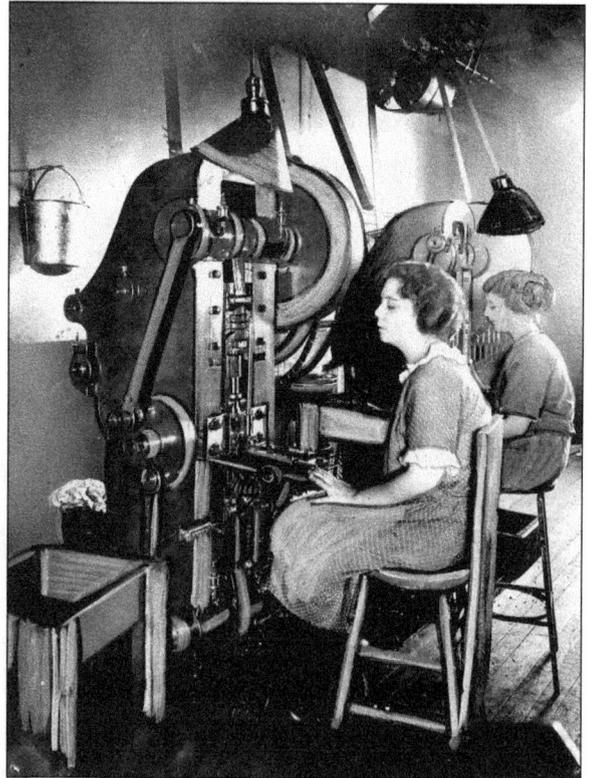

A worker at the Pennsylvania Collapsible Tube Company of Williamsport uses a machine that stamps, threads, and embosses tube caps. Collapsible toothpaste tubes manufactured at the plant each month were of a sufficient quantity to cleanse every tooth in the country three times over. Founded in 1919, the company was located at 495–497 Hepburn Street. (July 10, 1922.)

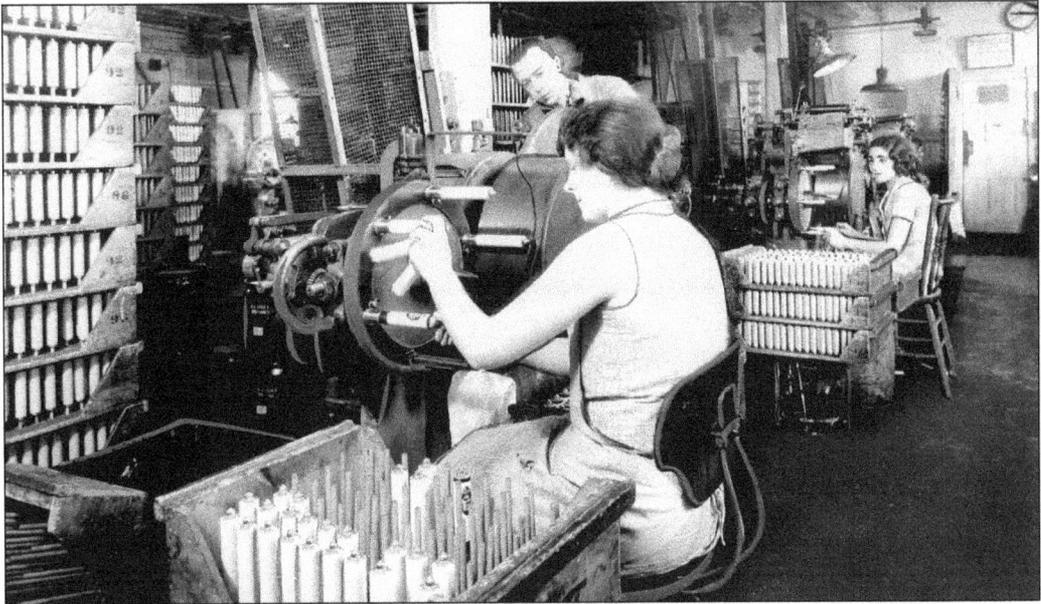

This worker enamels and prints tubes at the Pennsylvania Collapsible Tube Company, located at Hepburn and Fifth Streets. The company manufactured tin tubes used as containers for toothpaste, shaving cream, and other toiletries and household articles. The tin used in the manufacture of the tubes came from Malaya. The Williamsport plant also made tubes for a Filipino toothpaste manufacturer. (February 26, 1933.)

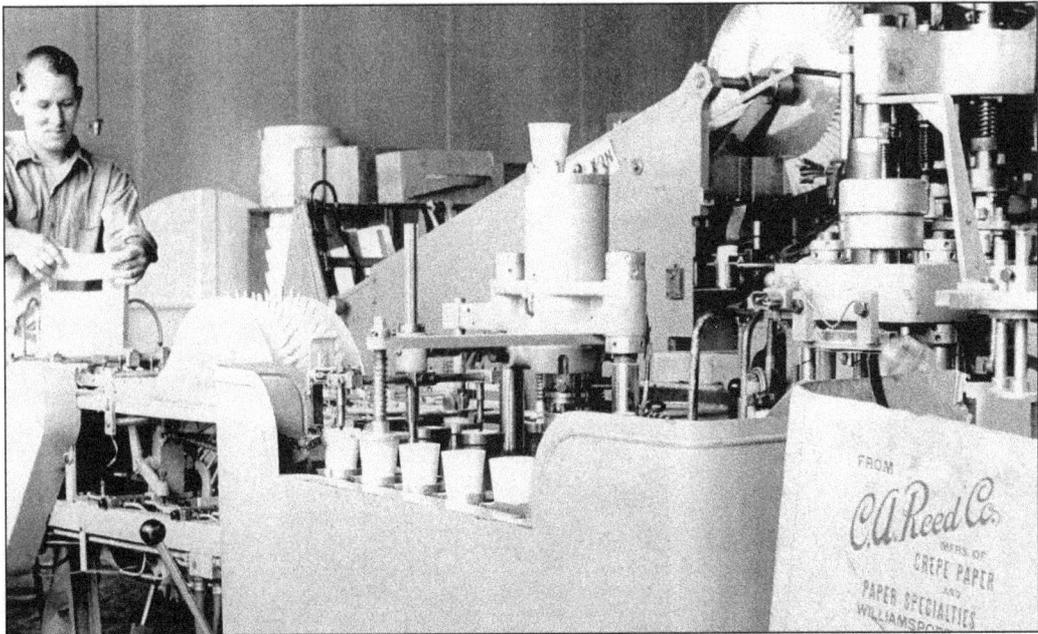

John Nittinger operates a machine to seal the bottoms on cups during the manufacturing process at the C. A. Reed Paper Products Company in Williamsport. Paper cups manufactured at C. A. Reed were used by American GIs in canteens, post exchanges, and mess halls throughout the world. The plant made millions of paper cups because of its efficiency and speed. The C. A. Reed factory closed in 1993. An outlet store remains open. (February 4, 1945.)

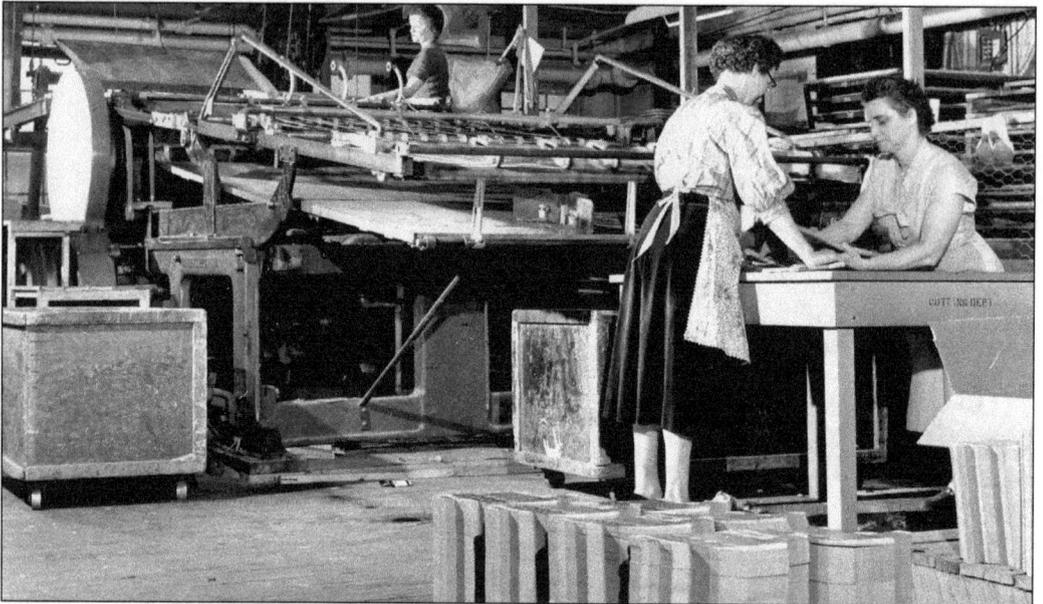

Women work at the flatbed cylinder cutter, which forms cartons, at the Eureka Paper Box Company, located at 401–435 Canal Street in Williamsport. In 1955, more than 75 brand-name companies used containers made by Eureka. Sixty-five of these were within a 200-mile radius of Williamsport. As many as 35,000 to 50,000 paper cartons were whisked off the Eureka assembly line in one hour. The plant employed 65 people. (April 10, 1955.)

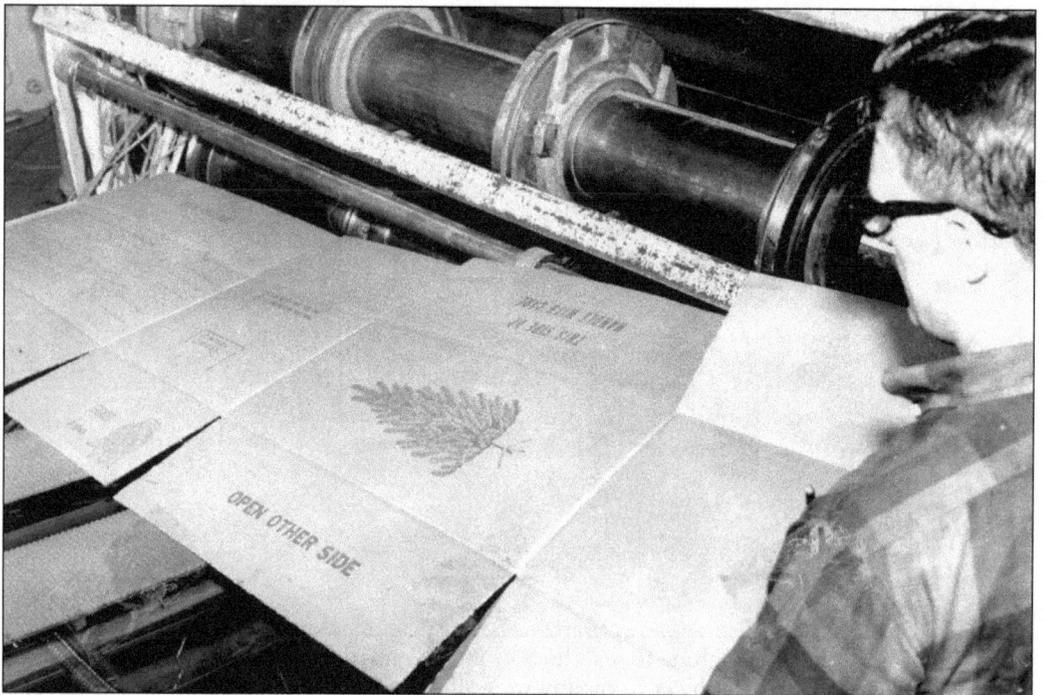

Penn-Central Containers made thousands of cardboard boxes for local companies to ship their Christmas production, as well as for wreath and toy manufacturers. Here, Bob Kelly works on a cutting and printing machine, turning out boxes in time for Christmas 1965. (December 19, 1965.)

Six

The Petroleum, Coal, and Chemical Industry

Companies specializing in the mining of coal have not found Lycoming County very profitable. Traditionally, its bounty has been in lumber and textile production. For the most part, Lycoming imported the coal it needed.

However, there are several coal basins in Lycoming County of significant size to interest commercial mining. The McIntyre coal basin, east of Lycoming Creek, is about seven miles long and four miles wide at the mountain face. Coal was mined here at an early date, but not until the Williamsport and Elmira (Northern Central) Railroad was completed from Ralston to Elmira in 1848 that active mining began. The mines were abandoned after being worked by Elmira companies for 20 years. The Red Run coal mines are located on the west side of Lycoming Creek, a basin that lies between the headwaters of Trout Run, Gray's Run, and Roaring Branch. In 1891, an incline plane was built for lowering the coal to the foot of the mountain, and for several years the mine was operated. The largest coal deposit in Lycoming County is the Pine Creek basin, about 14 miles long and 3 miles wide.

Lycoming once contained many more rich coal basins. But to lure people to the area, the state land company encouraged Pennsylvania to pass an Omnibus Bill on March 26, 1804. The bill broke the 12,000-square-mile Lycoming County into five additional counties: Clearfield, Jefferson, McKean, Potter, and Tioga. With this separation, Lycoming lost natural resources, as well as land. For instance, Blossburg, once part of Lycoming but now in Tioga County, contained significant coal deposits. In 1792, a party of immigrants cutting the Williamson Road from Loyalsock in Lycoming County to Painted Post in New York discovered coal there. They established a supply camp on the banks of the Tioga River known as "Peter's Camp."

A coal-mining boom began in 1900 in Indiana County, created on March 30, 1803, from parts of Westmoreland and Lycoming Counties. Mining dominated the economy until 1924 and boosted population to nearly 80,000. Mining was revived in the 1970s, and now Indiana County is the state's fifth highest bituminous producer, three-quarters of which is mined subsurface.

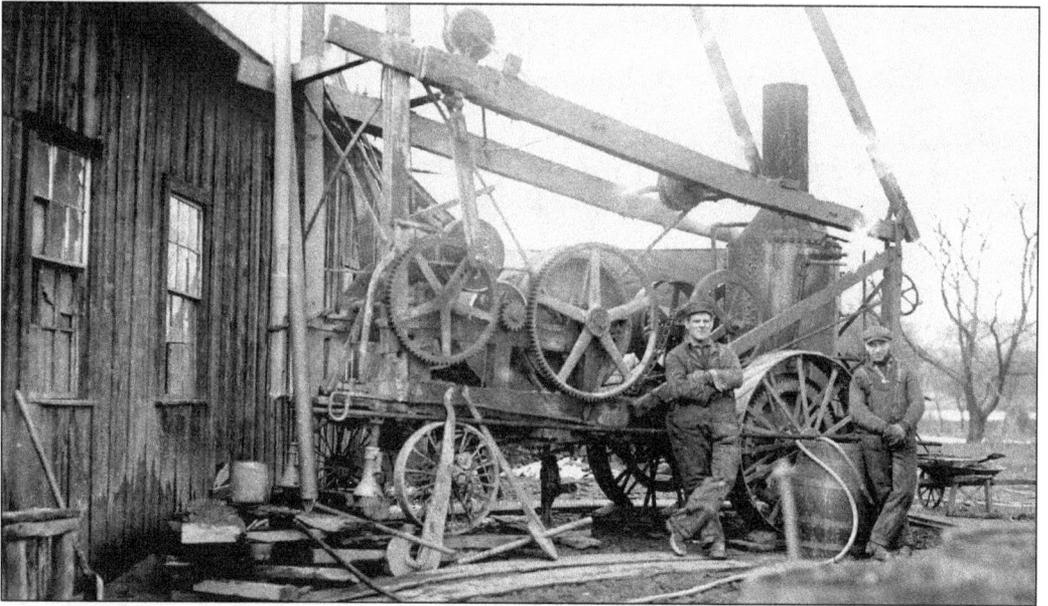

Men drill a well for water at the David Steumpfle's Sons brick plant in South Williamsport. The company switched from manufacturing handmade clay bricks to wire-cut shale bricks, and the plant's 50 small flues were replaced with one 70-foot-tall, nearly smokeless stack. A new elevator lifted the ground shale up 33 feet so that gravity, instead of men, could process the mineral, often referred to as "Rotten Rock." (March 14, 1915.)

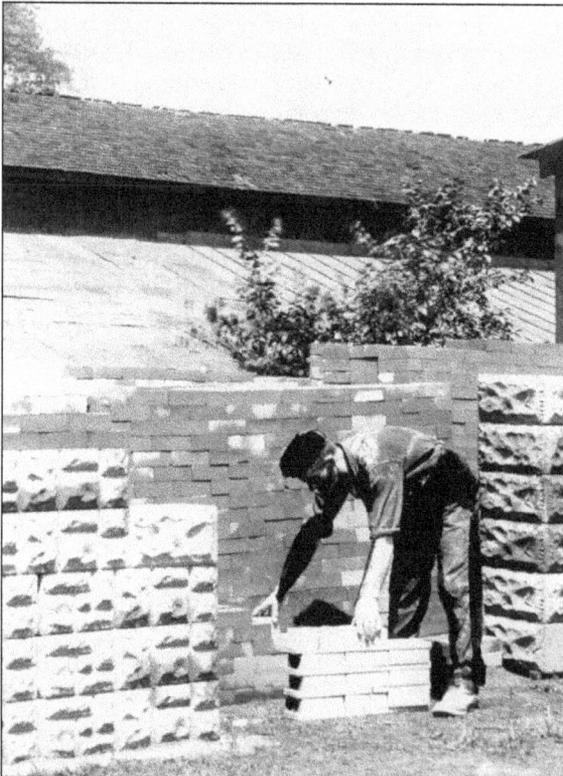

This worker appears inside the piling yard at the Portland Brick and Concrete Company on Edwin Street, east of Campbell Street, in Williamsport. In 1909, four men were able to turn out 5,000 concrete bricks a day. The bricks were then dried and piled in the yard for two weeks. Fred N. Culver was plant superintendent. (August 1, 1909.)

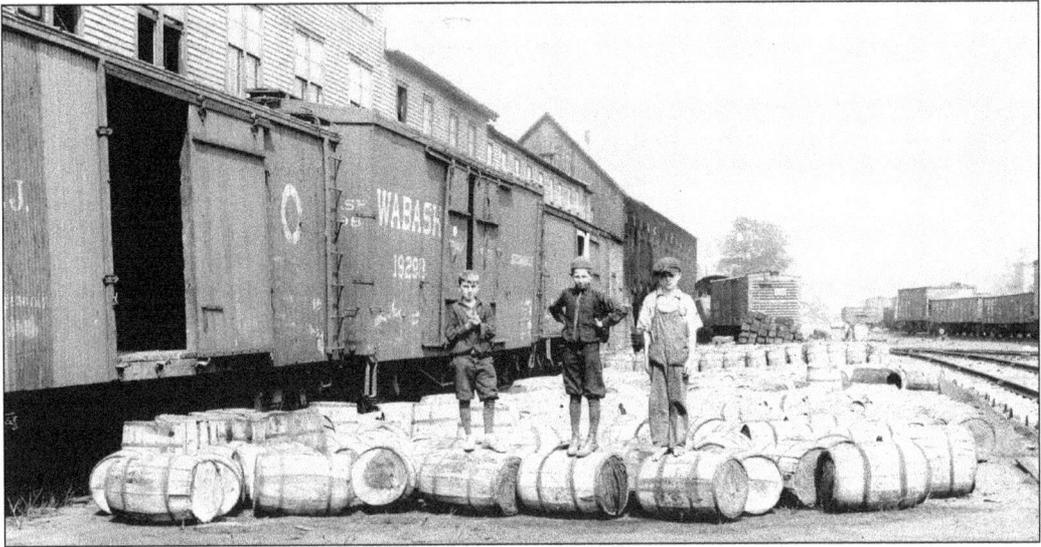

The Central Construction Corporation plant in Williamsport ordered more than 100 tons of raw asphalt in barrels for big paving projects in town. The machine that mixed the asphalt had a capacity of 200 tons a day, enough to pave 1,500 square yards of street. Today, 96 percent of all paved roads and streets in the country are surfaced with asphalt. (August 20, 1922.)

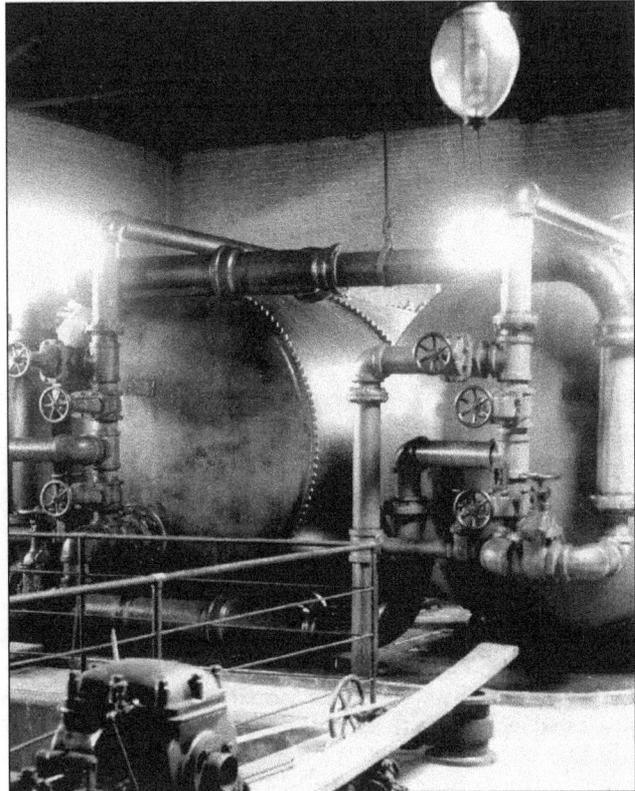

Shown here is a pressure filter at the National Silk and Dyeing Company. This and other equipment were used to reclaim chemicals from the dye works. Plant manager G. Mortimer Reed negotiated with state officials to comply with proper filtration and drainage regulations, so as not to threaten the fish population of nearby river and streams. (January 14, 1914.)

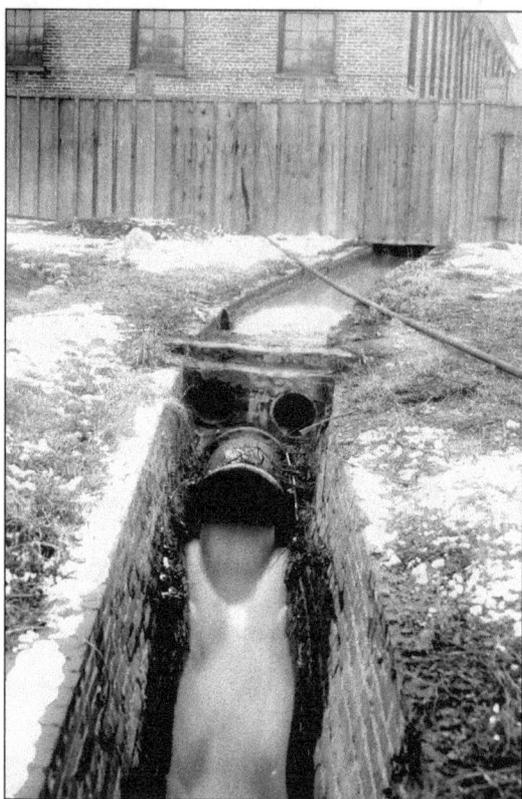

Water runs from an outlet at the National Silk and Dyeing Company, at 1300 East Jefferson Street in Williamsport. Company officials were concerned about whether they could meet drainage requirements set by the Pennsylvania Department of Fisheries. The previous year, the company had installed the most complete filtration system in the world, according to company officials, that would reclaim liquid tin from wastewater. (February 8, 1914.)

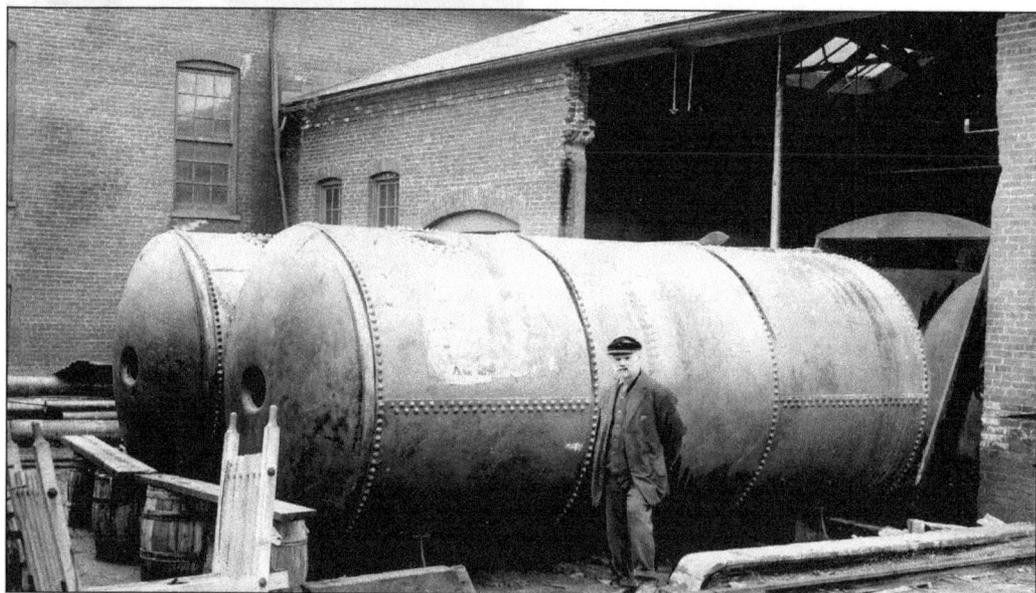

Although Williamsport lagged behind the national average during the 1914 building boom, work progressed steadily at National Silk and Dyeing, which installed a filtration plant that processed more than three million gallons of water daily. Here, a man stands beside a new force-filter tank that would boost the filtration system to five million gallons a day and return clean water to the river. (April 19, 1914.)

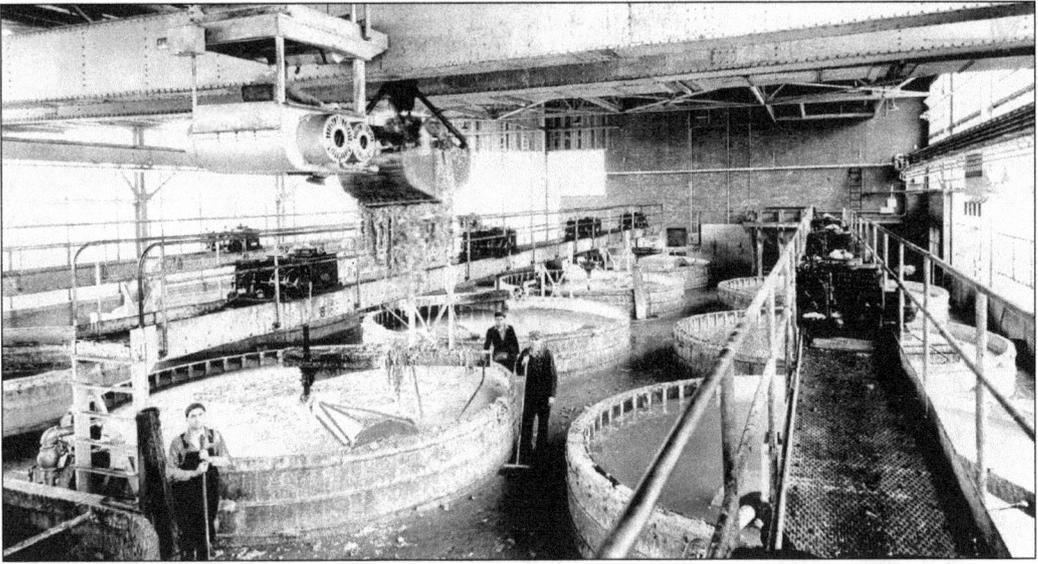

The washing vats at the Keystone Glue Company are pictured here. Smoke never ceased to rise from the plant because of its 24-hour production. The plant made four million pounds of hide glue byproducts per year. These byproducts were used in the silk- and soap-making industries. Ninety-five percent of the material was derived from green hide fleshings, byproducts of the tanning industry. (March 26, 1933.)

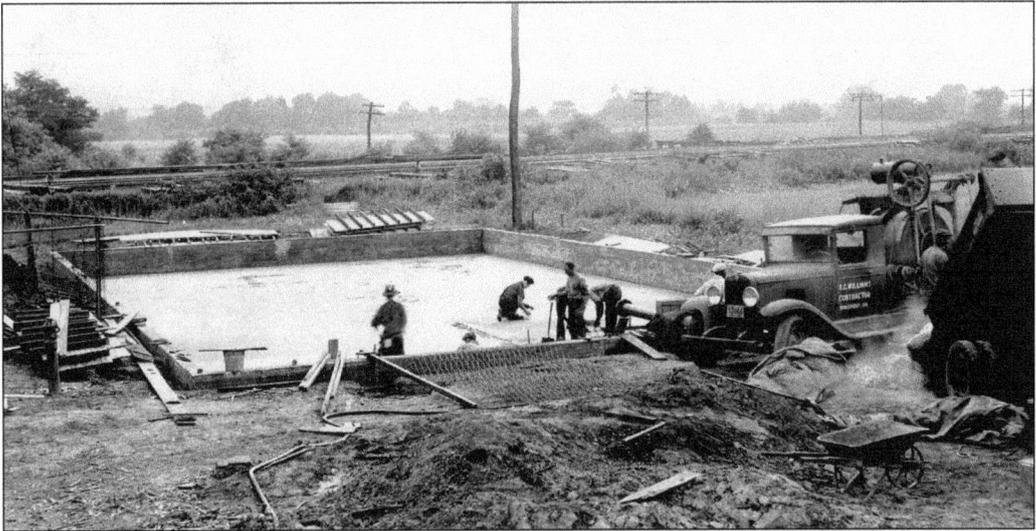

A pond to cool water used in the glue-manufacturing process was built at the Keystone Glue Company, Trenton Avenue. The pond was 75 feet long and 45 feet wide. At the same time, the interior of the building was refurbished to house new machinery enabling the company to manufacture a higher grade of tankage, a byproduct used as fertilizer. (August 5, 1934.)

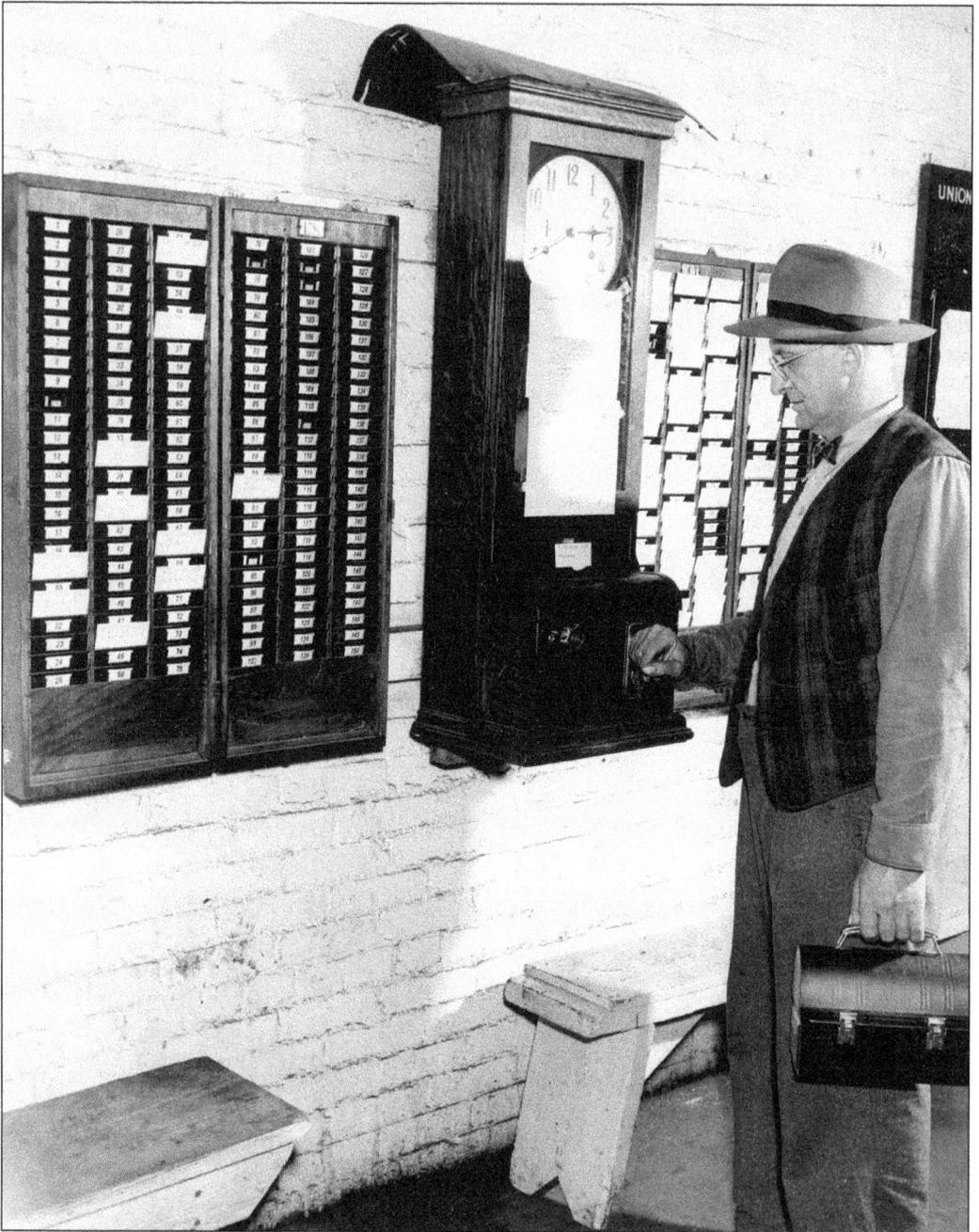

An employee of the Keystone Tanning and Glue Company punches out for the last time on October 19, 1951, as the company shuts its doors. Keystone had operated in Williamsport since 1907 and employed 125 at its plant on Trenton Avenue, in the Newberry section of Williamsport. The factory closed because its owner, the United States Leather Company, was disposing of its leather plants. The use of synthetic chemicals in a larger-scale industrial process led to the demise of the many tanneries nationwide. The *Grit* newspaper reported, "Men who worked at the company for years suddenly felt they had the rug yanked out from under them." (October 21, 1951.)

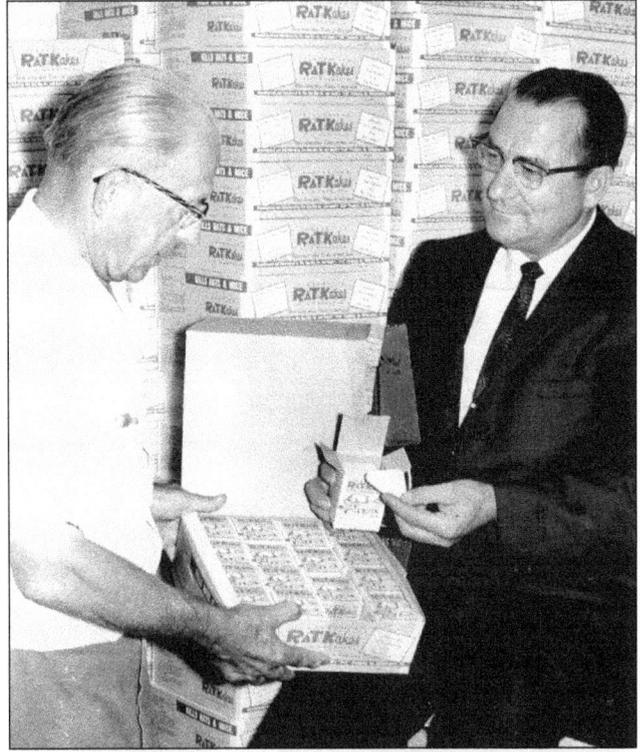

Business partners Harris M. Gould (left) and Dorsey Dunlap discuss their rat-killing product. The two owned a business that manufactured Rat-Kakes in an expanded garage just east of South Williamsport. The product was licensed by the U.S. Department of Agriculture under a partnership known as the Dun-Win Company and Gould's Dell Products. A total of 70,000 Rat-Kakes were produced each day. (August 20, 1961.)

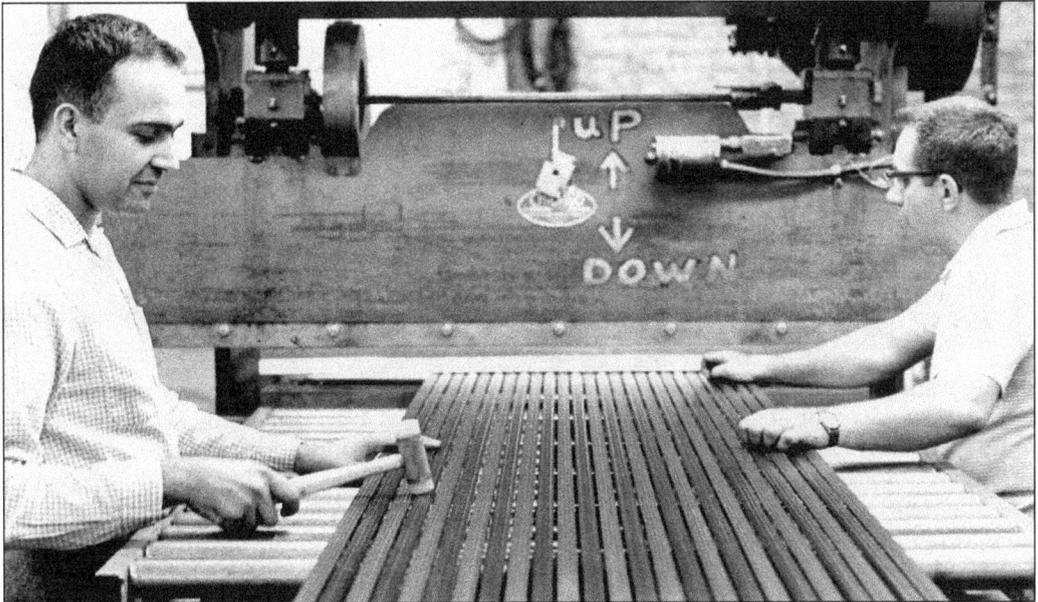

Robert C. Schurer (left) and Marlin D. Hanner install plastic on pedigrids, recessed entrance foot grids that the E-L Corporation creates from its aluminum architectural products. The company, which shipped its products around the world, also made expansion-joint covers and stainless-steel corner guards. The E-L Corporation began in 1955 in Newark, New Jersey, then moved its complete operation to Williamsport in 1960. The firm was managed by Gary R. Bartlett. (October 16, 1966.)

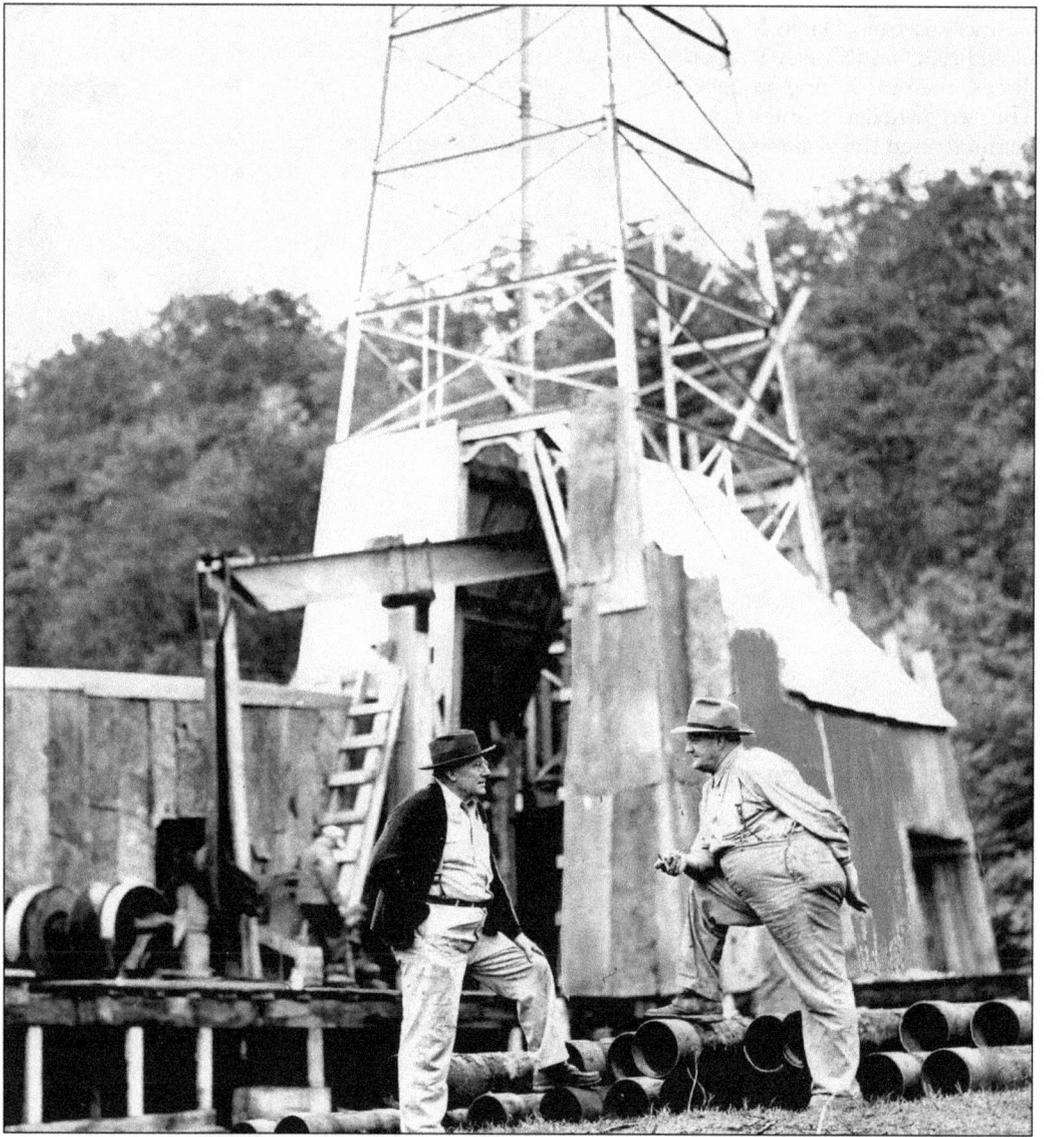

Pennsylvania's first gas field was discovered in 1860 at shallow depths along Lake Erie in Erie County. Above, contractors talk outside the new gas derrick for drilling in Leidy Township, Clinton County. When gas was discovered in the Oriskany sandstone at Leidy, new interest in drilling throughout the Appalachian Basin grew. In 1951, the record for the largest gauged initial production of gas for both Pennsylvania and the Appalachian Basin was held by the New York State Natural Gas Finnefrock No. 1 at Leidy. In 1985, the deepest producing well in Pennsylvania was the Texaco-Marathon USA 1, Commonwealth of Pennsylvania Tract 289, at 13,168 feet, in Lycoming County. (October 22, 1950.)

Shown here is the electric thermometer of the Pickelner Coal Company. By the mid- to late 1970s, Pickelner no longer sold coal and switched over to fuel oil, which it continues to sell today. William Pickelner, one of Williamsport's leading philanthropists and sports boosters, owns the business. (February 10, 1957.)

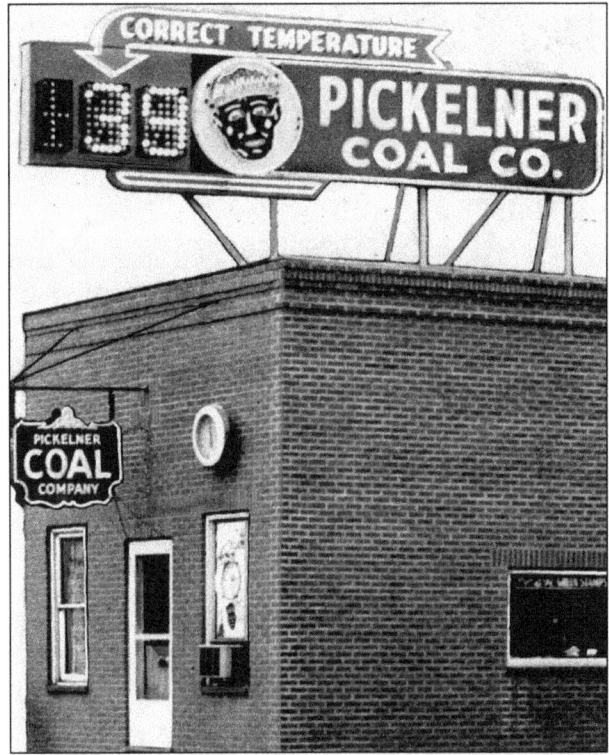

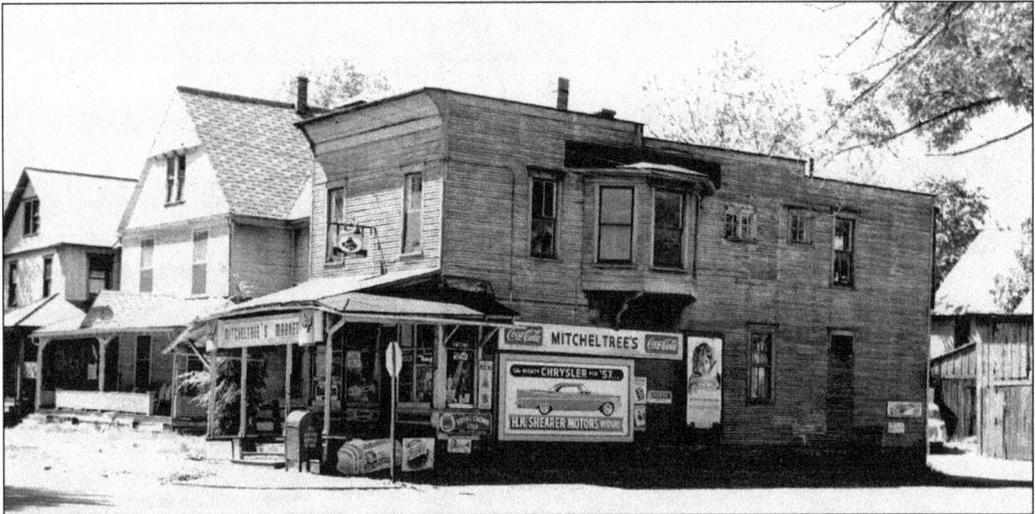

Mitcheltree's Market, shown here, gave way to a new gasoline service station built on the northwest corner of High and Locust Streets. On second and third readings, the city council passed an amendment to the zoning ordinance, permitting construction of the station. The petition changed the zoning classification of the area from a Class C residential to a business district. (May 19, 1957.)

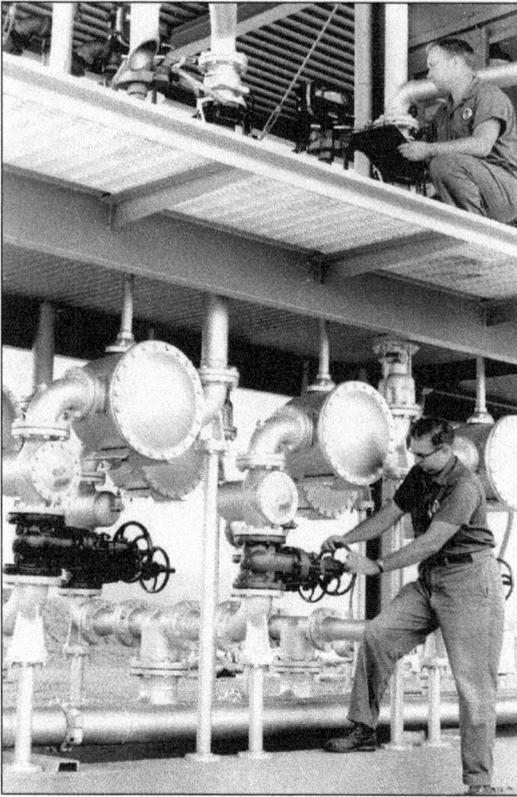

Two workers perform their daily check on the pipeline and turn off the incoming valve at the new oil terminal on Sylvan Dell Road in Armstrong Township, just east of South Williamsport. The Texaco sales terminal, operated by the Lycoming Gas and Oil Company, served as the distribution point for 10 counties in north-central Pennsylvania. (August 16, 1959.)

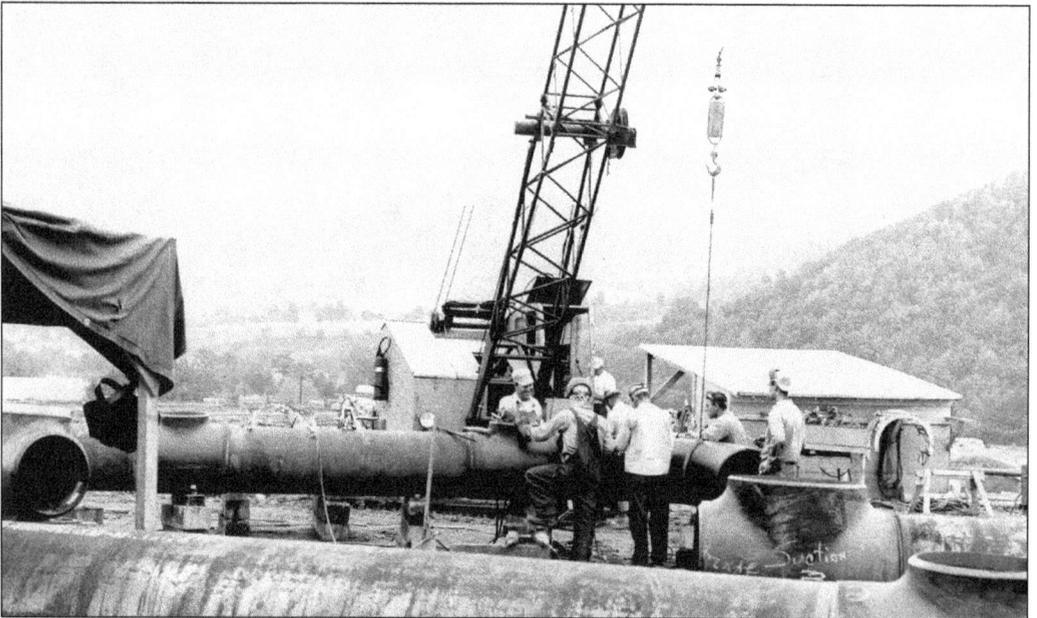

Employees inspect and lay the Transcontinental Gas Pipeline Corporation's pipe, which would carry natural gas from the transmission line through the compression station to the pumping unit. Located near Salladasburg, the station cost more than $2 million to construct. A water well that would produce 50 gallons a minute was also being drilled at the site. (September 25, 1960.)

Seven

THE STEEL, METAL, AND MACHINE INDUSTRY

Lycoming County has had a long, profitable history with its various iron foundries and machine plants.

The first iron foundry in Williamsport was established in 1832 by John B. Hall, who made and sold the first coal stoves in town. After shipping his stoves out of the county for several years, Hall soon decided to manufacture machinery for sawmills. In 1833, he got a contract from the state of Pennsylvania to furnish castings for the Columbia Railroad. The firm produced steadily and became prosperous. Besides the railroad castings, it made all the canal lock wickets to be used between Muncy Dam and Lock Haven.

Between 1825 and 1830, Isaac McKinney and his son William established a forge on Lycoming Creek. In 1835, they built a furnace and, in 1841, a rolling mill. McKinney Iron Works imported iron ore from Centre County by canal boat to Jaysburg (a neighborhood west of Williamsport), where it was unloaded and hauled to the furnace. The ironworks also manufactured 10-plate stoves for several years.

Crescent Iron Works, located along Lycoming Creek in the northwestern corner of the township, was erected in 1839. It began manufacturing in 1840 with one puddling furnace, one heating furnace, six nail machines, and one train of rolls for making bar iron. Crescent was owned by Gervis B. Manley, Warren Edward, and Charles G. Heylmun.

Philip A. Moltz, a pioneer machinist in Williamsport, moved to the area in 1854. Two years later, he purchased the plant of Mayby and Bowman at the corner of Basin and Church Streets. There, he carried on business until 1868. In 1877, he sold the plant to Rowley and Hermance, one of the oldest as well as most extensive of the machinists and iron foundries. Rowley and Hermance, headed by E. A. Rowley and A. D. Hermance, was established in January 1875 and commenced business on West Third Street.

With a capital of $100,000, the Morrison Patent Wire Rope Company was incorporated in 1886 by J. Henry Cochran, president; C. La Rue Munson, secretary; and C. W. Van Dusen, treasurer and general manager. A manufacturer of iron, steel, and galvanized wire rope, the firm built up a national reputation. In 1888, the name of the company changed to Williamsport Wire Rope, and in 1895, it relocated to 100 Maynard Street, its present location. During the past 100 years, the company has evolved from a local wire rope mill to a fully integrated wire and wire rope manufacturer recognized internationally for its craftsmanship, innovation, and performance. In 1937, Bethlehem Steel purchased the company and called it the Bethlehem Wire Rope Division of the Bethlehem Steel Corporation.

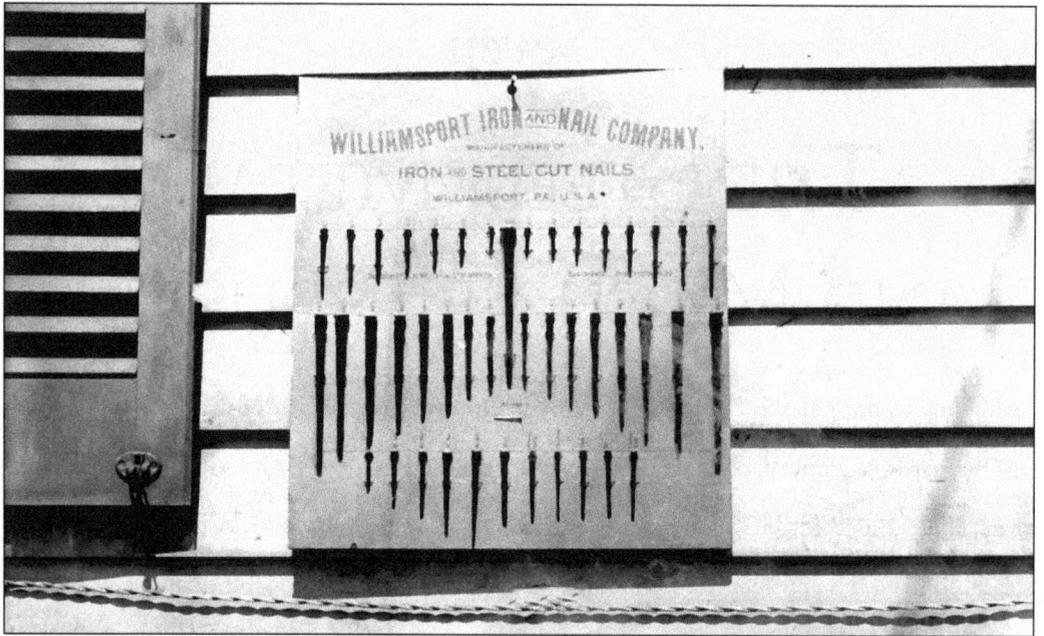

On display are products from the Williamsport Nail and Iron Company of South Williamsport. The largest industry in the borough, the nail works employed about 120 men and was established in 1882 with a capital of $100,000. The business was almost lost to fire in September 1909, but quick action by employees prevented the flames from spreading. (c. 1910.)

The main building of the Geiser Engineering plant was located at the corner of Church and State Streets in Williamsport. The business had a four-ton electricity-driven elevator, one of the largest of its kind in central Pennsylvania at the time. Nationally, power for all elevators came from steam systems; electricity did not replace steam until 1912. The company produced various types of agriculture-related implements. (November 24, 1912.)

Employees build and assemble machine parts at the workbench of the Villinger Manufacturing Company, at 643 Elmira Street. Various tools and machine parts are readily available on the bench. At the time of this photograph, annual income from foundry and machine shop products in Williamsport topped $1,164,737. (c. 1910.)

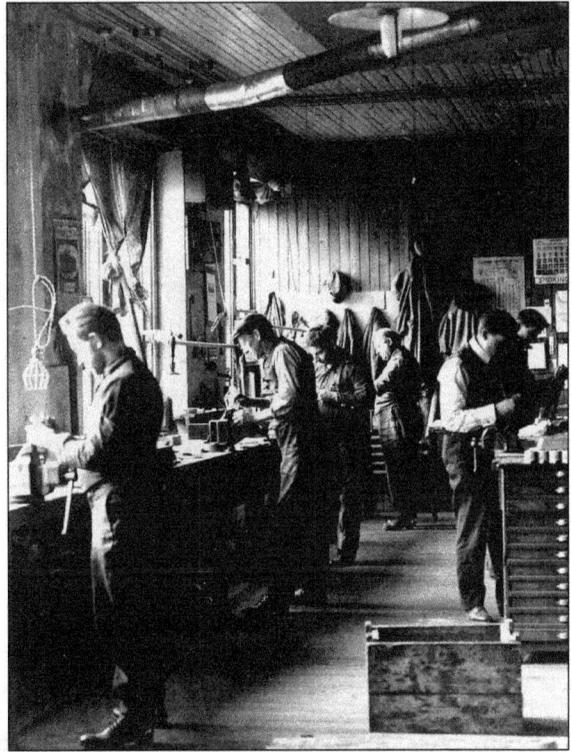

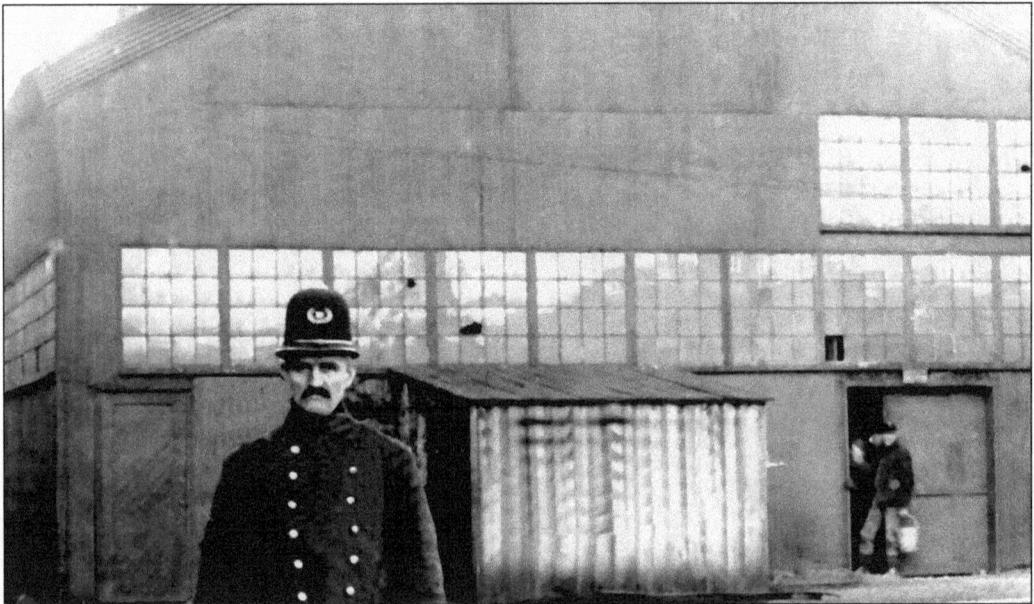

John R. Mahaffey, a Williamsport police officer, stands guard outside the rolling mill of a local foundry during the first decade of the 20th century. A rolling mill is a component of a steel mill in which steel strips or bars are formed between two rolls rotating at the same speed in opposite directions. During World War I, many steel mills produced armor, ordnance, guns, and munitions for the American and Allied forces. These plants, considered viable targets for sabotage, had to be protected. (c. 1917.)

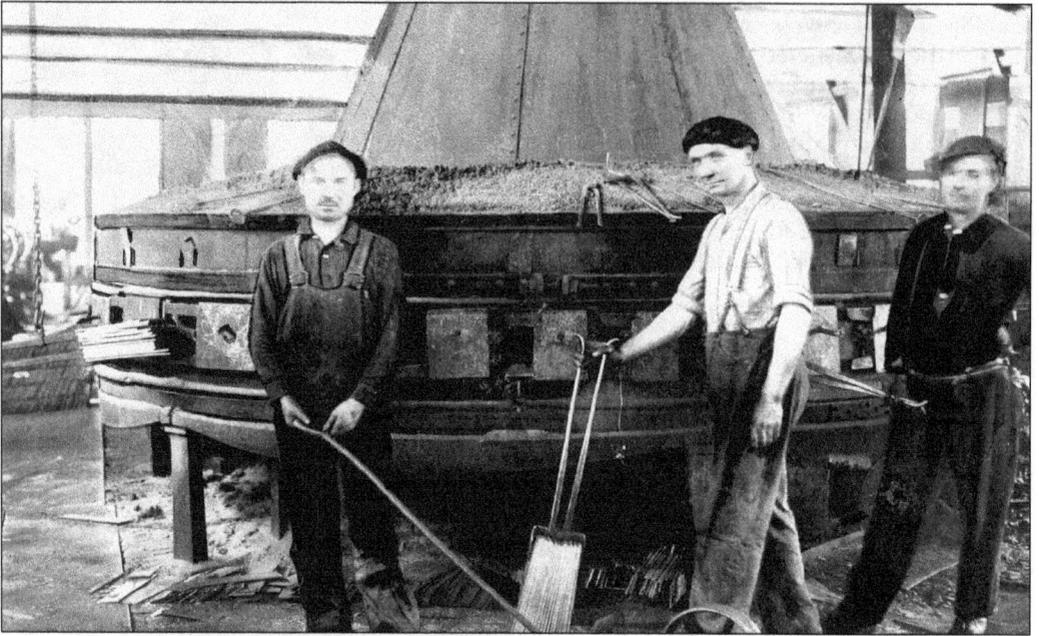

Men work at the "big oven" at the Lycoming Foundry and Machine Company early in the 20th century. Lycoming Foundry later became Lycoming Engines, then the Aviation Corporation, and now Textron-Lycoming. In 1908, the plant had a 47-man workforce. Two years later, the company produced its first automobile engine. Production expanded to include engines for virtually all the automobile and truck manufacturers. (c. 1915.)

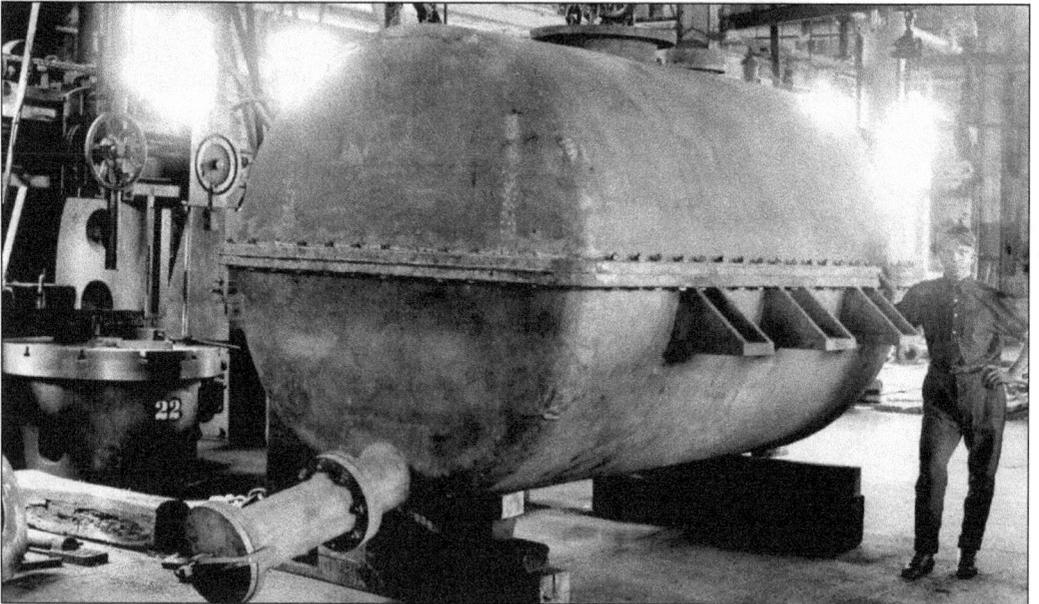

This mammoth retort, cast by Valley Iron Works and touted as the "biggest ever," weighed 21,000 pounds. At nearly 10 feet long and 6 feet in diameter, the iron retort was so large that the two halves had to be cast separately. The parts were then removed to the Sheppard Engineering Company at the foot of Maynard Street, where the sides were faced and prepared for bolting. (August 5, 1915.)

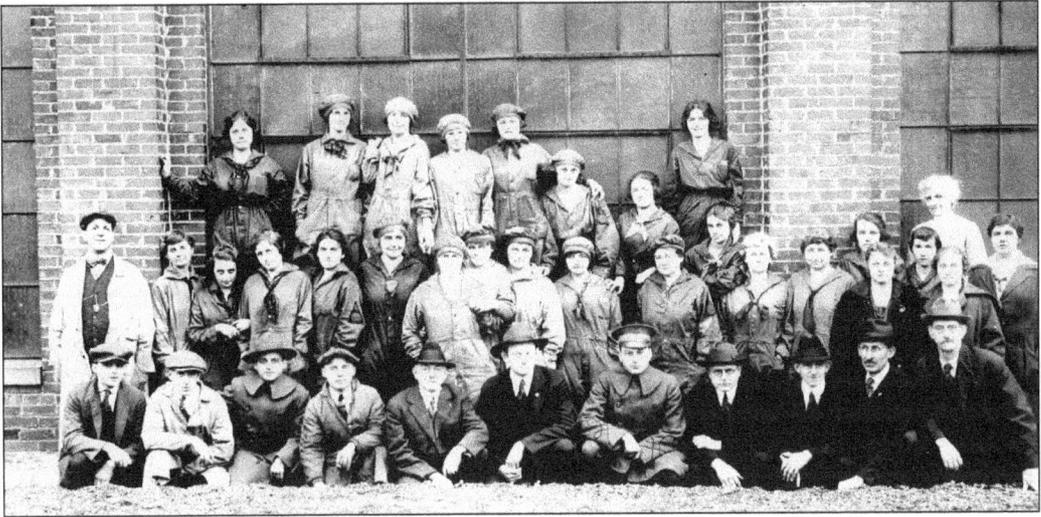

Bomb and grenade inspectors, including many young women, in the Ordnance Corps of the Lycoming Foundry and Machine Company plant in the Tenth Ward were experts on their job. Every hand grenade and aerial bomb made passed through their hands. The inspectors were put through a course of instruction and had constant practice performing a duty of special value to the government. (November 24, 1918.)

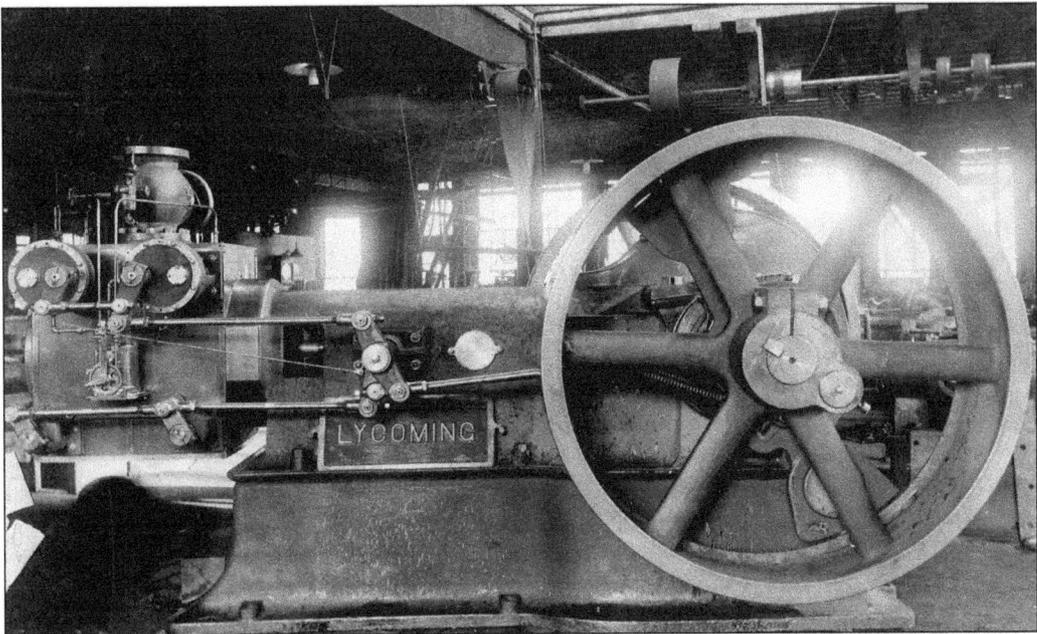

This Corliss engine was made by Valley Iron Works. W. P. Riley established the company in 1865, employing about 50 men. His specialty was automatic steam engines, which he shipped worldwide. The steam engine is regarded as the icon of the Industrial Revolution. Corliss steam engines allowed industries to locate where key considerations, such as access to markets for inputs and outputs, directed. (c. 1920.)

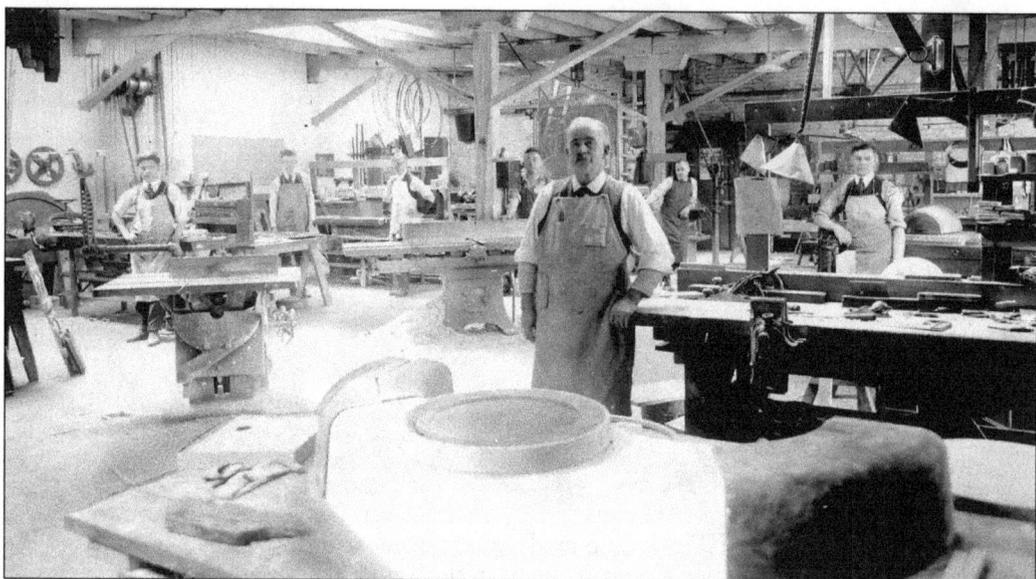

Workers at the Standard Heater Company take a break for this photograph. The plant covered four acres and contained 80,000 square feet of floor space. Located at the foot of Walnut Street, it was founded in 1905. In 1921, the Williamsport Radiator Company absorbed the Spencer Heating Company of Scranton, and the corporate name became Standard Heater. The plant provided boilers and radiators. (March 19, 1922.)

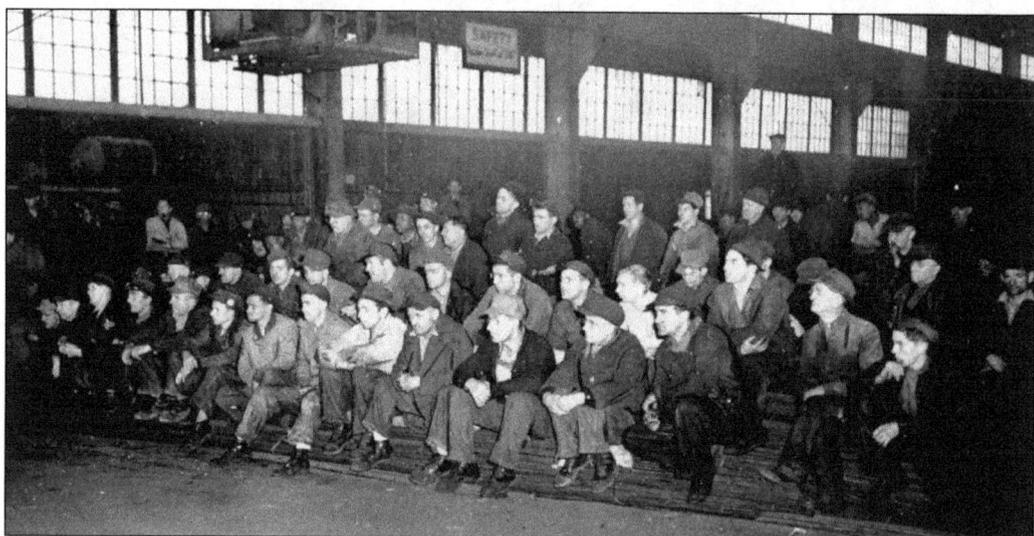

Workmen at Sweet's Steel Corporation, in Newberry, listen to an appeal to purchase war bonds at the fourth War Loan Bond Drive. Pvt. Abe Miller, a wounded veteran, addressed the men. That week, an advertisement in *Grit* proclaimed, "A man without a bond is a man without a country. . . . He who is neither able to fight nor willing to pay deserves to live somewhere else!" (January 30, 1944.)

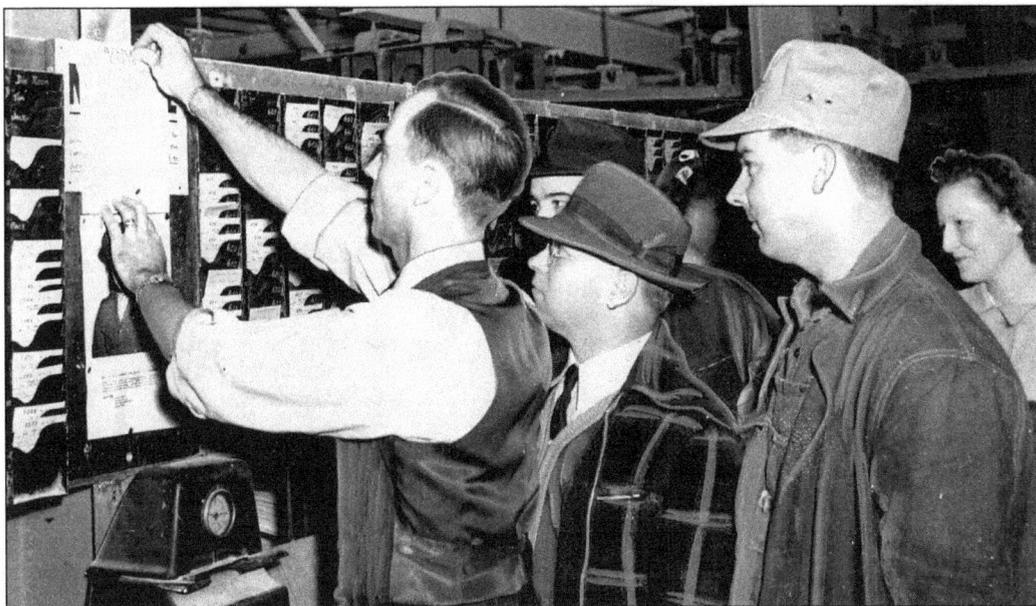

Workers at the Williamsport plant of the Bethlehem Steel Company read a citation from Rear Adm. W. B. Young, chief of the Navy Bureau of Supplies and Accounts. It described the company's record of wire rope production as "especially commendable" in view of the "paramount importance of the Navy's huge landing craft program in the present Allied strategy." (April 2, 1944.)

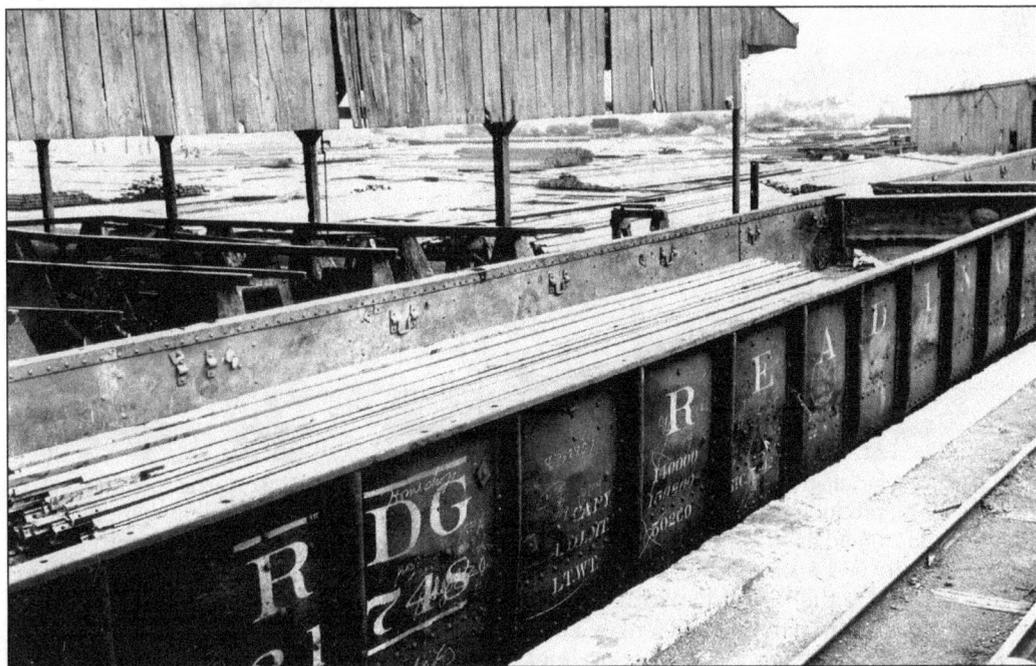

A railroad car at Sweet's Steel plant, filled with rails for the navy, sits idle because employees of the company had left their jobs. Union president Ralph Cupp said it was an "unauthorized walkout." Also at a standstill was the production of camouflage posts, so urgently needed by army engineers abroad that a "rush" was placed on the order. (May 28, 1944.)

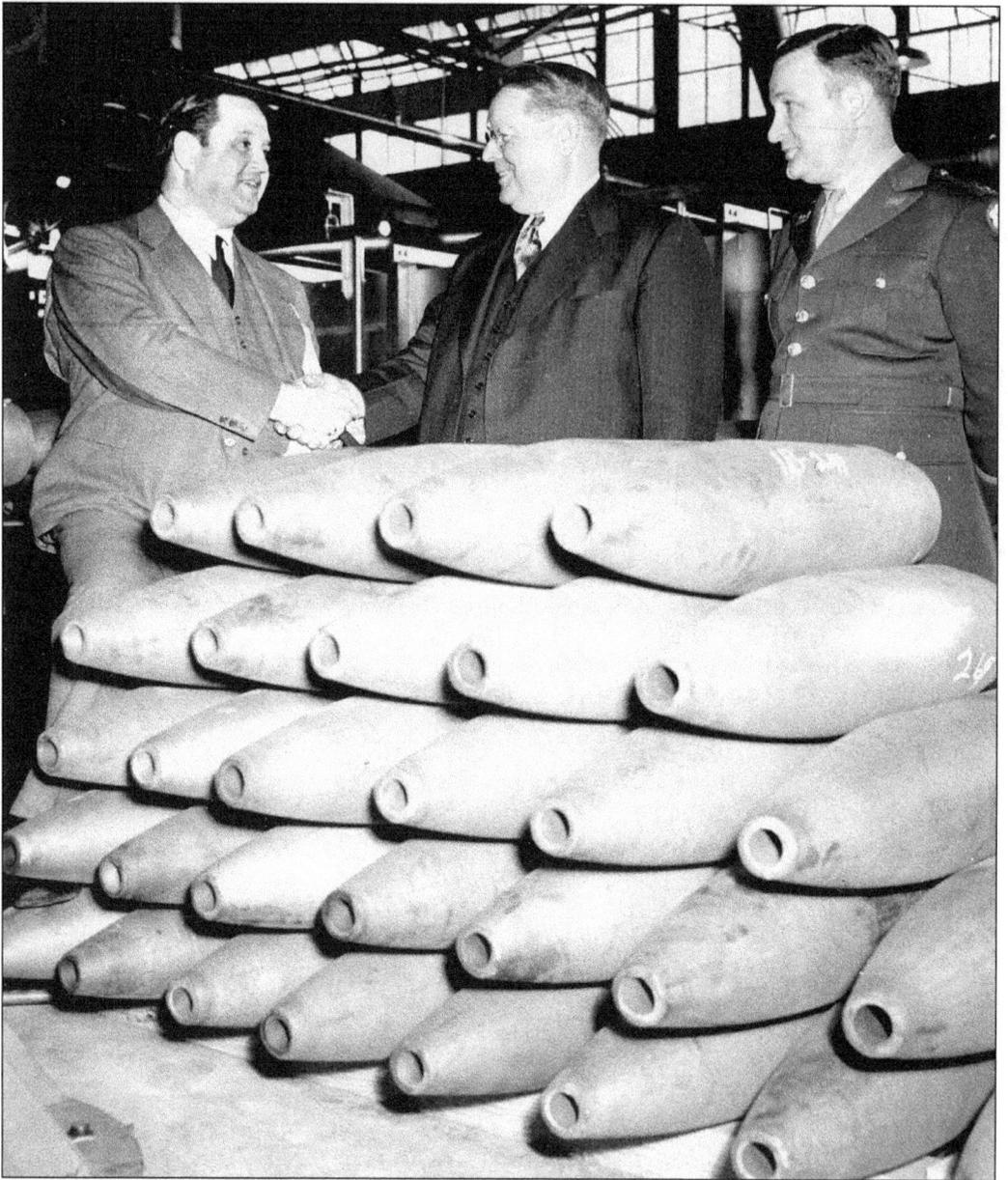

The Rheem Manufacturing Company, a Williamsport industry, began work the second week of January 1945, producing eight-inch artillery shells for the U.S. Army. The shells were likely for the howitzer, a field artillery piece. Howitzers fired heavier shells than the cannon with a lower muzzle velocity and a shorter range. The plant operated in the former W. D. Crooks and Sons Door Company at the foot of Park Street. Nationwide, factories retooled for the war effort and operated continually. The demand for labor attracted people from all over the country, including women who found jobs on the production line. Above, Williamsport mayor Leo C. Williamson (left) shakes hands with plant manager Tide Fletcher (center) and Capt. Robert Rosser of the U.S. Army. (January 21, 1945.)

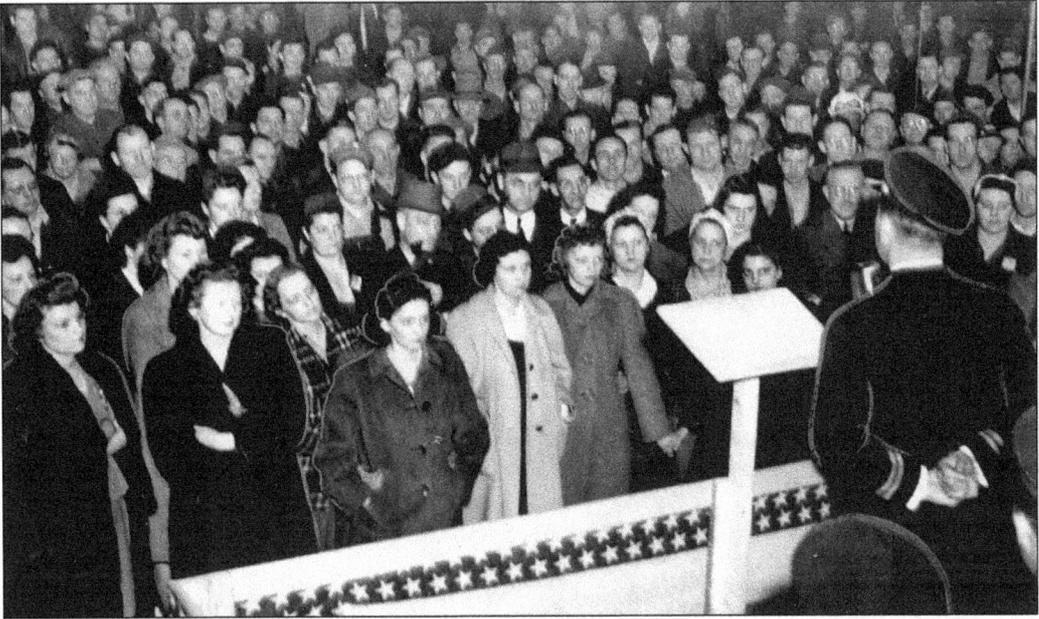

Two wounded World War II veterans return home from combat and address employees of the Bethlehem Steel plant during an Industrial Incentive Rally in 1945. The men are Cpl. Robert D. White, a Marine who fought in the Pacific campaign, and Shipfitter 2nd Class Charles Dougherty, a deep-sea diver who assisted in Mediterranean salvage operations. Both pleaded for continuous peak production. (February 18, 1945.)

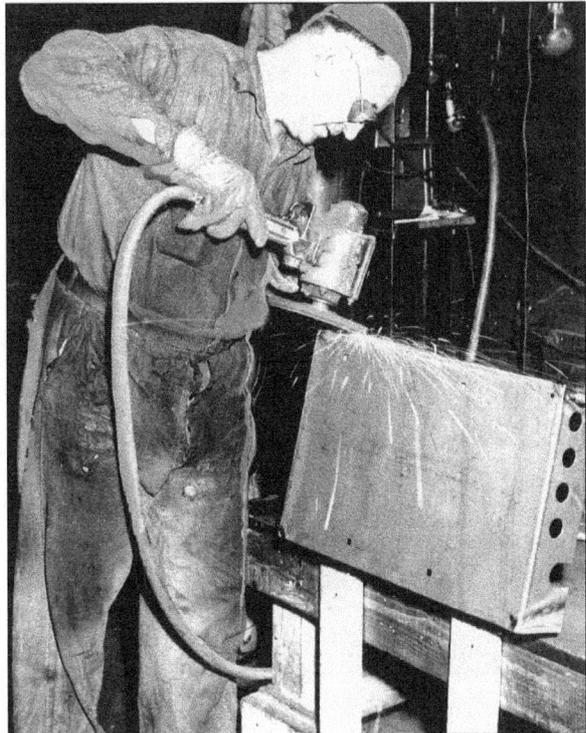

On August 6, 1945, the first atomic bomb attack occurred over Hiroshima, Japan. Three days later, Nagasaki was bombed. On August 15, 1945, World War II ended with the surrender of the Japanese. Following the cancellation of war contracts, local industries began the task of converting to peacetime production. Here, a worker uses a grinder on the first postwar order at Radiant Steel Products. (August 26, 1945.)

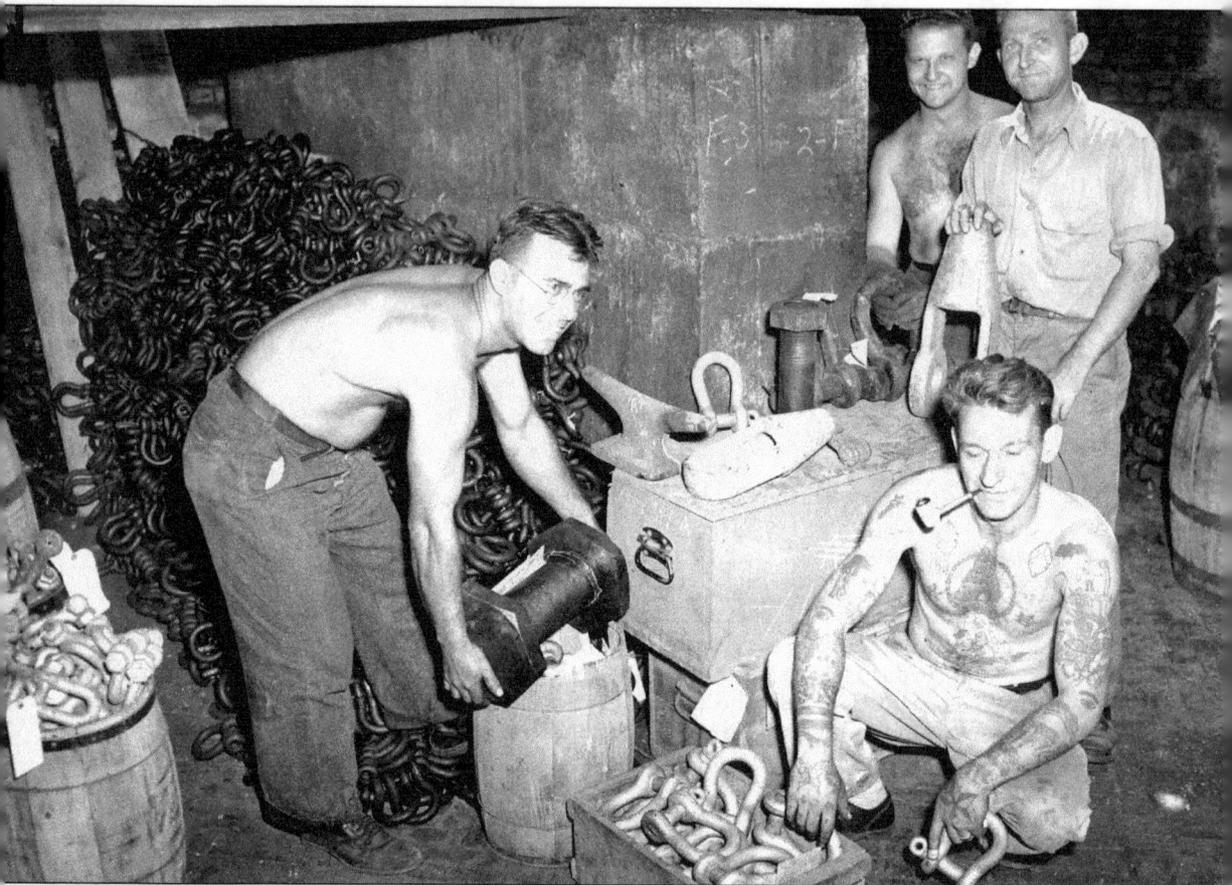

With World War II over, many young men returned home, hoping to find jobs and normalcy. Here, employees of a warehouse inspect anchor pins, shackles, and bolts. One of the young men sports many tattoos and smokes a corncob pipe, reminiscent of Popeye the Sailor. During the war, women and minorities entered the industrial workplace in order to fill the labor shortage and increased demand for war goods. (September 9, 1945.)

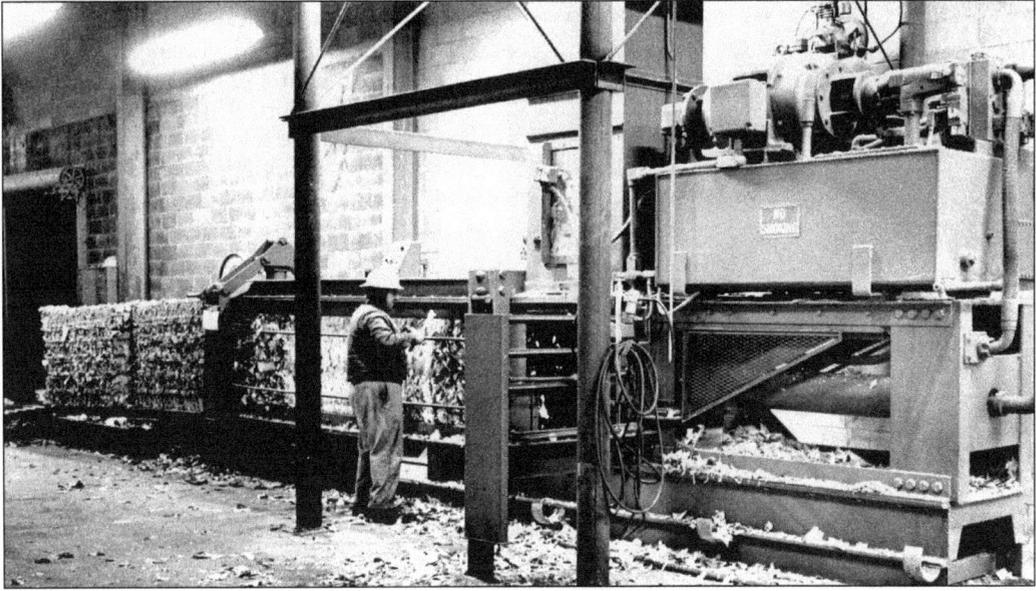

A giant shredder and baler at Minkin Industries processed 100 tons of paper during an eight-hour shift. The recycling firm, whose main plant was at 1315 West Third Street, constructed a new fragmentizing plant in Milton in 1972 at a cost $1 million. The new facility provided central Pennsylvania with a steady supply of raw materials. (c. 1972.)

This worker sprays paint on a lawn corner fence made by the Keystone Iron and Metal Company, known as KIMCO. The company was located at the foot of Locust Street in Williamsport and was organized by a group of returning World War II veterans. It made products such as welded steel bed rails, industrial racks used in the cinder block industry, ornamental gates, railings, fire escapes, and children's swings. (June 30, 1946.)

Growing machines from blueprints was the job and hobby of Hermance employee Louis A. Miller at 430 Percy Street in South Williamsport. With the company since 1911, Miller saw that Hermance woodworking machines were built according to blueprint specifications. (August 1, 1948.)

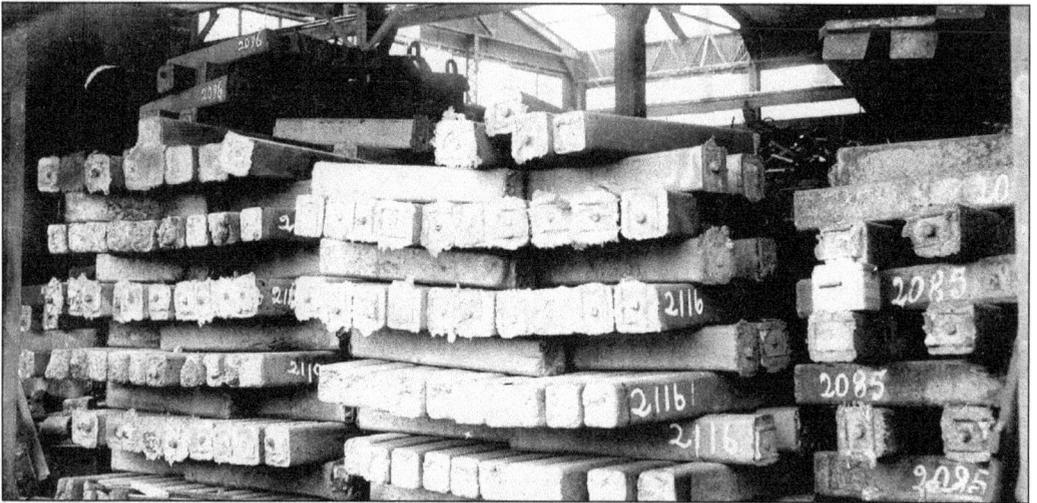

Owned by Scotsman William Sweet of Syracuse, New York, Sweet's Steel plant, at 200 Arch Street in Newberry, reused old railroad tracks in the fabrication of smaller-gauge items such as reinforcing bars, signposts, and stakes. It was an open-hearth steel plant that used three furnaces. At one time, the rolling mill was equipped with four trains of rolls. (October 10, 1948.)

Ira J. "Paddy" Morgan, 74, night superintendent at Sweet's Steel Company, moved to Williamsport from Syracuse, New York, when the plant relocated. At the age of 16, Paddy drove a milk wagon, delivering to William Sweet. When Sweet opened a Williamsport branch in 1903, Paddy came with him. He began as a helper on the ladles when the steel mill ran an open hearth. (August 15, 1948.)

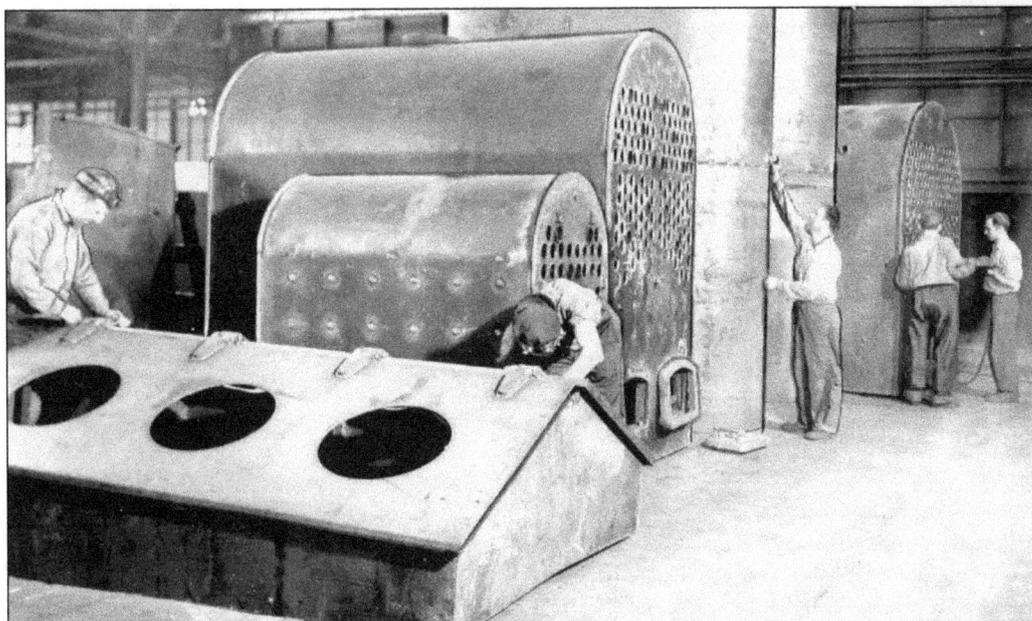

The Spencer Heating division of the Aviation Corporation (AVCO) converted 100 percent to war work and devoted a considerable part of its capacity to the production of steel-fabricated units for the country's fast-expanding merchant fleet. Shown above in the boiler shop, along with the steel tubular boilers for army cantonments and new war plants, are ship stacks. (October 10, 1948.)

John W. McKinney, a boiler checker at Spencer Heating, was still an active employee at 78 years of age. While the boiler's section was filled with 300 pounds of water pressure, McKinney checked for leaks. A native of Gettysburg, Pennsylvania, McKinney raised a family of 10 children and outlived two wives, the second one after 48 years of marriage. (October 24, 1948.)

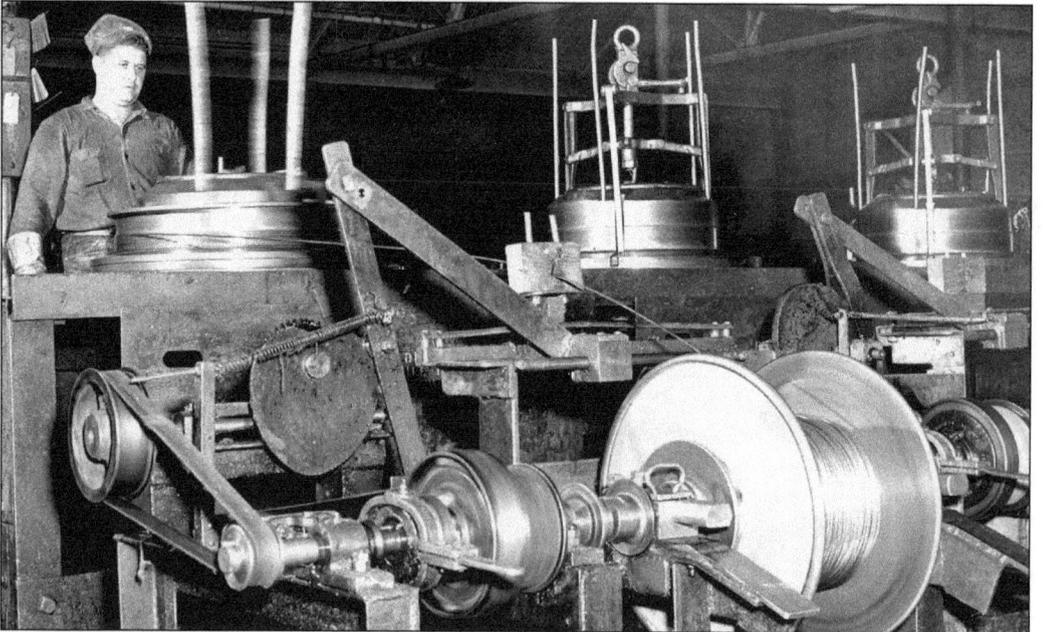

A worker at the Central Cable Corporation of Jersey Shore watches as wire is wound on a reel for strander, which makes cable. The Detwiler family of Williamsport owned Central Cable, an independent company that made bare and weather-proofed copper wire and cable. Its products were sold to railroads and utilities. Some of the plant's products were shipped to the Soviet Union during World War II's Lend-Lease Program. (June 29, 1949.)

An employee examines the machinery in a pellet mill during the final assembly process at the Sprout-Waldron Company plant in Muncy. Sprout-Waldron produced machines for grinding, crushing, mixing, and sifting a wide variety of materials. It also made screw conveyors, bucket elevators, and pneumatic conveyors for handling materials in bulk form. The company was once Muncy's leading employer and one of its most important industries. (January 7, 1949.)

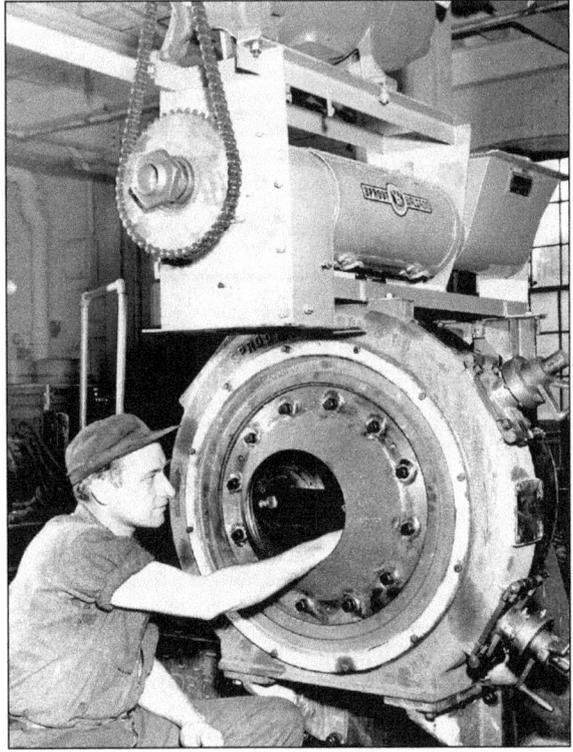

The shipping dock at the Sprout-Waldron Company dispatched products to all parts of the world. The company was founded in 1866 in Picture Rocks before moving to Muncy in the 1870s. Its first product was a feed and grain machine for farmers. Sprout-Waldron's formed to satisfy the local farmers' need for grain milling. (August 7, 1949.)

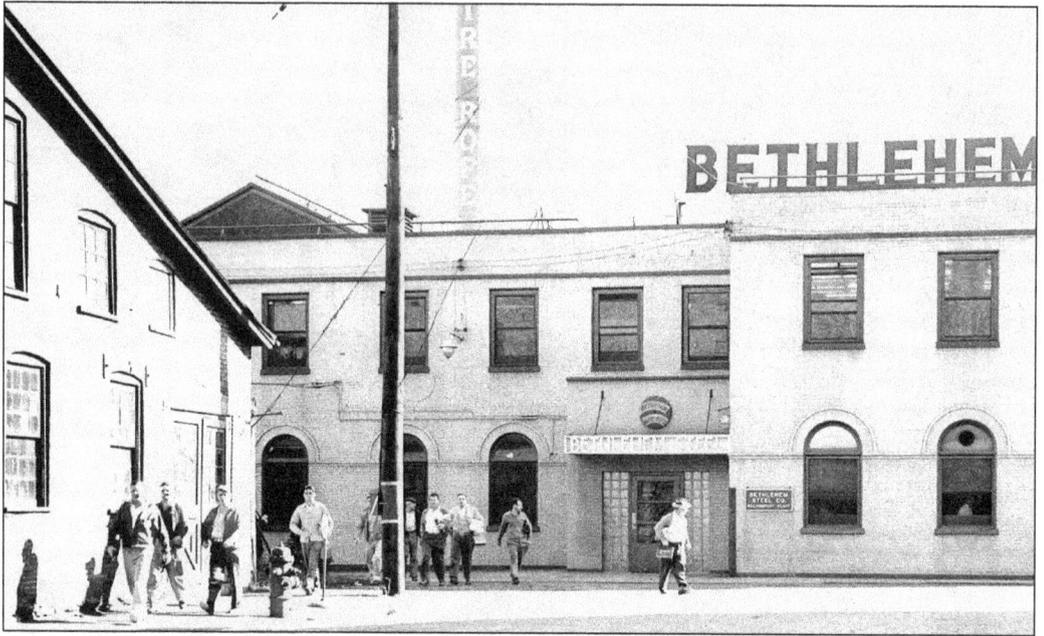

Men on the last regular shift at Bethlehem Steel leave the wire rope plant during a nationwide steel strike. James V. Ferguson, superintendent of the local division, said everything was orderly as work ended. A maintenance crew remained on duty at the plant and no interruptions were anticipated at either Sweet's Steel or Radiant Steel. (October 2, 1949.)

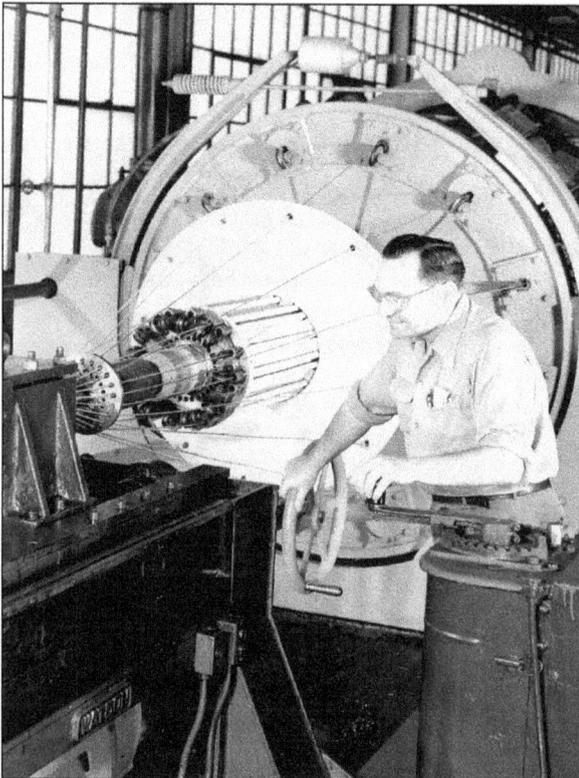

An employee oversees the operation of a planetary strander at the Williamsport plant of Bethlehem Steel. All cable and wire rope is derived from basic strand, which is made using either tubular or planetary stranding machines. In 1968, the company installed a 72-wire planetary stranding machine capable of manufacturing structural strand up to five and one-half inches in diameter. (December 4, 1955.)

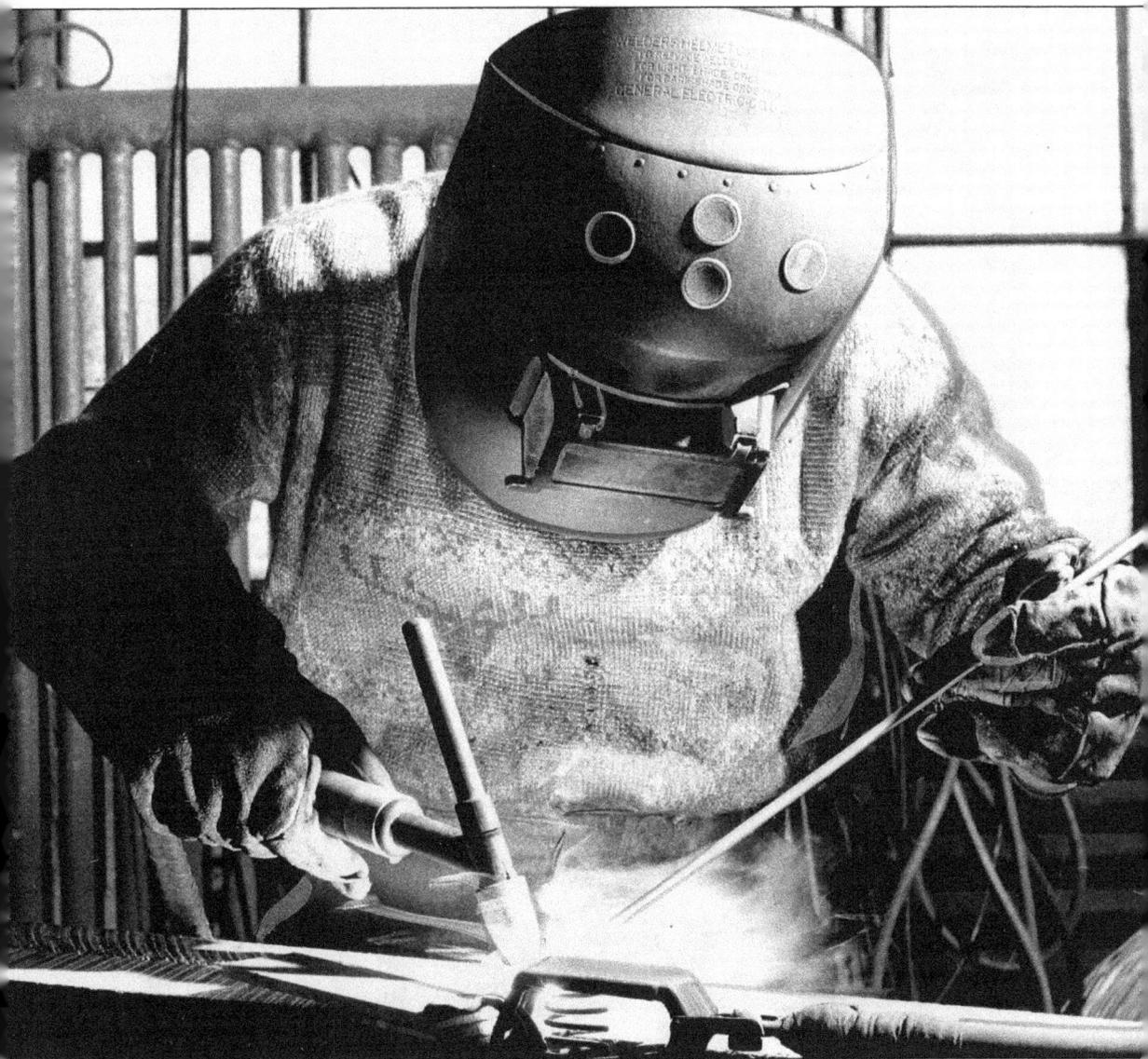

This heli-welder operated at the Keystone Iron and Metal Company (KIMCO), located at the foot of Locust Street in Williamsport. KIMCO shaped aluminum and steel into sizes for specific purposes. The locally owned metal company, operated by Jack Hirsh and John Fischer, supplied most of the metal for the dike projects from Sunbury to Elmira. If the dike project had been completed in the mid-1930s, the cost would have been about $125,000. When the project was finally completed in 1952, the cost was about $6 million. The work on the dikes was scheduled to begin in late 1941, but the country's entry into World War II interrupted construction. (January 29, 1950.)

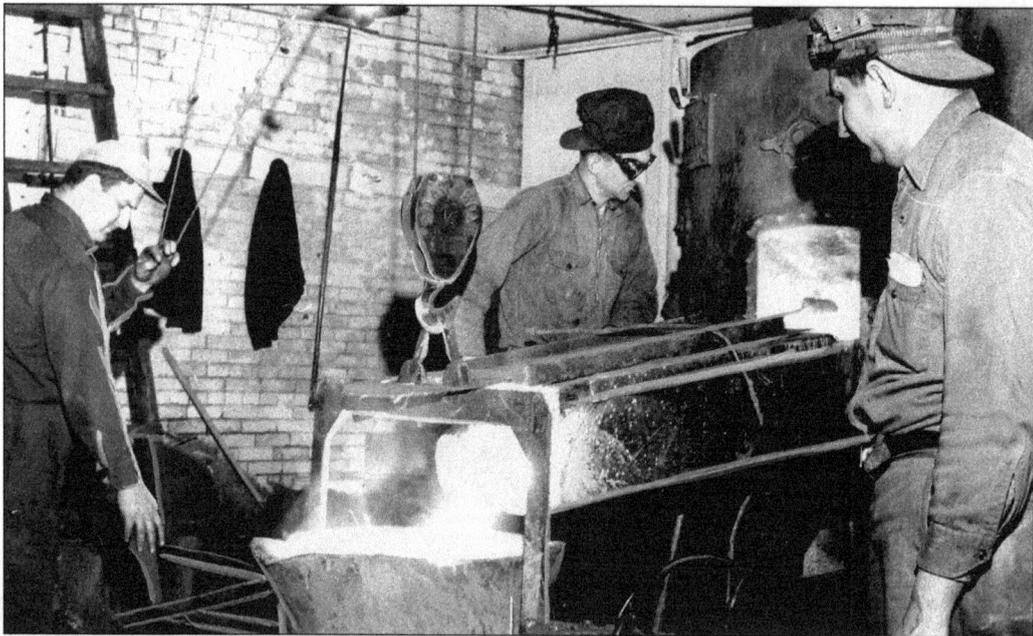

Carl Seitzer (left), Walter Ertel Jr. (center), and Wilson Doebler tap out molten iron at the Williamsport Foundry. In 1956, the foundry, located at 164 Maynard Street, produced 600 tons of iron castings. That year, more than 75 manufacturers used castings made by the foundry. Opened in 1916, the company is still in business today. (January 22, 1956.)

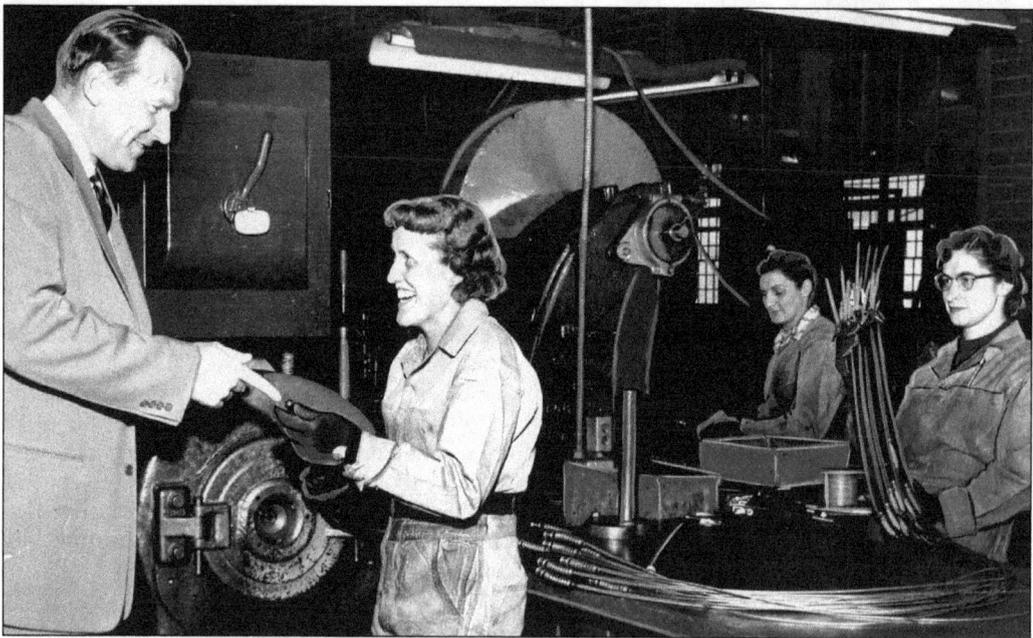

Company president Russell Curry inspects a cable assembly at the Wire Rope plant. With him are, from left to right, Theo Snyder, Alvina Markle, and Rea Kline. At the time, Wire Rope made cable assemblies for Cadillac automobiles. The plant was located at 905 First Street. (April 15, 1956.)

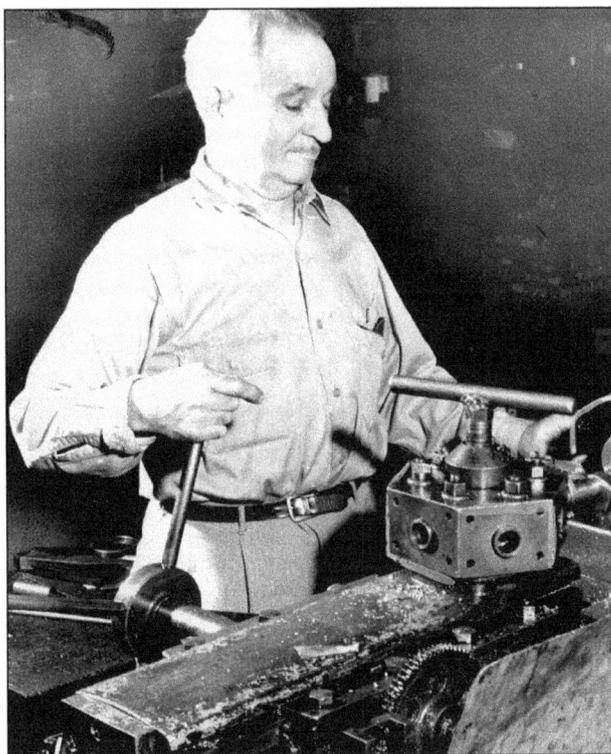

Alexander Kurilenko operates a hand screw machine at Lemco on Beauty's Run Road. Founded in 1946, Lemco manufactured special tools, fixtures, machinery, and aircraft engine parts. Kurilenko, a refugee from Estonia, invented a safety-door latch for cars. The latch was mounted in front of the car so that if a crash occurred, a plunger moved forward to prevent the door from flying open. (May 13, 1956.)

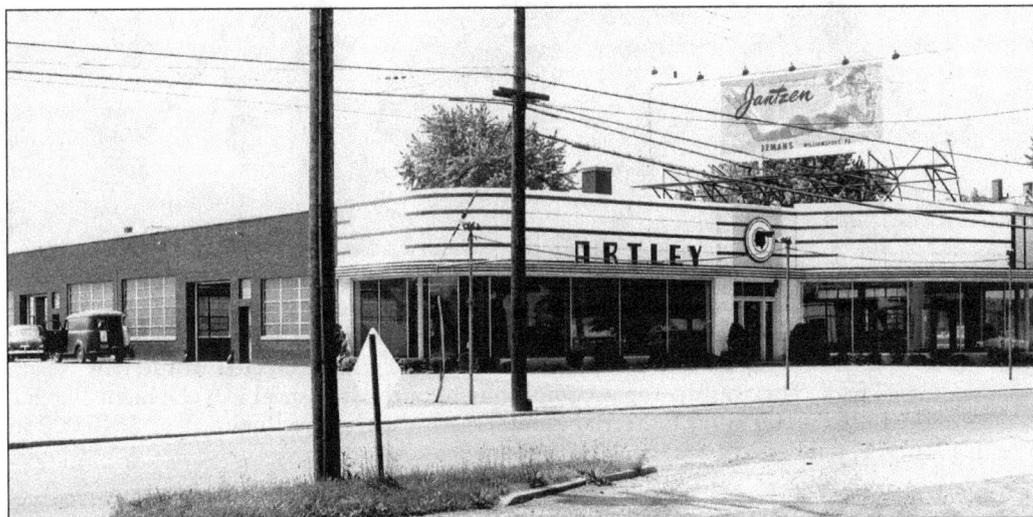

One of Williamsport's new Lycoming Industrial Fund Trust (LIFT) industries, the Babcock and Wilcox Company acquired the former Artley Pontiac building at 1544 East Third Street. Employment was expected to hit 125 with a $500,000 annual payroll. The company, reported to be the world's largest boiler and heat transfer firm, concentrated on engineering, drafting, and designing for various plants nationwide. (June 24, 1956.)

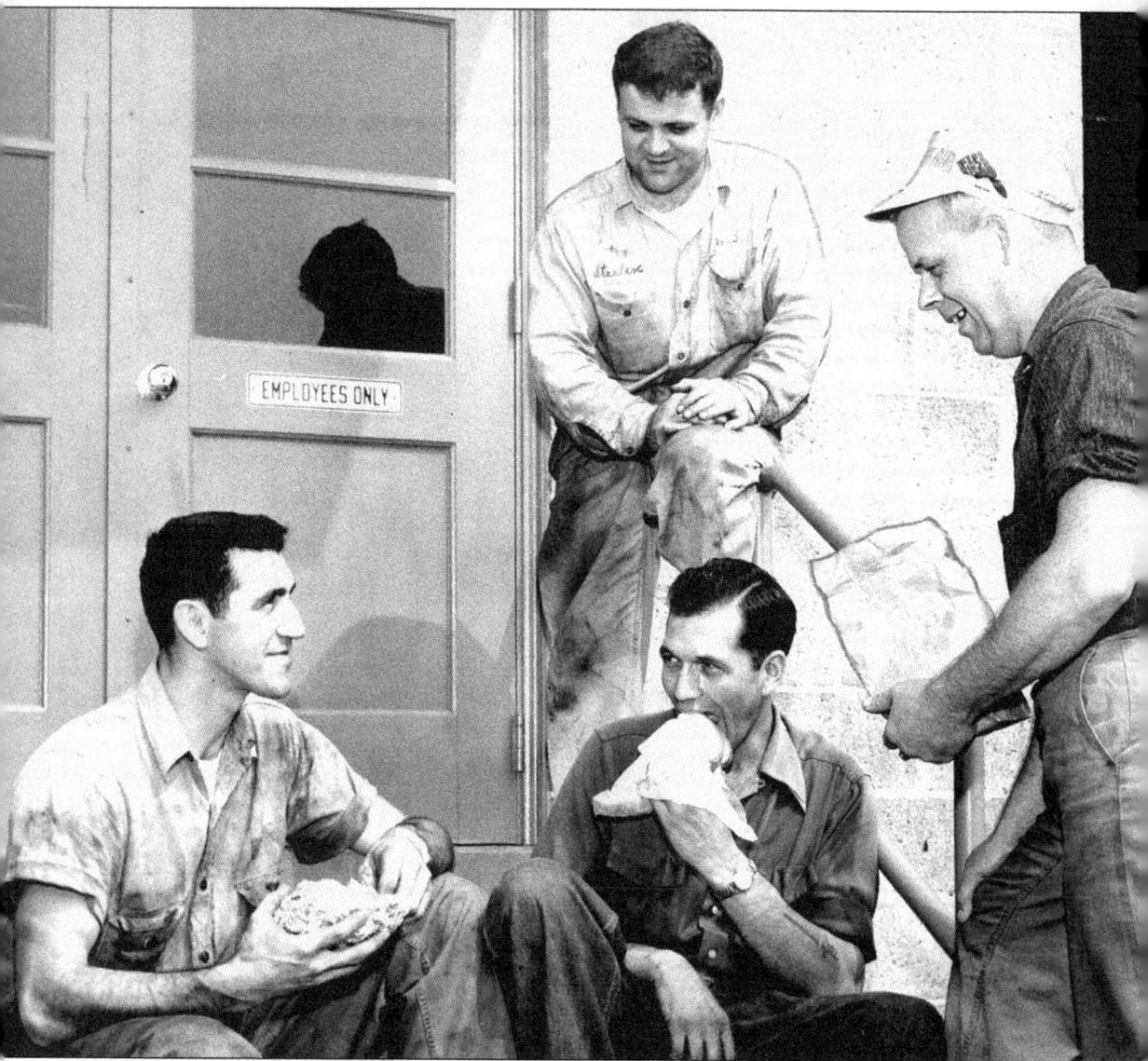

Ron Gizzi and Harold Boring, seated and eating lunch, talk about their jobs at Steelex with Russell Munsell and Joe Salafani. One of the highlights of the city's industrial year was the acquisition of a new business for a new building. Steelex moved its stainless-steel fabrication works here from Brooklyn, New York, and took over the building erected in the new Reach Road industrial park. This was the top accomplishment of the Industrial Development Bureau, and it sparked LIFT (Lycoming Industrial Fund Trust), which raised more than $640,000 in March 1956. (September 2, 1956.)

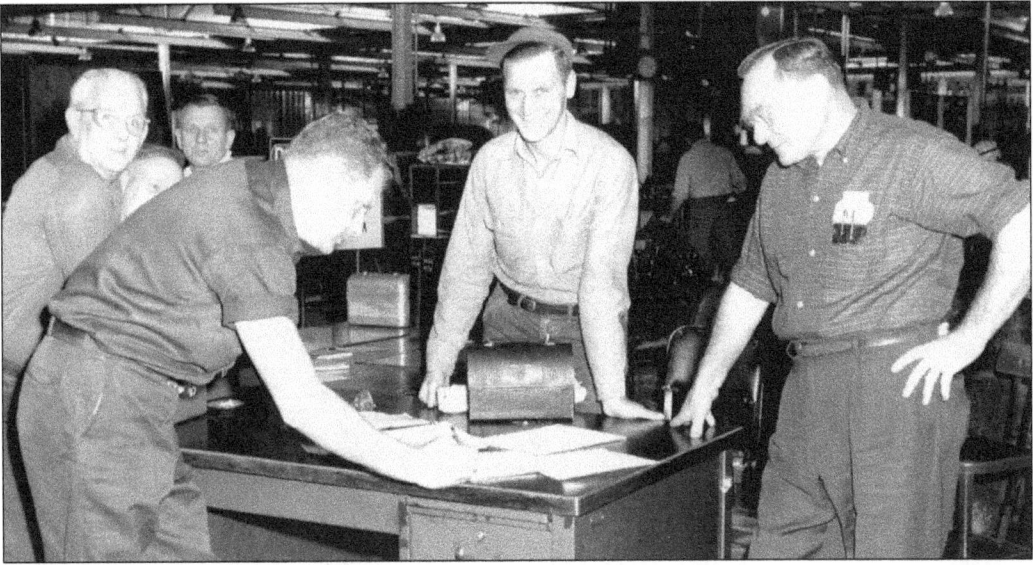

Steelworkers get assignments upon returning to Williamsport's Bethlehem Steel plant. The strike put 500,000 workers nationwide on picket lines for 116 days in 1959. The only other Lycoming County steel plant to be shut down by the strike was the Jones and Laughlin Steel Company in Muncy. Locally, 1,200 steelworkers were idle. (November 8, 1959.)

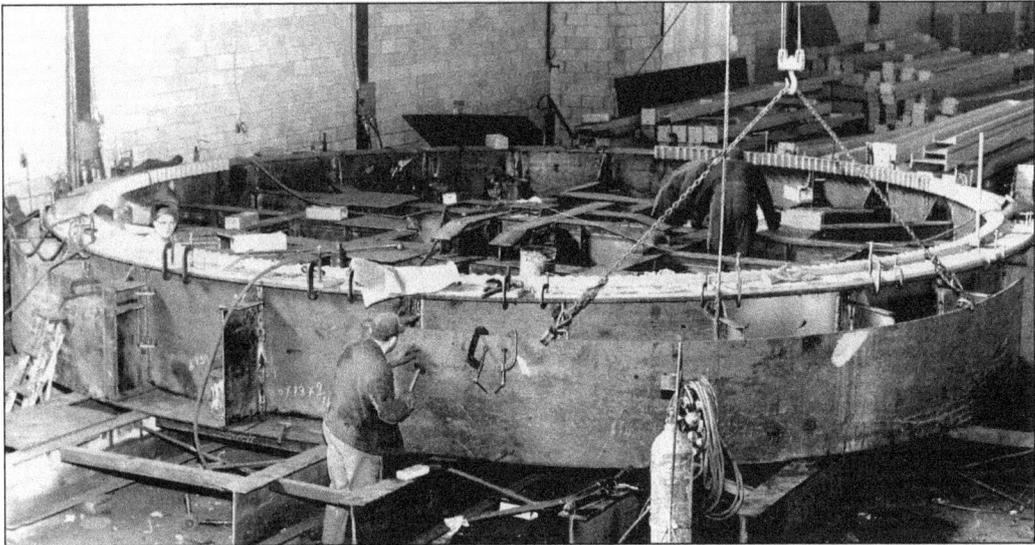

Claster Steel employees fabricate steel tubs in the Park Street plant, one of many projects in progress at the time. Claster was an outgrowth of M. L. Claster and Son, which had 14 lumber and building yards in central Pennsylvania. The business developed from a one-machine shop fabricating steel to a major supplier of structural steel for the Northeast. (February 14, 1960.)

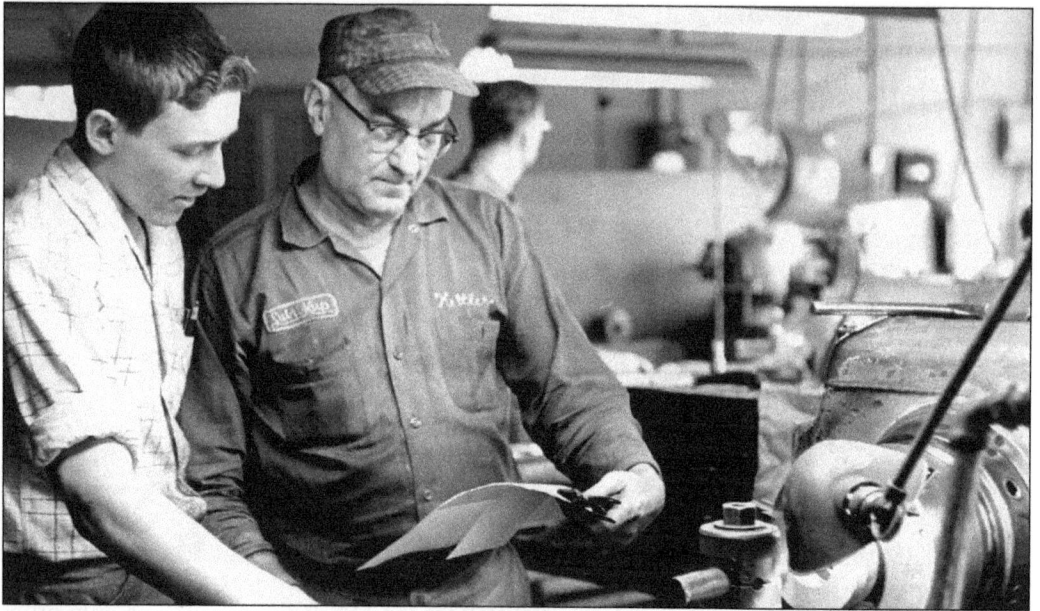

Clyde Schon (left) of Cogan Station, a senior in Williamsport Technical Institute's student cooperative program, checks a job with machinist Jack Ketter at the LubriKup Company. LubriKup, which manufactured pumps, is now Garlock of Ohio. The cooperative became Williamsport Tech in 1941, Williamsport Area Community College in 1965, and Pennsylvania College of Technology in 1989. (March 21, 1965.)

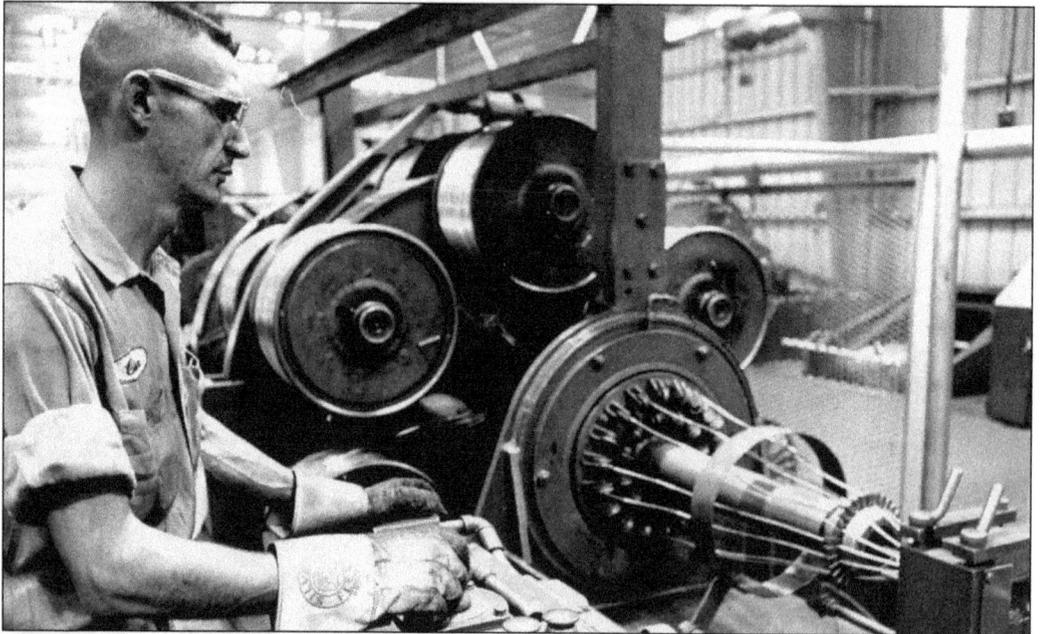

Clair W. Dauler operates a stranding machine that makes cable up to two inches in diameter and with a current carrying capacity of 750,000 volts for the Alcan Cable Corporation. The firm began operating in Williamsport in 1964, making bare and insulated aluminum and copper cable for the utility industry. The local plant, managed by John T. Detwiler, was in excess of 250,000 square feet and employed about 250 people. (September 4, 1966.)

Reynolds Iron Works, located at 139–141 Susquehanna Street, specialized in steel chairs, ornamental metalwork, and aluminum fabrication. The company was founded by W. E. Reynolds Sr. in 1922 and incorporated in 1950. The firm employed 10 men in 1966 and was headed by Robert E. Reynolds, president and shop foreman. William E. Reynolds was treasurer and bookkeeper. (September 25, 1966.)

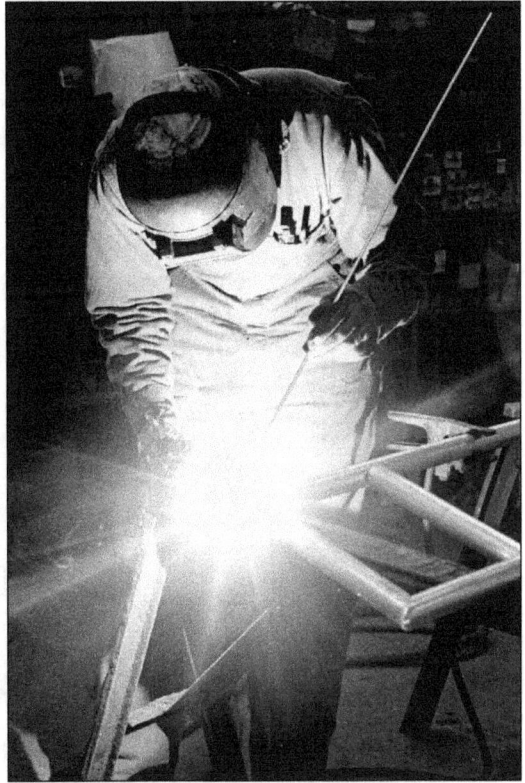

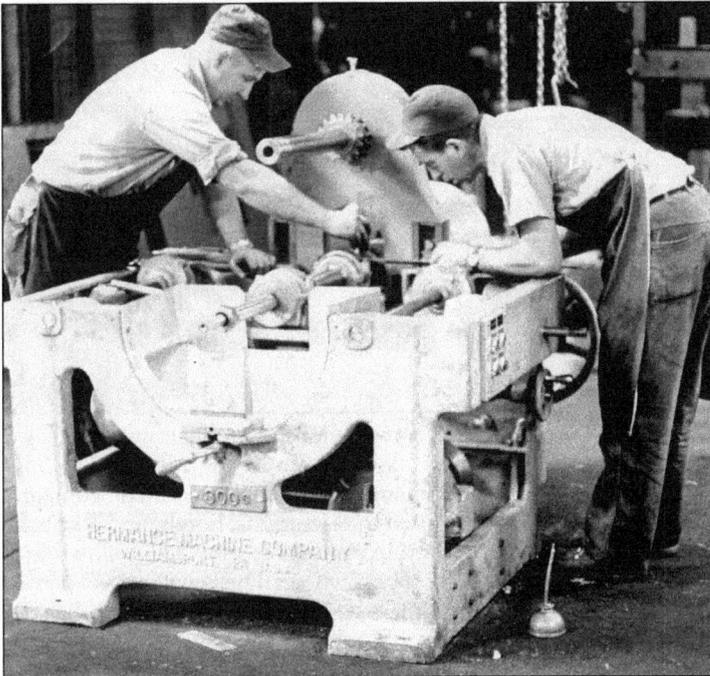

John S. Farnsworth (left) and John F. Ringler assemble a woodworking machine at the Hermance Machine Company, at 178 Campbell Street. Hermance manufactured gang ripsaws and special equipment for the woodworking industry, which sold nationwide through dealers. A locally owned corporation founded in 1902, it employed 25 people. (November 6, 1966.)

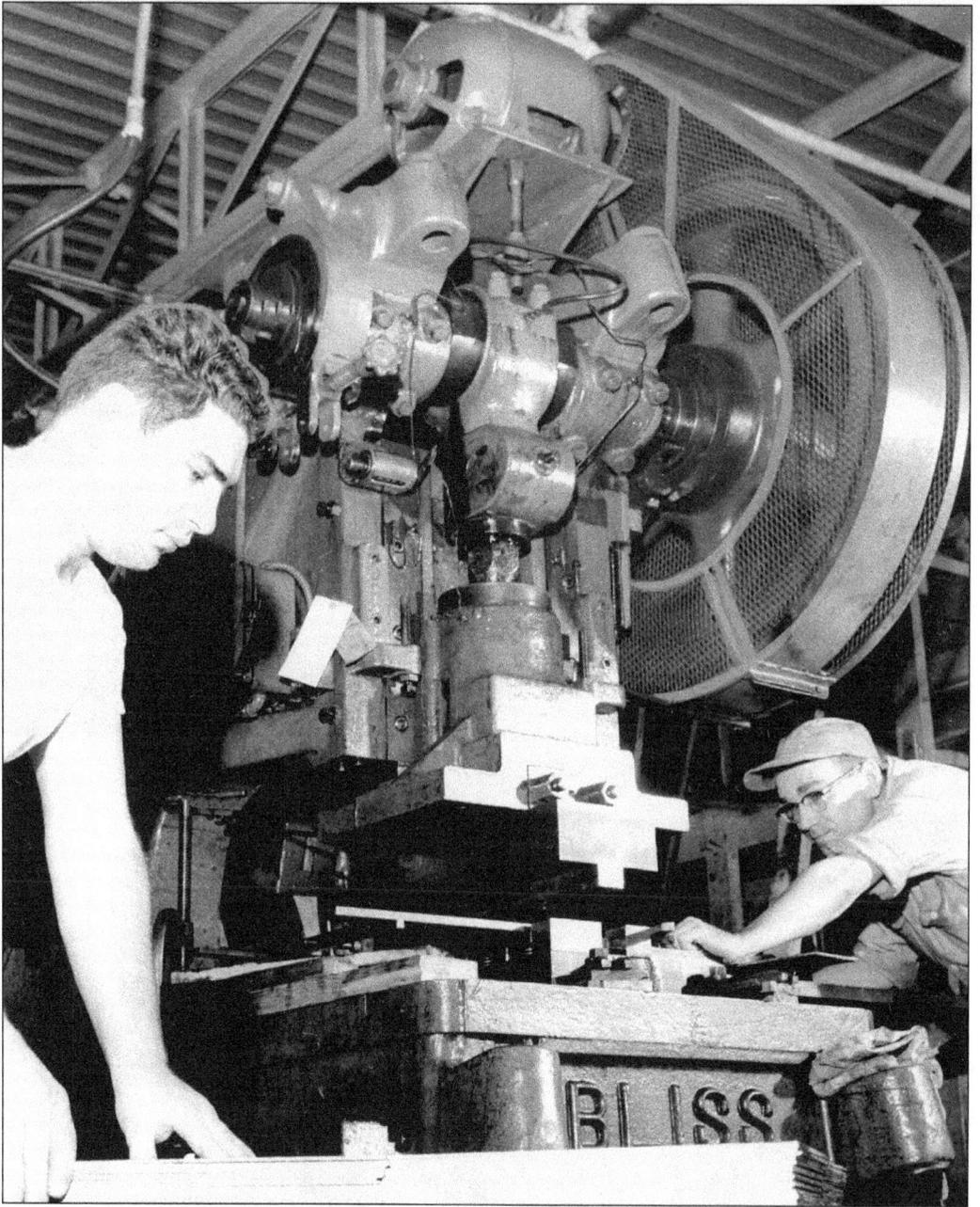

Lawrence Nobel (left) and Steve Adams stamp out steel sections for fall products at the Steelex Corporation, established at Williamsport's industrial park along Reach Road in the fall of 1956. Steelex occupied a 100- by 200-foot plant with 21,000 square feet of floor space. The company made stainless-steel parts used for jet engines and articles used in restaurants, hotels, and hospitals. Harry Brearley of England is credited by many with inventing stainless steel in 1912. The son of a steel melter, Brearley went to night school and studied on his own until he became an expert in the analysis of steel and its production. He developed stainless steel when he discovered that the addition of chromium to iron created a rust-resistant alloy. (October 26, 1958.)

Eight

MANUFACTORIES

Industrial developments beginning in Lycoming County prior to the Civil War accelerated after 1865, when 430 regional manufacturers boasted capital of more than $2 million. Ten years later, 608 factories were in operation and capital investment had tripled. Soon, the transcontinental railroad linked the two coasts, and millions of immigrants from Europe and China filled the ranks of the country's working class.

The first real boost came as a result of the 73-mile West Branch Canal, which extended from Northumberland to Williamsport, through Lock Haven, and finally to Bellefonte, constructed at a cost of $1,158,580. Not only did the canal bring people of working age to Williamsport, it stimulated the economy through the development of manufacturers and industries.

The Demorest Manufacturing Company was a large Williamsport industry that, by adapting and keeping up with changing technology, was able to keep producing. It was founded by Madame Demorest, the former Ellen Louise Curtis of New York. An energetic businesswoman, at age 18 she opened a millinery shop. She married William J. Demorest in 1858 and conceived the idea of mass-produced accurate paper patterns for home dressmaking. She retired in 1883, selling her interest in Demorest after her pattern business declined. In the 1800s, Demorest manufactured an average of 60 sewing machines daily, as well as opera chairs and the "New York" bicycle. As the production of sewing machines slowed, Demorest became the Lycoming Foundry and Machine Company, manufacturing duplicating machines, cup vending machines, typewriters, gas irons, platen printing presses, and button sewing attachments.

By 1909, the company had again turned, this time to the auto industry, and made gasoline engines for the Velie Motor Vehicles Company. In 1911, the Lycoming Foundry began making engines for the Herreshoff Motor Car Company. By 1913, it employed 275 skilled mechanics. Soon, the company's engineers developed aircraft engines. By 1928, the company had perfected its engines, and it made thousands during World War II as the Aviation Corporation.

AVCO is now a division of Textron, one of the world's largest and most successful multi-industry companies.

At one time, the Wire Buckle Suspender Company, the largest in the world, operated out of Williamsport. It began at Jersey Shore in 1885 as the Economy Suspender Company, and in 1886, the manufactory moved to Williamsport. Its new owners—William Silverman, Solomon Silverman, C. R. Harris, and Joseph E. Austrian—had enough capital and Harris owned a patent for the wire buckle. The manufactory produced 40,000 pairs of suspenders daily and employed an average of 150 girls and boys, and 30 men as traveling salesmen.

These men appear outside the Williamsport Macaroni Manufacturing Company, at 111 East Third Street. Opened in 1900, the plant was owned by three Italian immigrants: Sylvester Ribaudo, Vincenzo Scaduto, and Ignazio Gaglione. Later, Anthony DiSalvo Sr. became a partner and owned the building. The business fell victim to the Depression in 1933. (c. 1915.)

R. J. Browning was a Williamsport watchmaker. Around the beginning of the 20th century, the pocket watch got competition: the timepiece worn on one's wrist. Initially, wristwatches were simply pocket watches with lugs. By the mid-1950s, the "throw away" watch was becoming increasingly popular, signaling the decline of the pocket watch. In 1920, there were more than 100,000 watchmakers in the country. There are now less than 5,000. (c. 1920.)

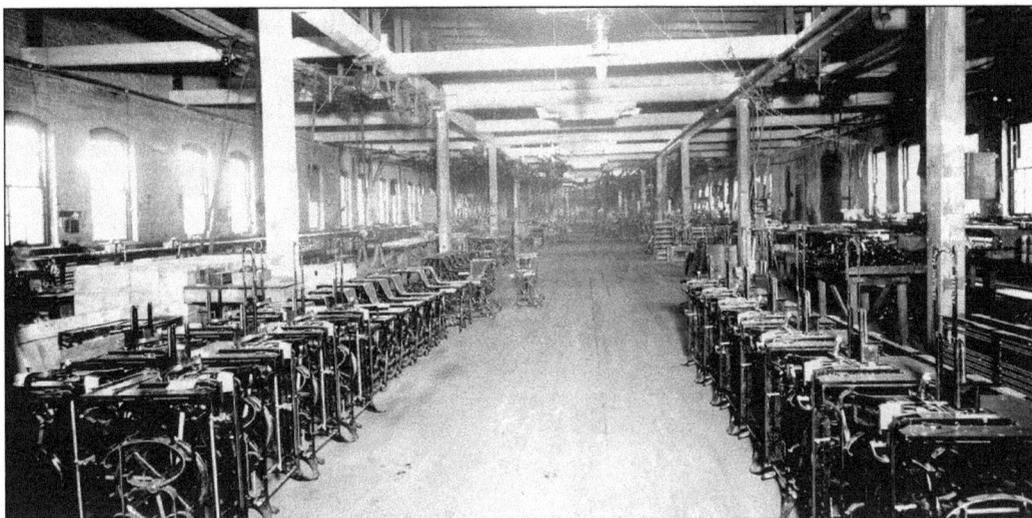

Shown here is the assembling room of the Demorest Manufacturing Company. The company turned out 60 sewing machines a day. It was in business from 1888 to 1908. Demorest became the Lycoming Foundry and Machine Company and eventually Textron-Lycoming, a maker of aircraft engines. Demorest also made cabinets and bicycles. The company's sewing machines sold for between $15 and $50. The bicycles were priced from $85 to $150. (c. January 1915.)

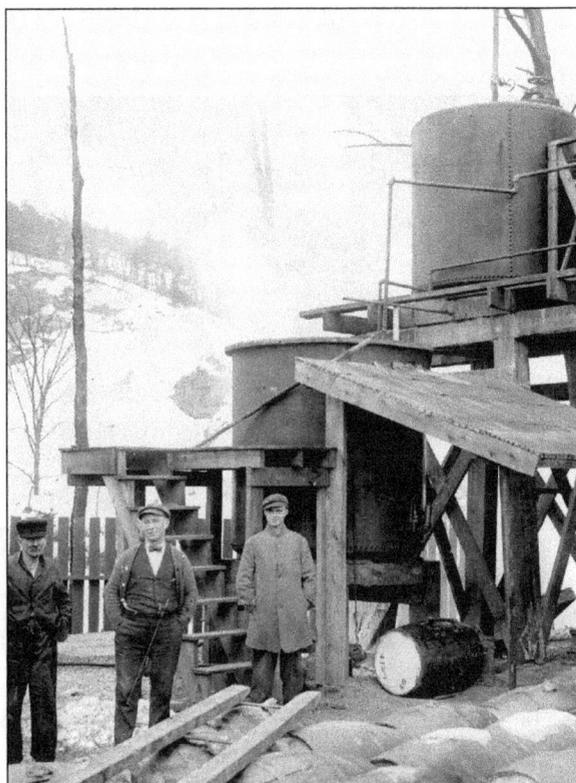

Distillers work at the de-greasing plant of the Williamsport Staple factory on Lycoming Creek. The company had four factory sites in the Williamsport area. In January 1914, the staple factory consolidated its operation from four plants to just one. The de-greasing plant was operated because of the materials used in the process. (January 25, 1914.)

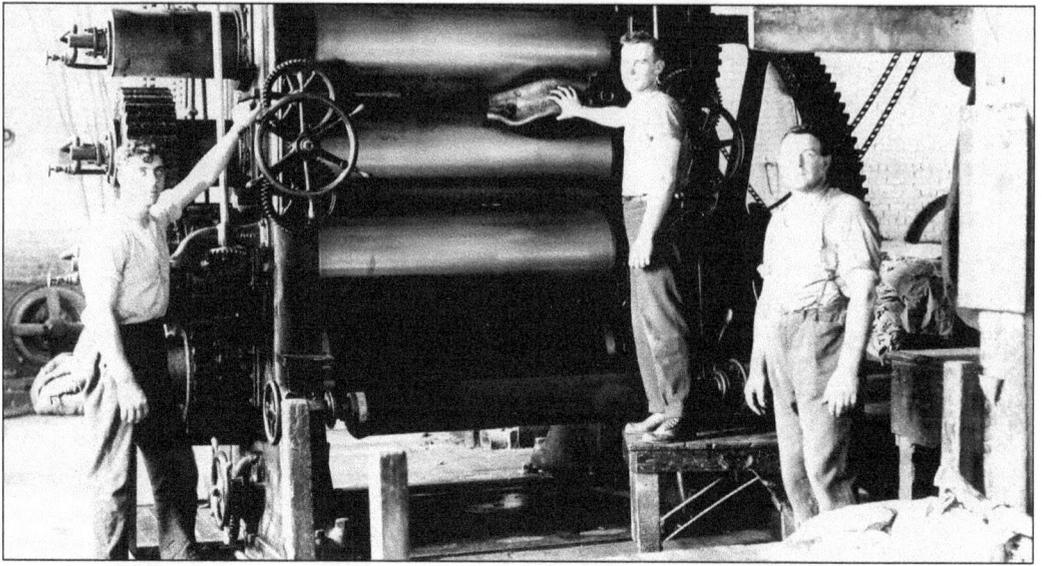

Employees are pictured with the powerful calendar rolling machine at the Lycoming Rubber Company plant. A *Grit* article reported, "Experienced rubber workers who left the job declared that there has been no occupation cleaner and more healthful." Women trainees at the plant received 75¢ a day. No experienced shop worker earned less than $9 per week. (July 22, 1916.)

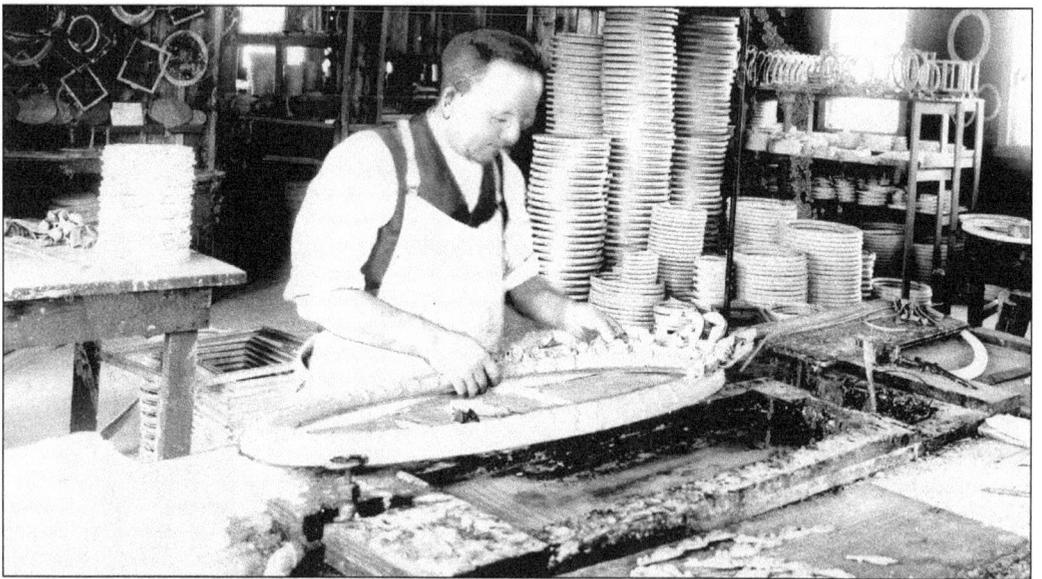

This workman finishes frames in the gilding department of the L. M. Castner Picture and Mirror Frame Company, at 1448 West Fourth Street. The plant took up an entire city block and, in 1921, was the largest facility of its kind in the country, with 70,000 square feet of floor space. More than 50 percent of the labor in the plant was hand work. (December 18, 1921.)

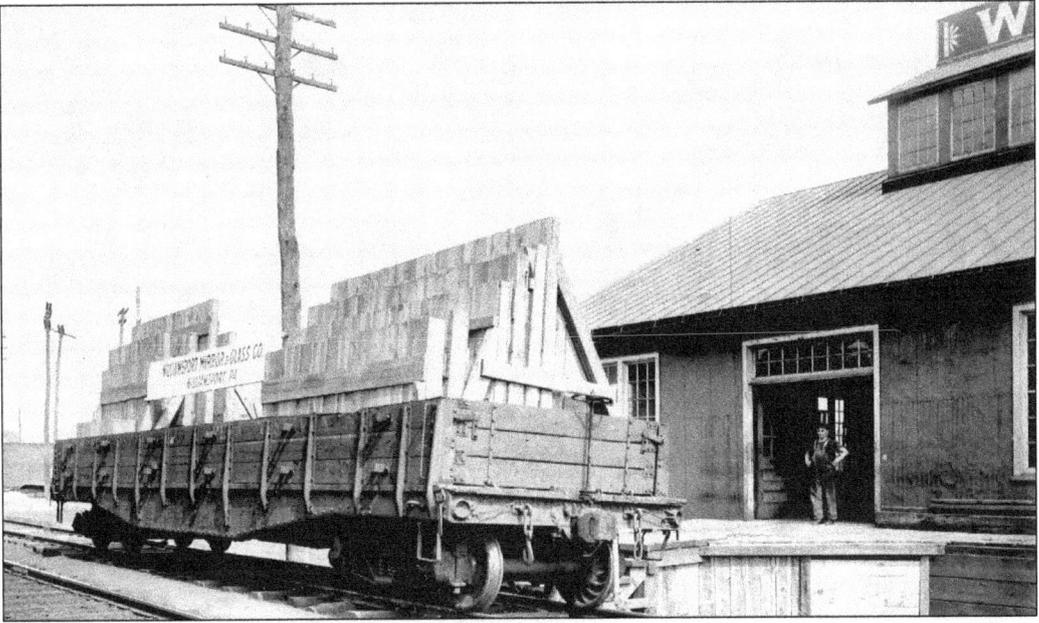

A railcar pulls up to the shipping and receiving facility of the Williamsport Mirror and Glass Company, at 317 Railway Street in Williamsport. The company was brought to Williamsport in 1903 from Pittsburgh by the Williamsport Board of Trade. It produced mirrors for local furniture factories. As the furniture manufacturers went out of business, Williamsport Mirror made glass for storefronts, show windows, and for aluminum doors and frames. (c. 1920.)

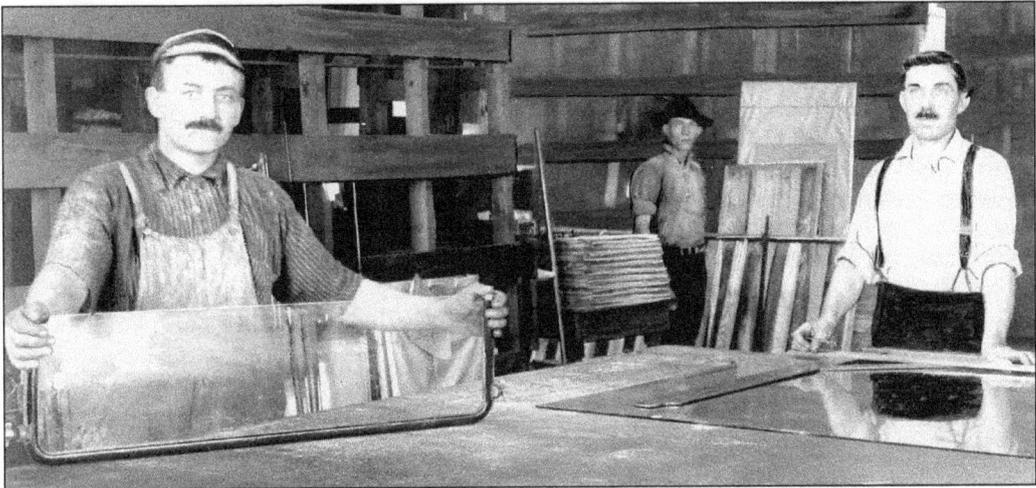

The Williamsport Mirror and Glass Company started making automobile windshields in 1925, and that became a major staple of the business for many years. In later years, the company produced replacement glass for windows, sashes, and storm doors. The company discontinued making mirrors in 1958. (c. 1925.)

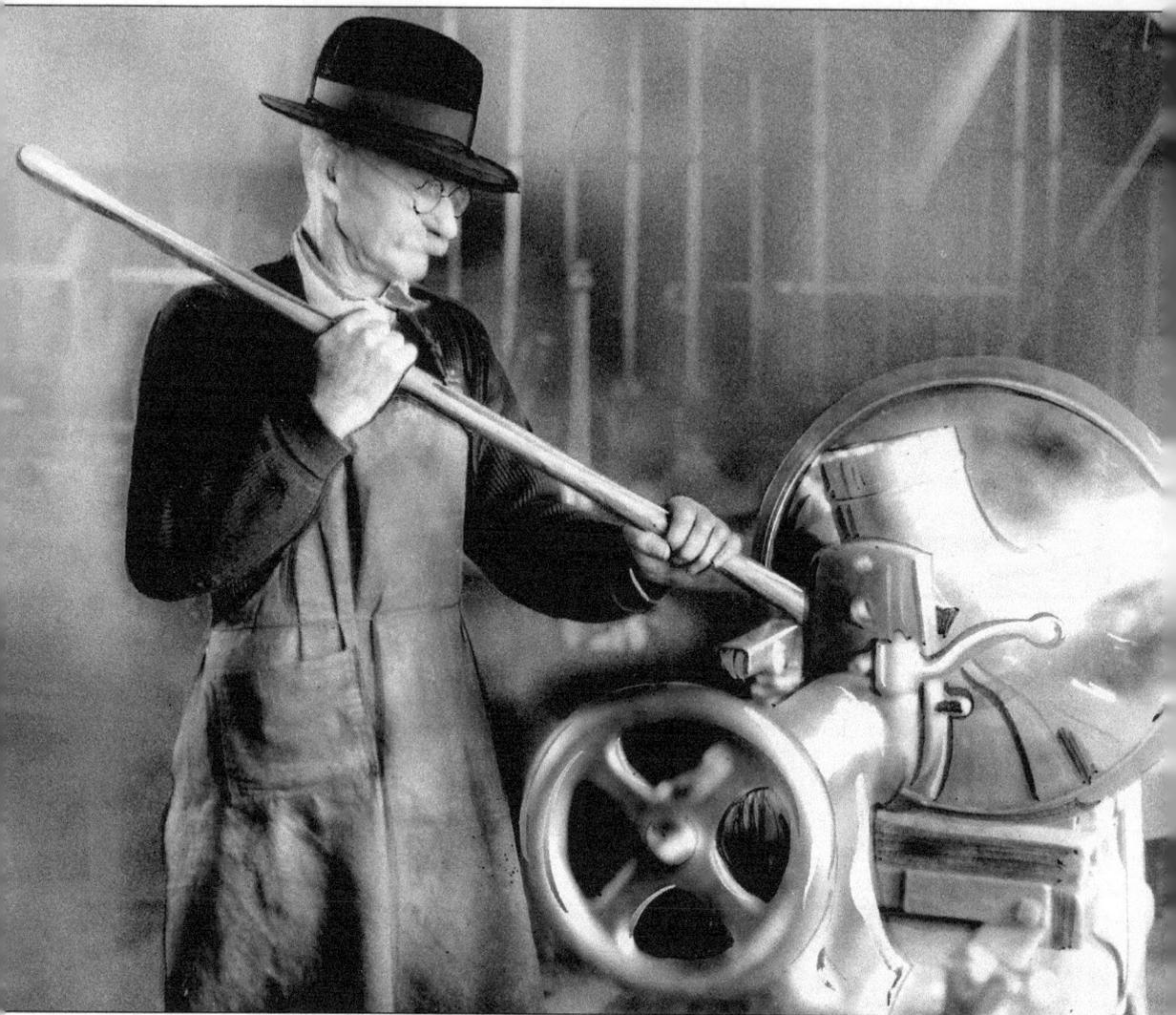

This worker spins the bell as he manufactures a horn at the Brua C. Keefer Company, which made various types of brass instruments. Originally the Distin Company, it was the largest producer of musical instruments in the country during the early 1900s. Brua C. Keefer had managed Distin when it moved to Williamsport from Philadelphia. He acquired financial control of the company in 1909 and changed the name to Keefer. His factory, located at the corner of Walnut Street and Rural Avenue, supplied many of the instruments used by the federal government and its armed forces. The site is now occupied by the Williamsport Hospital's Medical Arts Building. (April 16, 1922.)

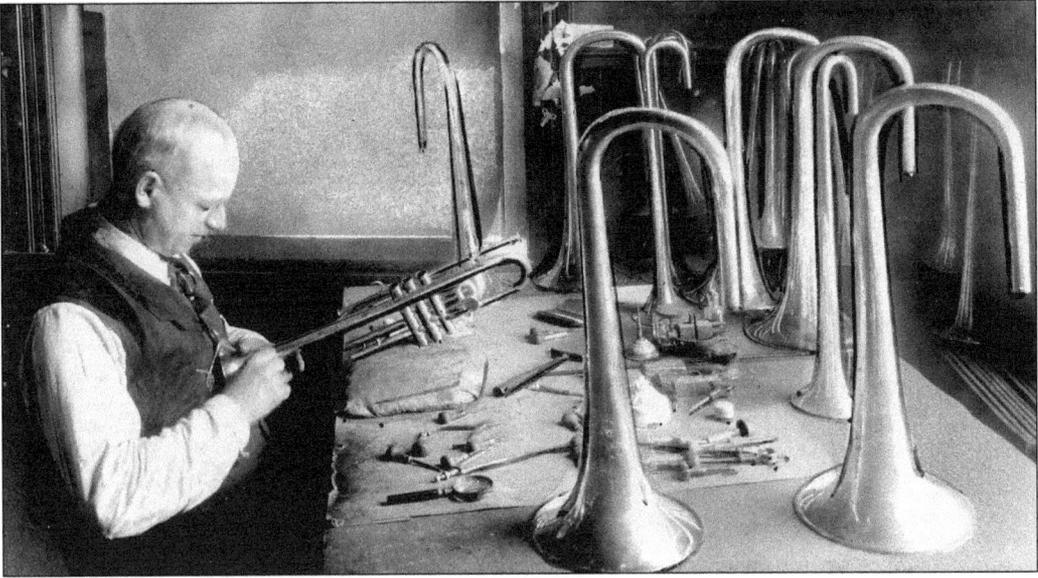

Charles F. Otto works in the engraving department of the Brua C. Keefer Company. In 1888, the factory was brought to Williamsport from Cressona, Bucks County, by the Henry Distin Manufacturing Company. The factory was destroyed in a disastrous fire on November 25, 1960, ending 72 years of business. (April 16, 1922.)

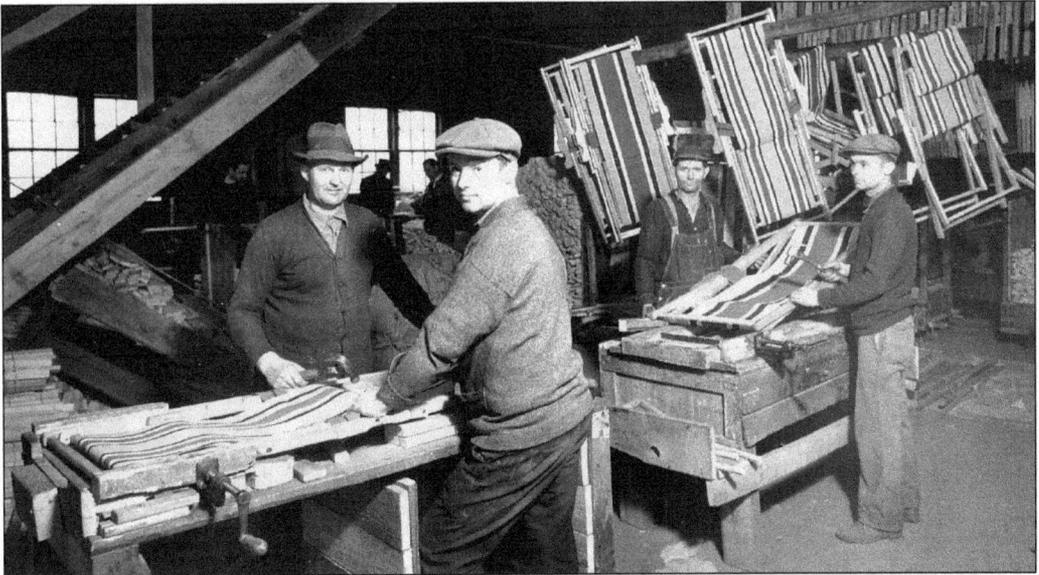

Workers assemble chairs at the Lind Manufacturing Company, at 200 Chatham Street in Williamsport, which made collapsible chairs for beaches, cabins, picnics, and porches. During its peak season, Lind employed 35 to 40 workers and was able to turn out about 1,000 chairs per day. Three types of beach chairs were manufactured by the company: the conventional long canvas-backed chair, a yacht chair, and a baby beach chair. (April 9, 1933.)

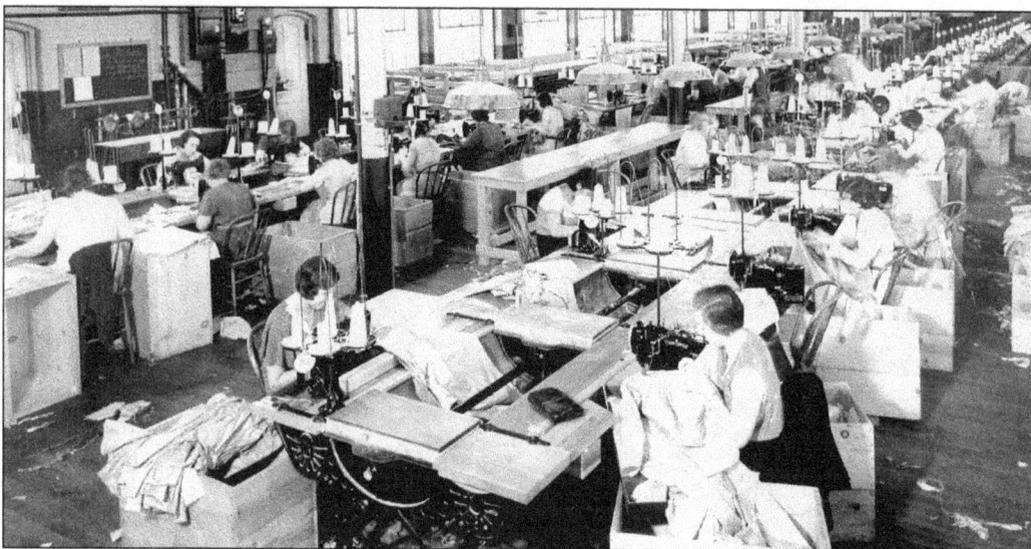

Women operate sewing machines at the Joseph G. Smith Pajama Factory, once located on the fifth floor of the Lycoming Rubber Company building. The firm was a branch of the main Smith factory in nearby Sullivan County. One hundred sewing machines were used at the Williamsport facility, which later became the Weldon's Pajama Factory. (February 19, 1933.)

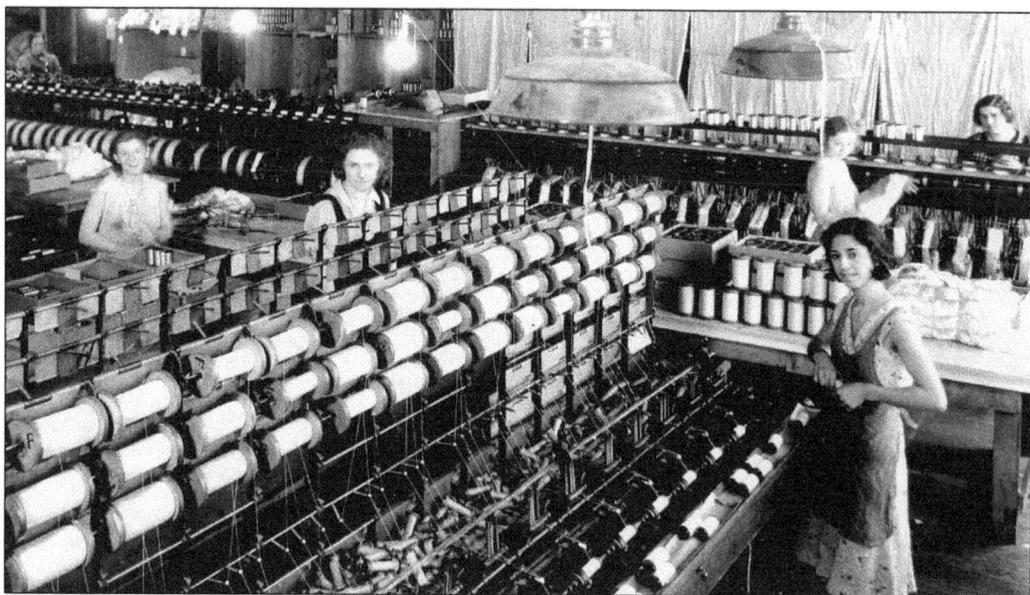

At the Narrow Fabric Company, at 406 Bridge Street in Williamsport, women double and wind thread. Narrow Fabric expanded during 1933, moving 200 braiding machines to town from its plant in Brooklyn, New York. Narrow fabrics are any textile not exceeding 45 centimeters in width with two selvedges. They are most often used in the garment and home furnishing industry. In 1955, the company merged with a New England firm and became Assembled Products of Williamsport and, in 1959, Trimtex. (April 16, 1933.)

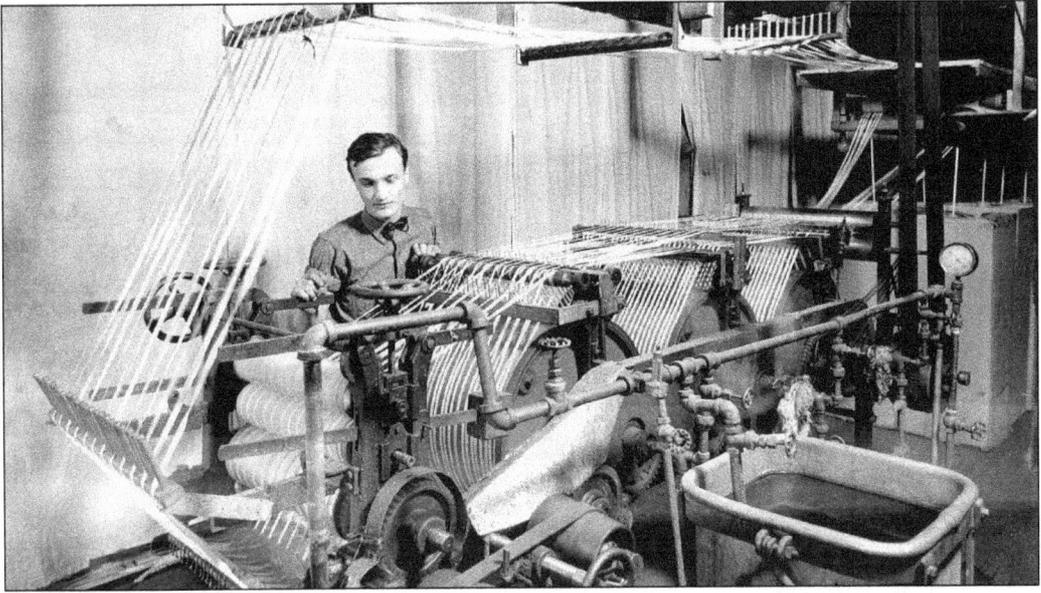

A worker at the Narrow Fabric Company sizes tape at his machine. Narrow Fabric was originally located in the Weightman Block of West Fourth Street in Williamsport. The company was founded in 1918, later moving to East Third Street. With the advent of the Depression, more people were doing their own millinery and dressmaking, thus demanding the products of Narrow Fabric. (April 16, 1933.)

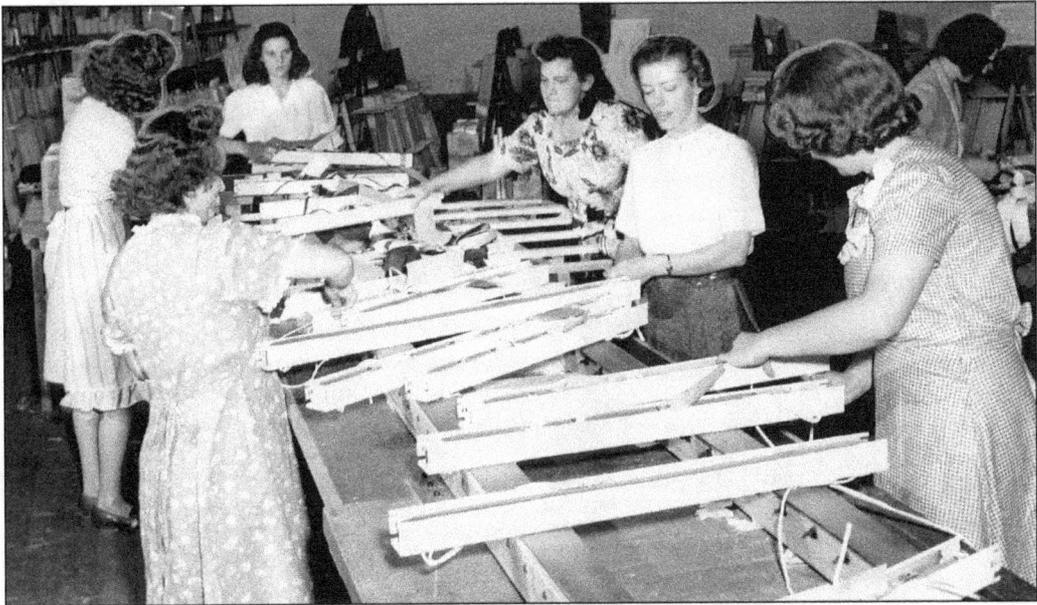

Women workers at the Carey-McFall plant in Montoursville complete the final assembly of a blind. For many years, Carey-McFall was one of the country's leading manufacturers of Venetian blinds. Company officials always tried to keep up with the latest innovations in materials, methods, mechanization, and management. (October 31, 1948.)

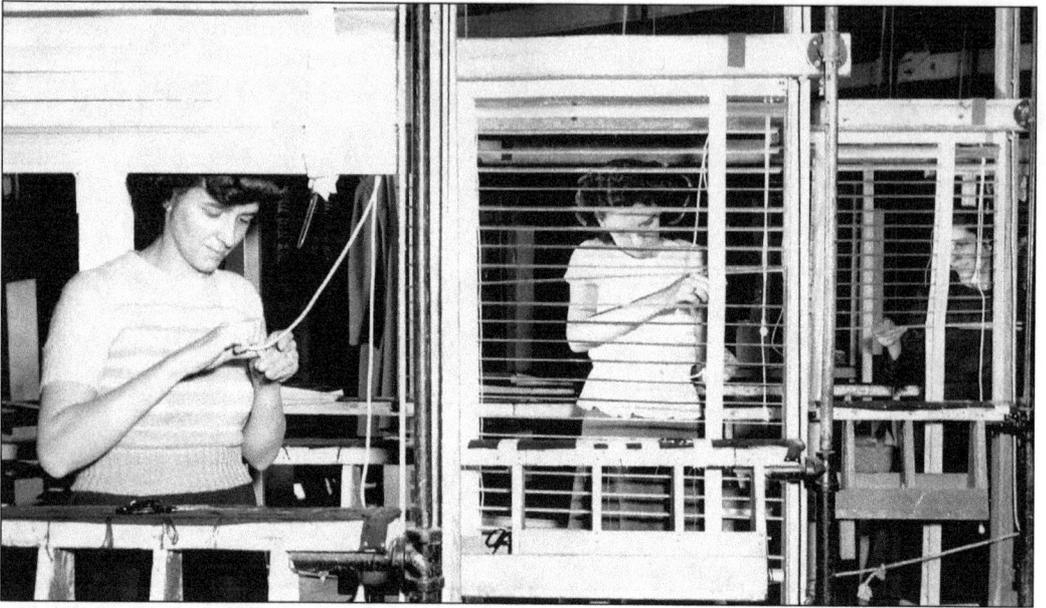

Nimble-fingered women insert cords into Venetian blinds manufactured at the Carey-McFall plant. Carey-McFall produced wooden slats for blinds, but mostly manufactured steel and aluminum blinds. Founded in Philadelphia in 1864, the company first made carriage lamps, then switched to lamps and wooden shades for automobiles. (October 31, 1948.)

A disabled GI is fitted with a prosthetic leg by a technician at the Williamsport Orthopedic and Surgical Supply Company. Shoemaker Nunzio Pulizzi, an Italian immigrant, started the company in 1918. In 1966, the firm provided an artificial leg for a patient still on the operating table at Williamsport Hospital during an experimental procedure to immediately replace amputated limbs with artificial ones. It was the only orthopedic business of its type in north-central Pennsylvania. (January 4, 1947.)

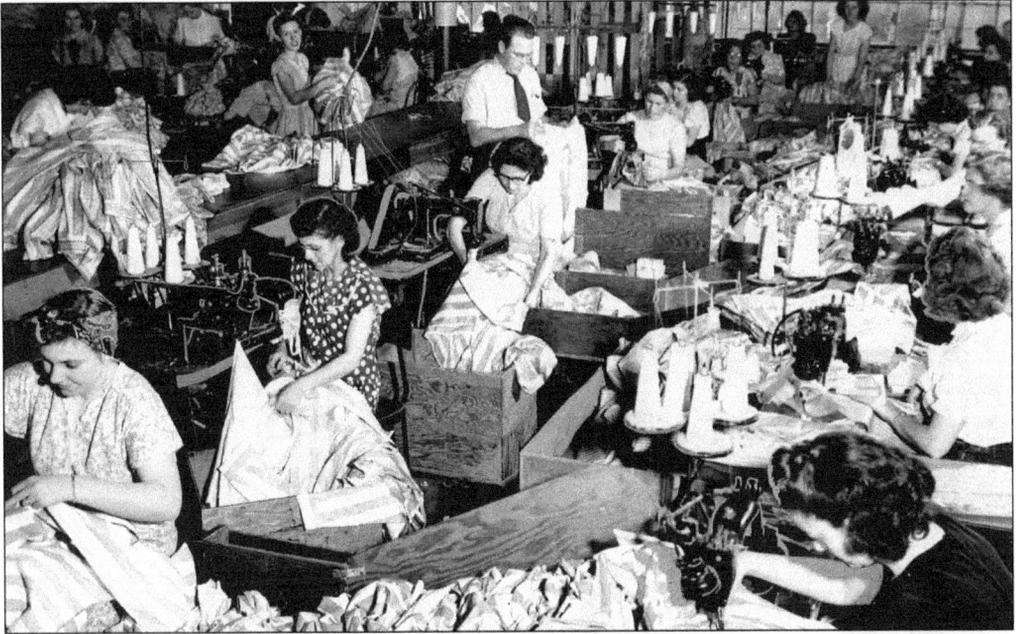

Women sew up pajama sleeves in a flurry of production at Weldon's, at 1307 Park Avenue in Williamsport, to meet the demand of the 1949 Christmas season. Members of the Broadway play *The Pajama Game* used pajamas made at Weldon's, and the company supplied some of the sewing machines used in the film version of the play, starring Doris Day. (December 18, 1949.)

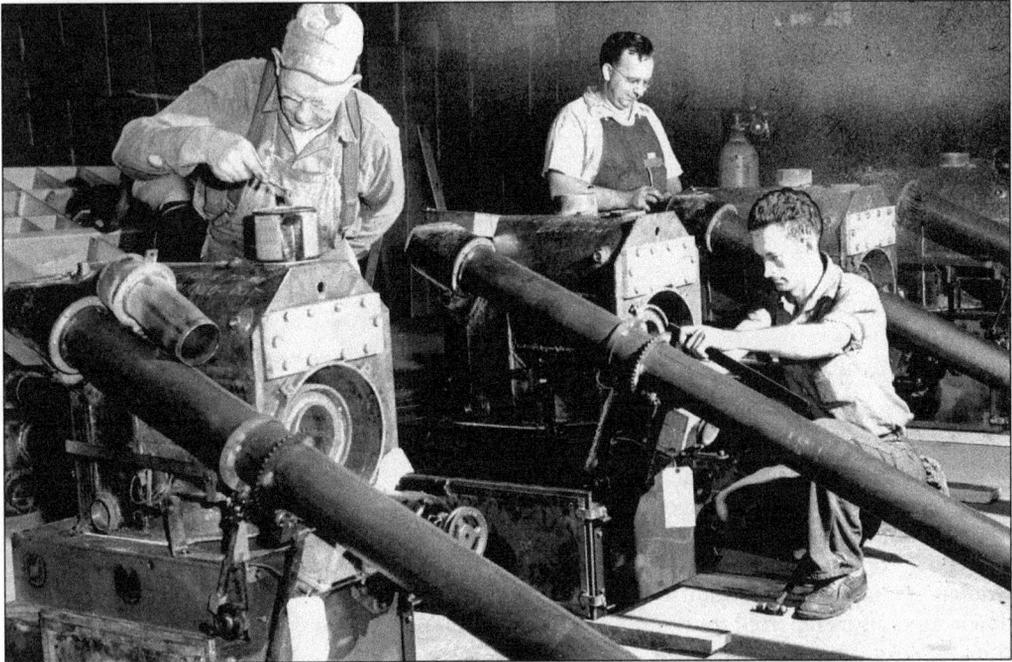

Anthratube, a heating unit made locally by the fast-growing firm Axeman Anderson, combined revolutionary ideas and processes. James E. Axeman and William S. Anderson Jr. privately financed the industry specifically to develop the revolutionary heating unit. The company was located in the former Valley Iron Works plant. (August 22, 1948.)

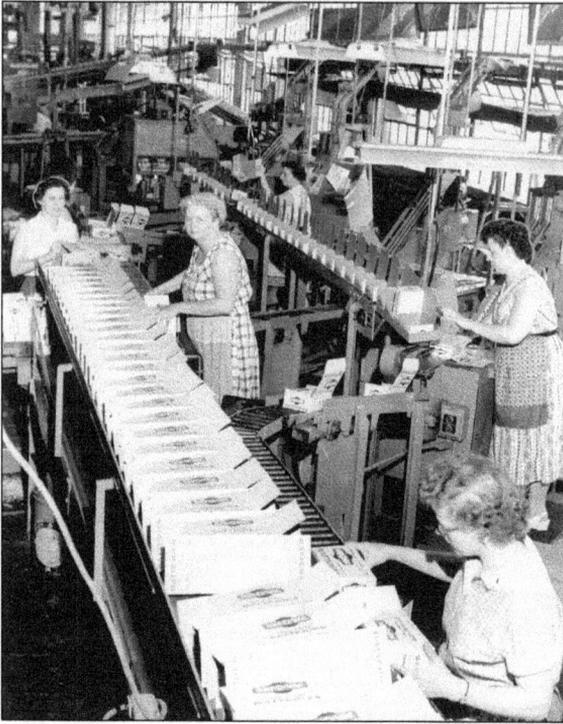

An assembly line produces dry-cell batteries at the newly opened Ray-O-Vac plant, located in a former silk mill at 110 Reynolds Street in South Williamsport. It employed 300 people at the time of its opening in the spring of 1946. Ray-O-Vac began in 1906 as the French Battery Company in Madison, Wisconsin. It was renamed in the 1930s. (June 23, 1946.)

When the shortage of electrical engineers reached an acute stage in 1943, officials at Sylvania Electric Products decided to train women as engineering assistants. Their supervisors reported that they were "doing an excellent job." In this view, Dorothy Nebraska (center) works at her desk with its tiers of meters, assisted by two new girls. (February 13, 1944.)

The Sylvania Electric Products East Third Street plant housed an electronic "brain," which represented the latest thing in modern automation. The unit handled about 1,900 messages a day, sending 18 and receiving 15 at the same time. Shown here are Henry E. Baumann, senior attendant, and Patti M. Hughson, assistant clerk. At the console is Dolores Sweet, who typed 75 words a minute on a teletype machine. (April 1, 1956.)

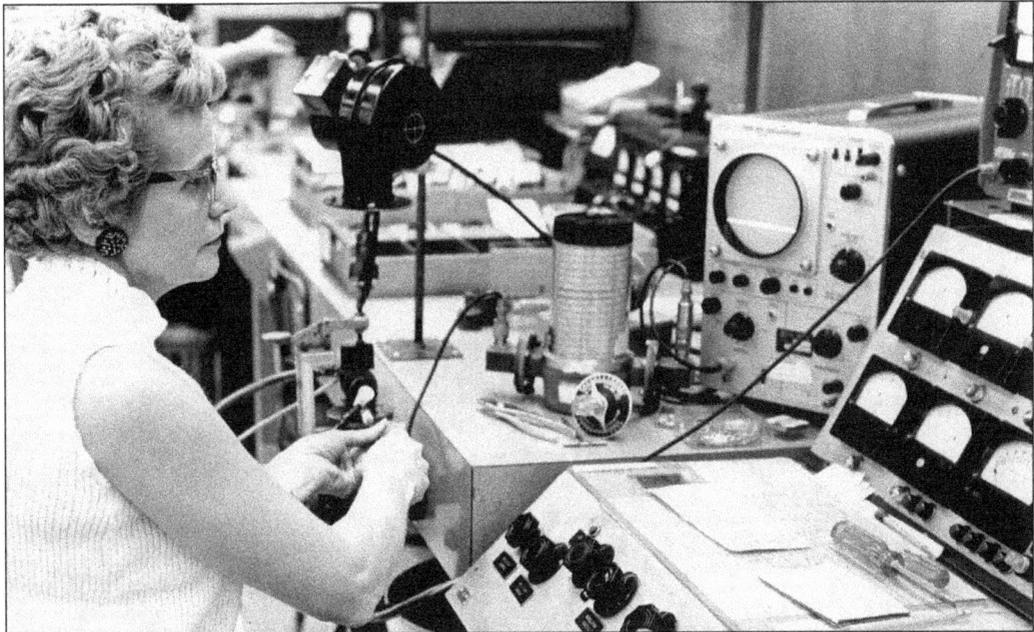

Mary Liberati tests connections at the Loyalsock Township plant of Litton Industries in 1965. A diversified American multinational corporation, Litton was founded in 1953 by Charles Bates "Tex" Thornton as a small electronics firm, which evolved into a $3.6 billion aerospace-defense company. Its more than 80 divisions provide products and services ranging from electronic and electrical components to aerospace and marine systems and equipment. (November 21, 1965.)

More flash lamps were made at the Montoursville plant of Sylvania Electric Products than any other producer in the world. Daily shipments of Blue Dot flash lamps left the plant for delivery to 21 warehouses throughout the country. Sylvania produced several hundred million flashcubes annually, running from the world's smallest to largest. The plant employed more than 1,300 area residents. (October 30, 1966.)

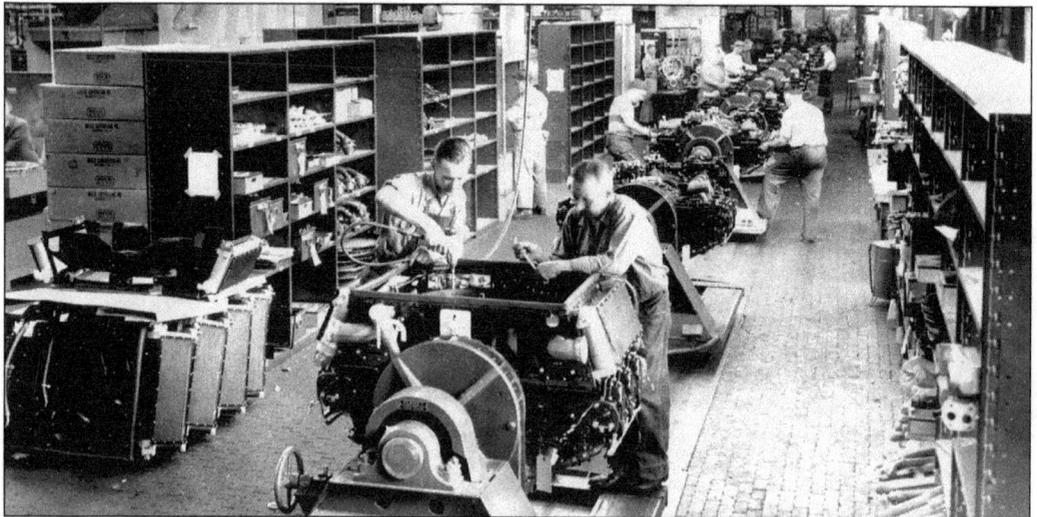

These men work on tank engines moving along the assembly line at the Lycoming-Spencer division of the Aviation Corporation (AVCO) during the spring of 1952. The production count, as well as the employee number, reached new highs at the time, partly due to the demand created by the then raging Korean War. AVCO, known previously as Lycoming Engines, turned out aircraft, marine, and automobile engines. (May 18, 1952.).

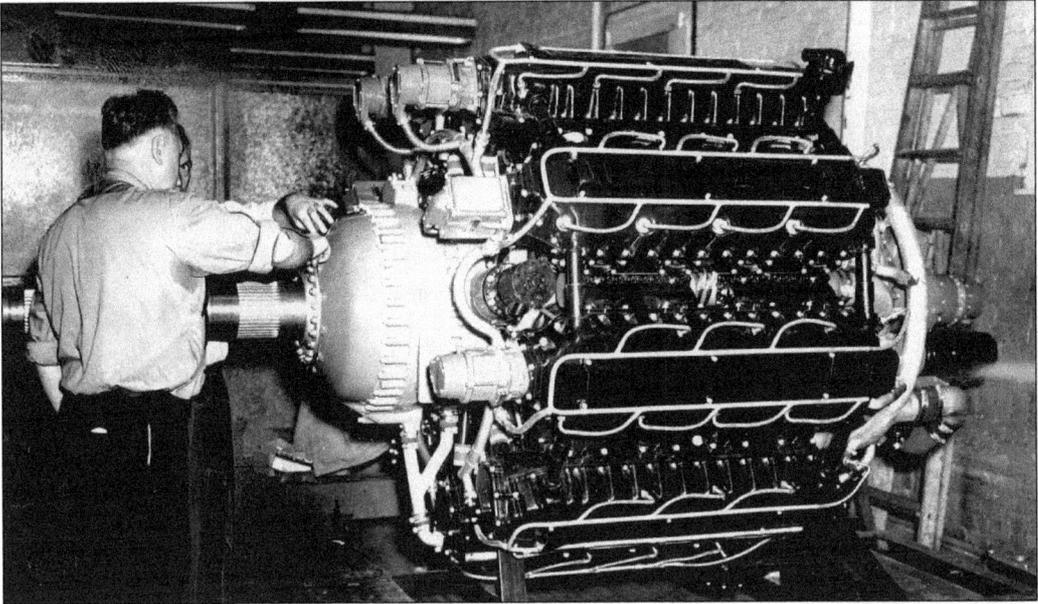

On display at the Lycoming division of AVCO is the world's largest reciprocating engine, completed under army supervision at the Williamsport plant. The engine was given its initial test on October 31, 1946. The huge 5,000-horsepower engine was tested at a $1 million laboratory at the local plant. The XR-7755 was more than twice the size of any other engine made at Lycoming. (October 6, 1946.)

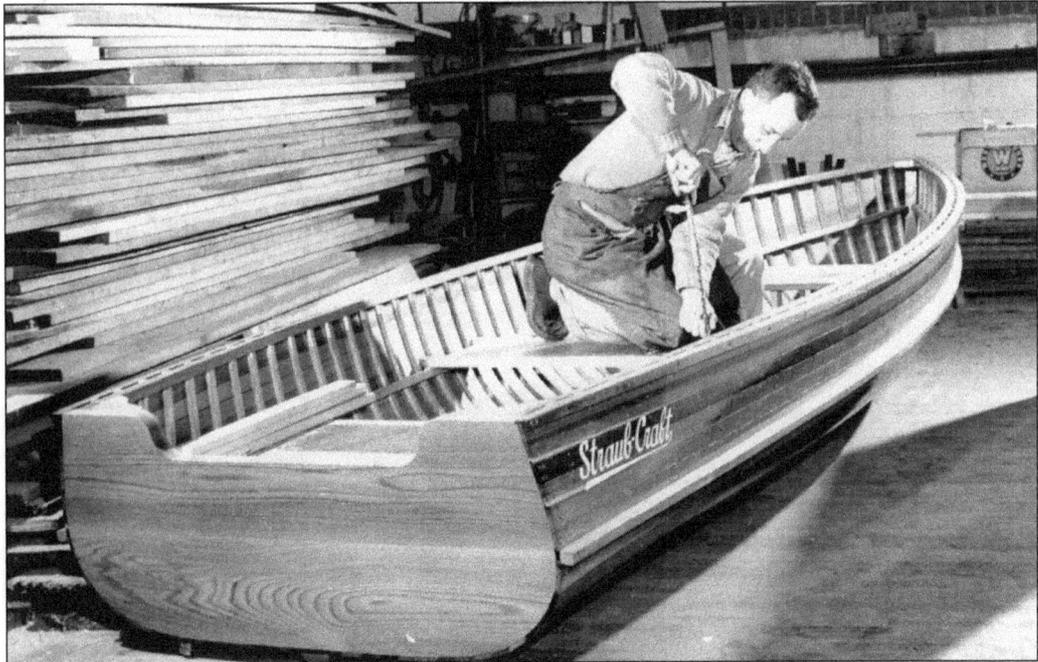

Billie Straub installs seats in a nearly finished boat at Straub's Woodworking Company in Williamsport. In the spring of 1957, the company started making 14- and 16-foot boats called Straub-Craft. The business was the only boatbuilding manufacturer in the area at the time. A 16-foot boat cost about $395 then. (March 3, 1957.)

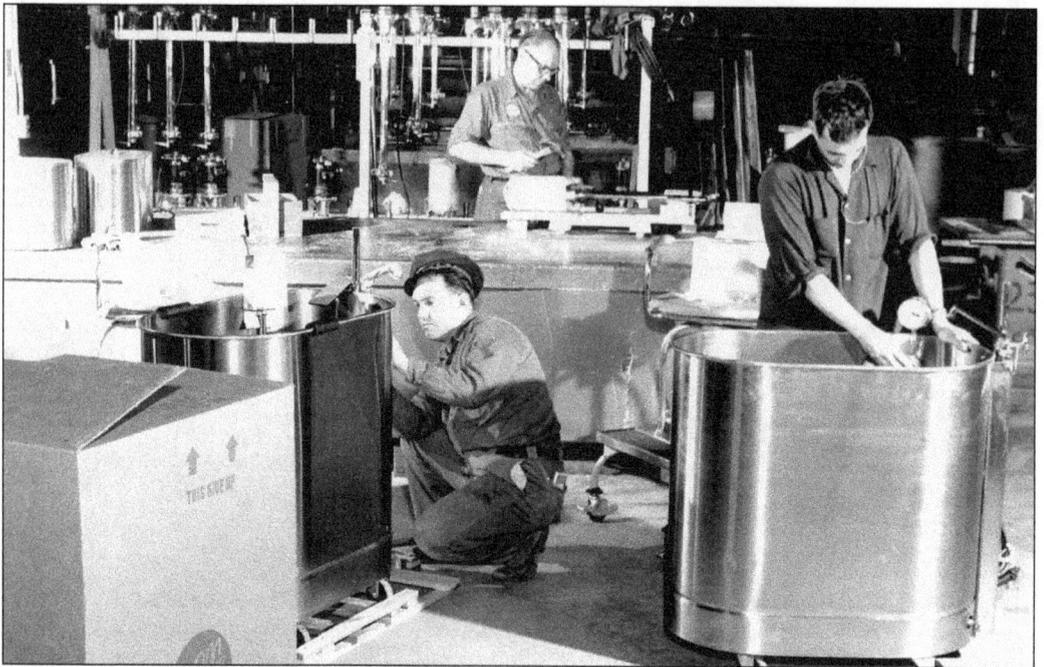

Bill Grandell (left), Olaf Johnson (back), and Bill Spooner work in the shipping department of Ille Electric Corporation, which pioneered the manufacturing of hydrotherapy equipment. The company also made moist-heat apparatus, paraffin baths, and water-purified baths and therapeutic pools at its Reach Road plant. A Williamsport industry since 1957, it sold its products to hospitals and rehabilitation centers. (June 16, 1957.)

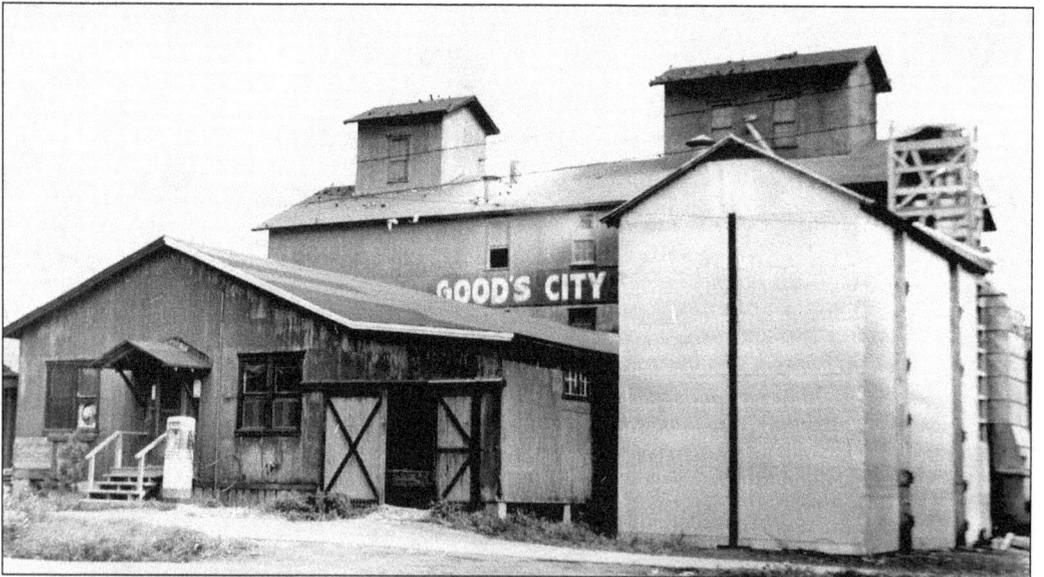

Good's City Mills occupied a block at Webb and Howard Streets in Williamsport. The new grain warehouse stands at the right. Good's was founded in 1858 by Abram Good. In 1957, it handled 70,000 bushels of wheat and turned out 2.9 million pounds of flour. In addition to wheat, the mill handled corn, oats, barley, and rye, processing about 100,000 bushels of grain annually. (July 28, 1957.)

114

James Carnevale (left) and Joseph Randello examine plans for a welding cabinet at the Vidmar Company, located at 2323 Reach Road in Williamsport's industrial park. Vidmar produced cabinet systems designed for more effective industrial storage and, at the time, was the only plant of its kind in the country. (November 9, 1958.)

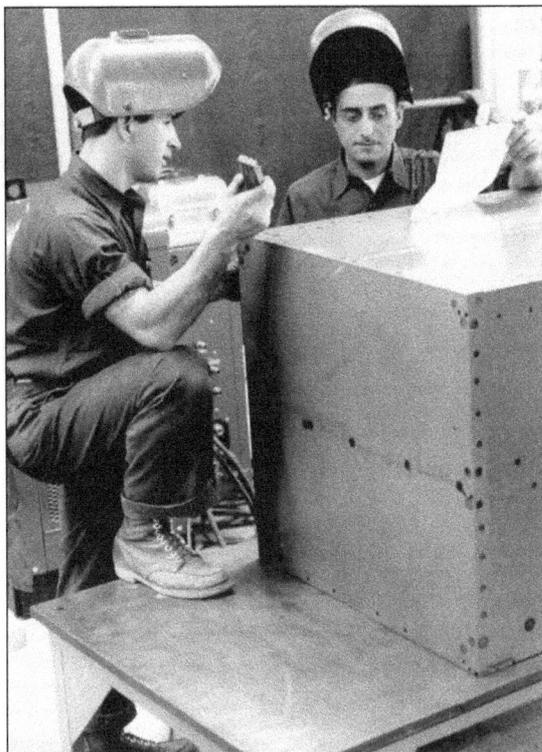

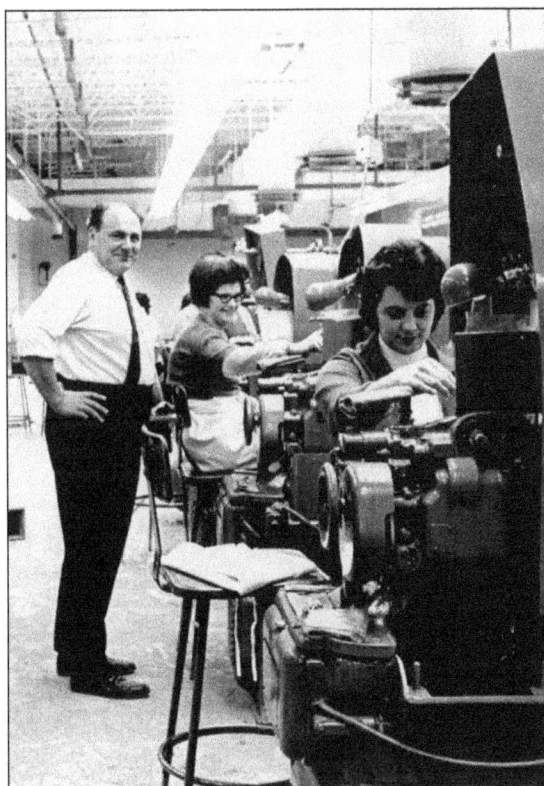

Armin W. Biedermann, executive vice president of the Iseli Swiss Screw Machine Company, watches as women operate their machines in the new industrial park plant, a 30,000-square-foot building. The firm, which manufactured precision parts for watches, cameras, and other items, trained operators at its former factory at 1221 West Third Street. (c. 1960.)

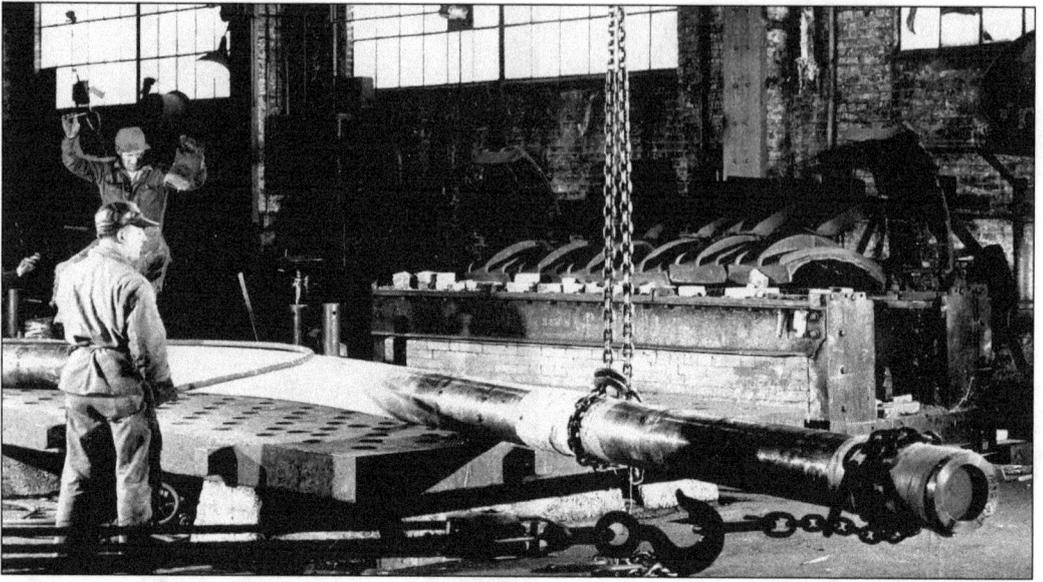

Bending long sections of heavy-walled piping was one of the most critical steps in manufacturing power-piping systems at M. W. Kellogg. Piping had to be heated to predetermined temperatures, placed on a bending table, and bent to an exact radius. Inert gas was often forced inside the pipe to ensure quality work. Note the wall thickness of the piping here being bent. (February 28, 1960.)

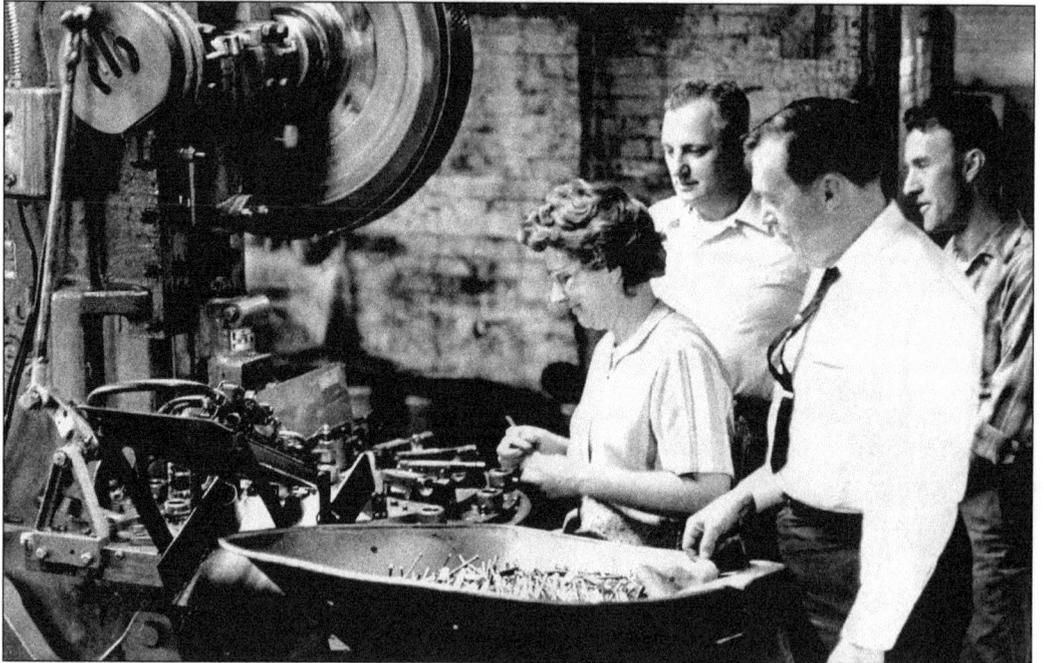

Mrs. Dale Kitchen operates a stamping machine at Keystone Friction Hinge. Watching are the new owners, from left to right, Miles C. MacGill, Grantham I. Taggart, and Lamont A. Seitzer. Custom work and specialty items made from steel and wire were produced by Keystone in South Williamsport. The company shipped furniture hardware items such as hanger bolts, corner braces, and casters. (January 16, 1966.)

Georgia Welshans places fillets of wood on adhesive backing at the Cromar Company, formerly the Crooks-Dittmar Floor Company, founded in 1919. The firm pioneered most innovations in the wood-flooring industry, including the creation of parquet. In 1966, it introduced cromoglass, a resin fiberglass casting operation that produced lightweight, durable septic tanks, water-treatment units, steam bath cabinets, and diving boards. The firm employed 175. (March 13, 1966.)

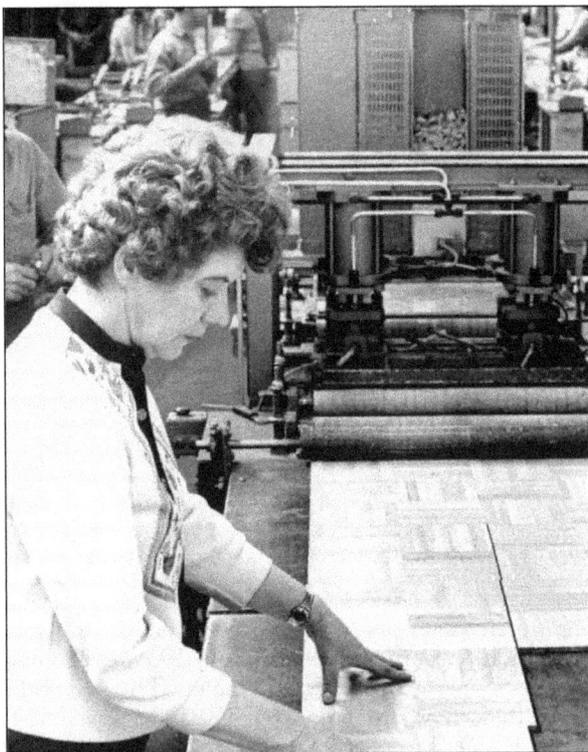

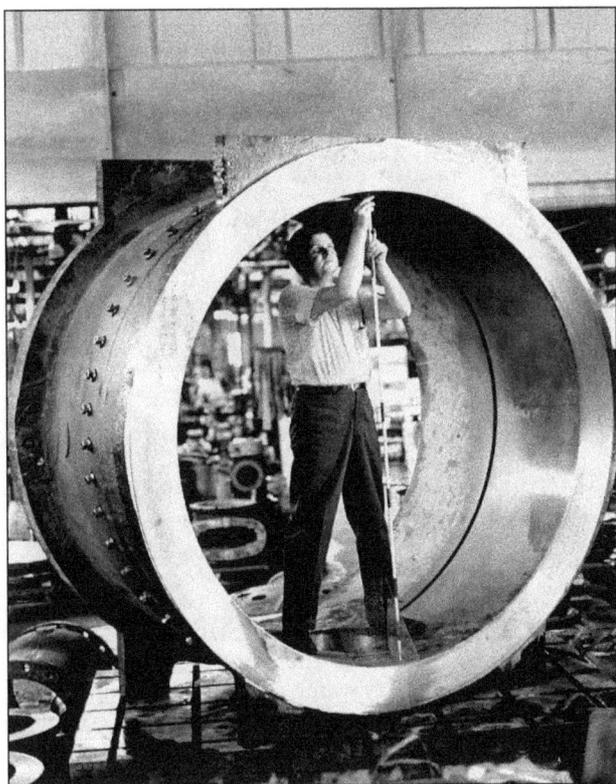

Gordon Greenly checks the 17,485-pound butterfly-valve casting to be used in regulating and controlling the flow of drinking water on the second Los Angeles aqueduct. Darling made valves—gate, butterfly, check, ball, hollow core, and surge suppressor—as well as hydrants for all nuclear, oil, water, and gas service. The company, founded in 1888 as Darling Pump and Manufacturing, employed 535. (July 24, 1966.)

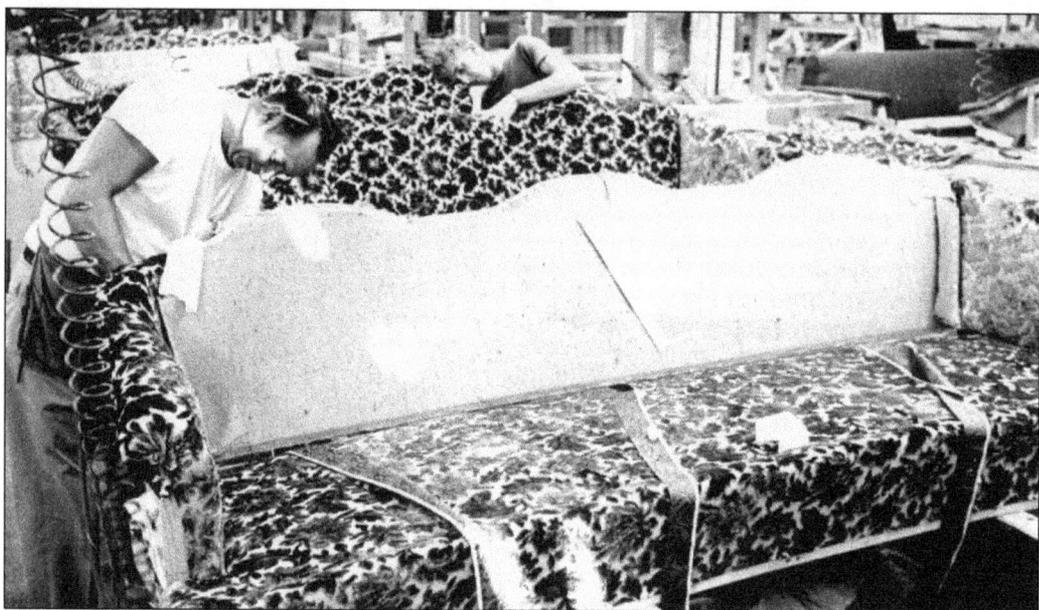

Upholsterers Emerson Shuhler (left) and David Laidacker work on sofas at the Schnadig Corporation in Montoursville. Built in 1939, the company specialized in living room furniture. Brand names manufactured there included International Furniture, Karpen Furniture, and J. L. Chase Chairs. The firm employed 450 and shipped 50 to 60 truckloads of furniture each week. James F. Reeder was plant manager, and Richard A. Rich was his assistant. (August 28, 1966.)

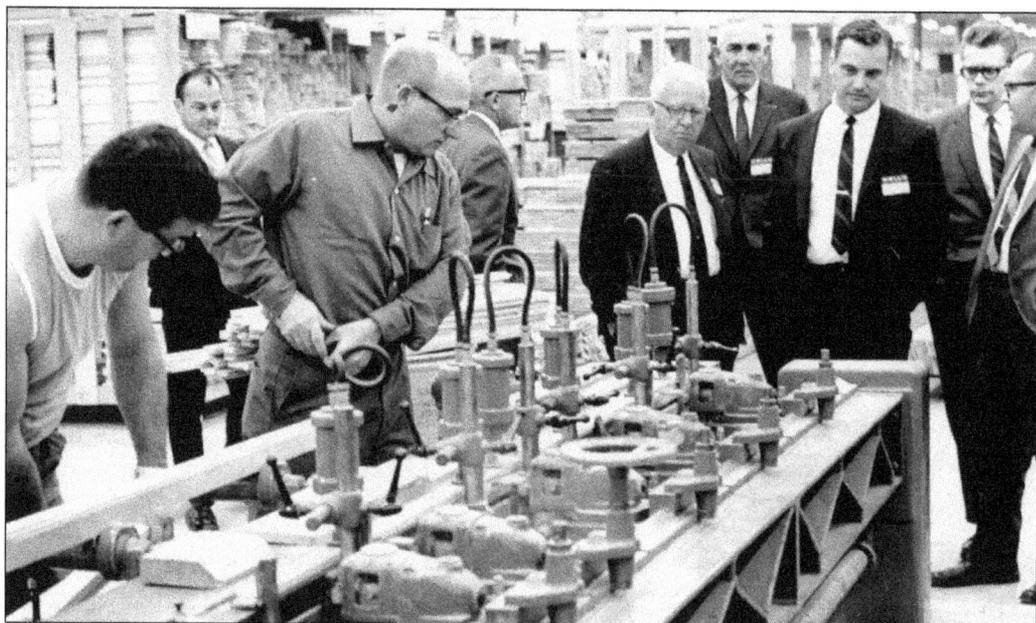

A high point of the Kemper Brothers dedication ceremonies was the plant tour that had been arranged for invited guests. Here, members of the touring party watch an employee at one of the machines in the highly animated operation. Unique features, officials said, included complete conveyorization from initial assembly through finishing, packaging, and warehousing. (October 5, 1969.)

118

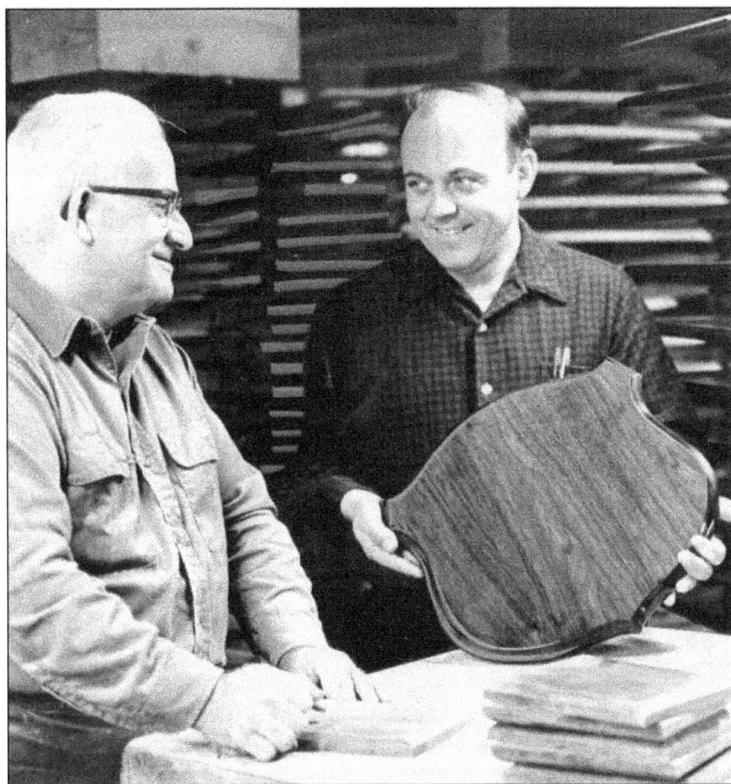

Charles E. Muffley (left) hand-rubs a panel board as he chats with Luther M. Ertel, his boss at the Nippon Panel Company, the country's oldest and largest manufacturer of game panels. The firm, located at 124 Reynolds Street in South Williamsport, produced more than 300 designs of plaques, panels, and shields for everything from miniature models to elephants. Named after the Nipponose Indians, the company was founded in 1902. (November 13, 1966.)

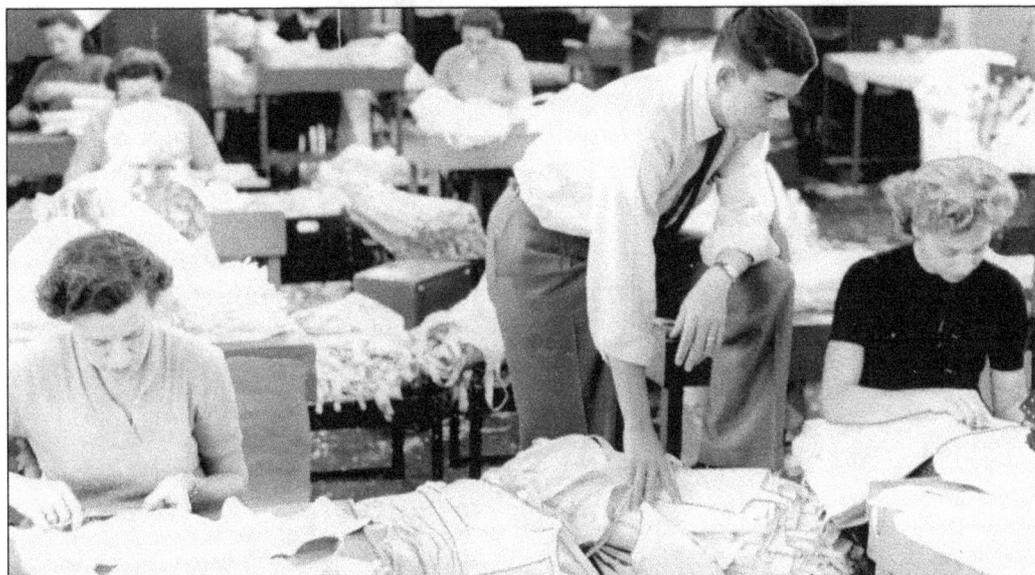

Donald Mullings, plant traffic manager, watches as Frances Burley examines the finished product at Glamourise, located at 228 Pine Street in Williamsport. The plant later moved to the industrial park, where it produced women's undergarments. It employed 220 and hired an additional 50 to 75 workers in 1959. A teletype system kept the plant in constant contact with the company's headquarters in New York City. (February 1, 1959.)

This compacting machine condenses metal into small bales at Staiman Brothers Salvage, at 201 Hepburn Street in Williamsport. In December 1970, Williamsport had three other scrap metal processing centers: the Eastern Baling Company, Simon Wrecking Company, and Minkin Industries. These companies were gearing up their operations for the fledgling recycling movement that was in full swing in that year of the first Earth Day. (December 27, 1970.)

A giant shredder and baler at Minkin Industries processed 100 tons of paper during an eight-hour shift. The recycling firm, whose main plant is at 1315 West Third Street, constructed a new fragmentizing plant in Milton at a cost of $1 million in 1972. The new facility provided central Pennsylvania with a steady supply of raw materials. (December 27, 1970.)

Nine

RETAIL AND WHOLESALE TRADE AND TRANSPORTATION

In Lycoming County, shops specialized in specific areas, often reflecting the owner's origins, and others—such as the general store—provided a variety.

In 1790, William Hepburn and Samuel E. Grier opened the first general store east of Lycoming Creek, before the borough of Williamsport was laid out. This store was located on the Deer Park Farm, at the foot of what is now Park Street. Later, a prosperous Hepburn built a brick home there. William Wilson opened the first store in Williamsport in 1801. This shop was on Third Street, at the corner of South Alley. Andrew D. Hepburn, the city's second storekeeper, opened his business on June 2, 1802. He became quite prominent, serving as county treasurer from 1806 to 1808, and was frequently appointed by the court to serve on road views and as commissioner in the division of townships. Henry Lenhart opened a drugstore in 1815 on the southeast corner of Third and Pine Streets. Before that, in 1811, he operated a hat shop.

When railroads began to connect the city with the outside region, wholesale merchants opened their doors. During the business boom after the Civil War, the wholesale trade expanded.

Specialty shops found it increasingly difficult to attract customers because general stores had widespread offerings, with convenience and one-stop shopping the main attractions. As general stores grew ever more popular, they also increased in size, becoming supermarkets or department stores. On October 11, 1889, L. L. Stearns and Sons opened as one of the most progressive stores in the region and continued operating for nearly 100 years. The store boasted electric lights and elevators, and a vacuum tube whisked sales slips and payments to the cashier's office. Stearns, always willing to experiment and try new methods, was among the first to place price tags on goods. When this merchant prince died on January 3, 1906, all dry goods stores in downtown Williamsport closed between 2 and 3 p.m. as a mark of respect.

The use of the word "supermarket" began in the late 1920s in this country. It is difficult to pinpoint the shift from small general stores to supermarkets, but one milestone was the 1859 founding of the Great Atlantic and Pacific Tea Company (A&P) by George Huntington Hartford and George Gilman.

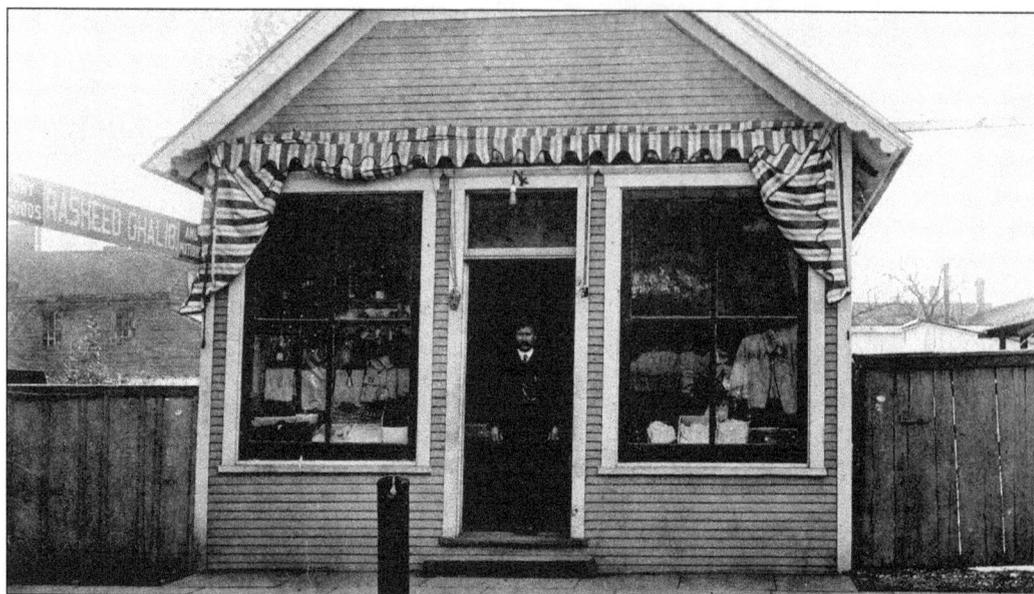

This Syrian grocery store served the needs of the urban Assyrian community in Williamsport. Assyrian immigration has passed through three distinct stages: those from Iraq and Iran, from Syria and Turkey, and from Lebanon. Because of severe economic restraints, persecution, and discrimination, early-20th-century Assyrian immigrants were encouraged by Protestant missionaries to seek fortune and higher education in the United States. (c. 1920.)

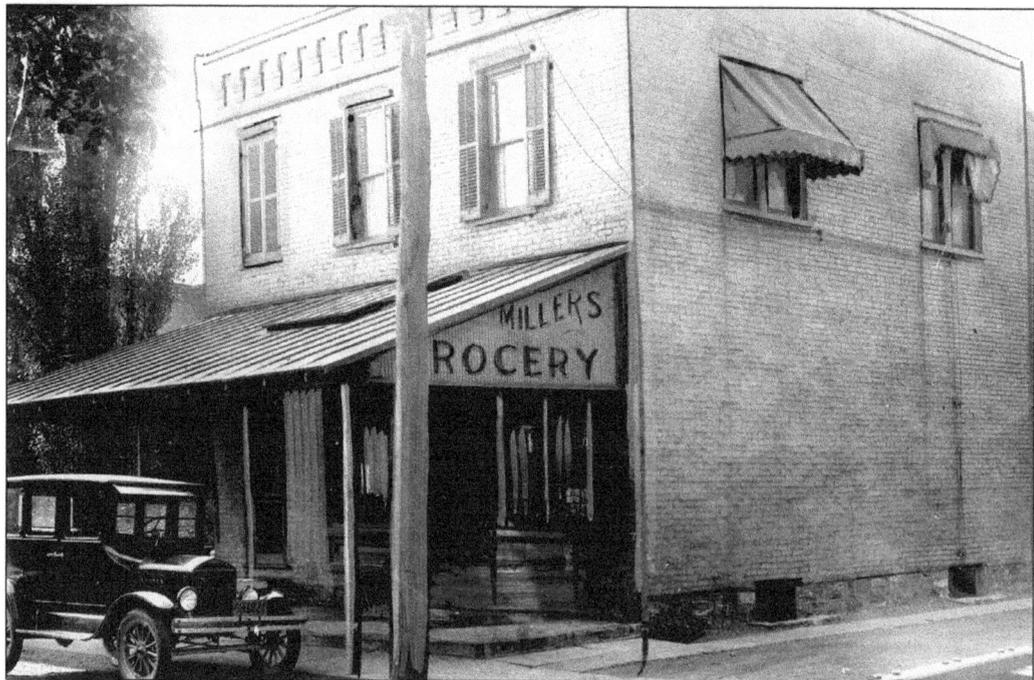

Miller's Grocery, which had been in the same family for more than a half-century, was established in 1869 by Catherine Streets. In 1925, when this photograph was taken, the store was still in business in the heart of Williamsport's Little Italy. Two daughters, Catherine Miller and Mrs. T. M. Davis, operated it then. (September 27, 1925.)

In 1928, the city council decided that a popular curbside market had to go because of threats to public safety and traffic control. Vendors had until October to find an indoor location. After that, a city ordinance would remove the salespeople and hucksters. A local developer suggested building a large, indoor growers' market, a plan that was later realized. (July 29, 1928.)

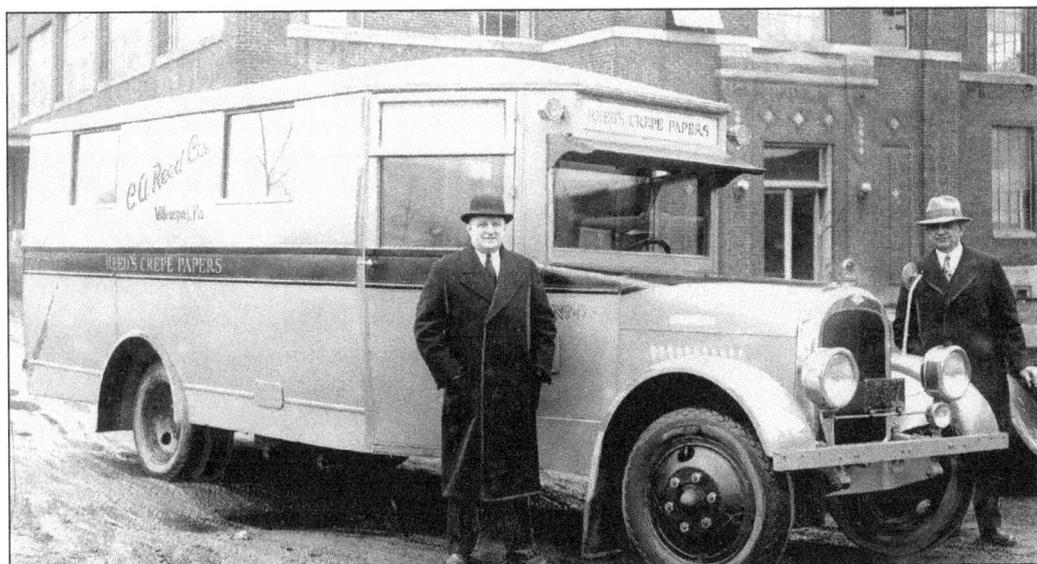

This motorbus was equipped inside as a shop for the C. A. Reed Paper Products Company. Reed used the bus to promote its various products, exhibiting crepe paper novelties and favors to its customers and retail dealers. Instead of having a salesperson carry a number of large trunks with him and arrange displays in hotel rooms, the company invited its buyers to step inside the traveling showroom. (March 10, 1929.)

A woman purchases a Thanksgiving chicken instead of a turkey in 1944 at the Growers' Market, located at 210 Market Street. Turkeys were in short supply that year. The market served Williamsport-area consumers for more than 40 years, in business from February 7, 1931, until October 27, 1973. (November 19, 1944.)

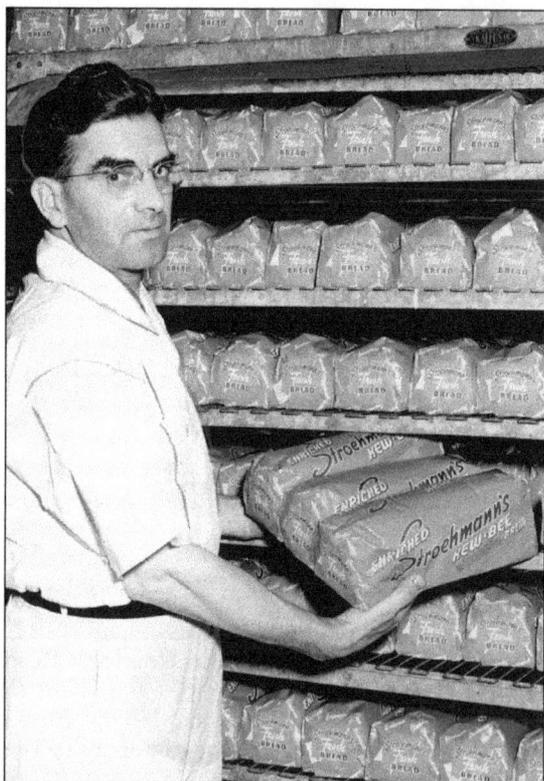

Clarence Mattoon had been with Stroehmann's Bakery of Williamsport for more than 25 years when this photograph of him was taken in July 1948. He worked in various departments, serving as a truck driver, maintenance man, shipping clerk, salesman, and later supervisor of both retail and wholesale trade. Stroehmann's was headquartered in Williamsport until its takeover by a Philadelphia-area firm. Stroehmann's still maintains a roll plant in Old Lycoming Township. (July 11, 1948.)

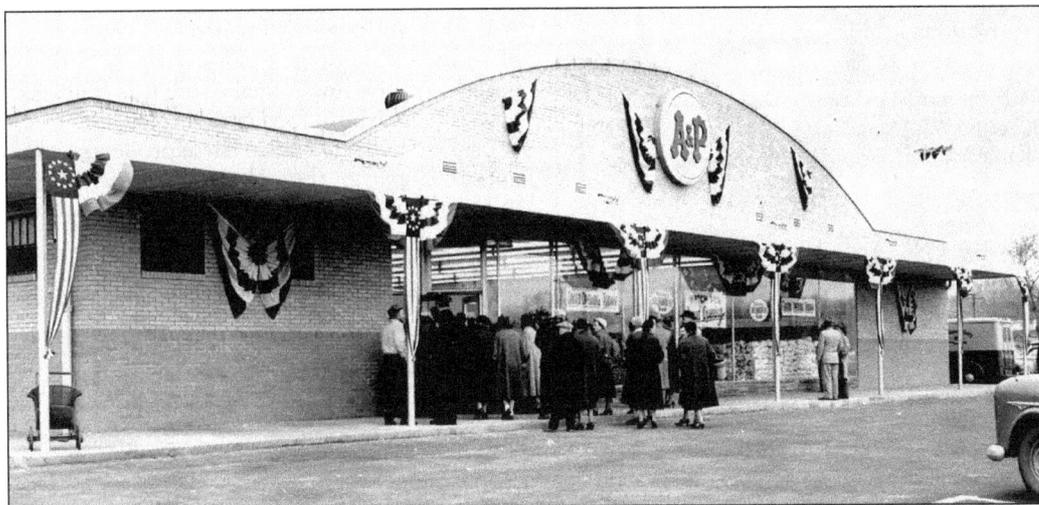

The opening-day crowd enters the new A&P market on River Avenue at Washington Boulevard. The store featured parking spaces for 280 cars, a parcel post pickup system, and self-service departments for meat, produce, frozen foods, baked goods, and dairy products. Founded in 1859, A&P fought its way back from financial distress and now operates 649 stores nationwide. (December 5, 1954.)

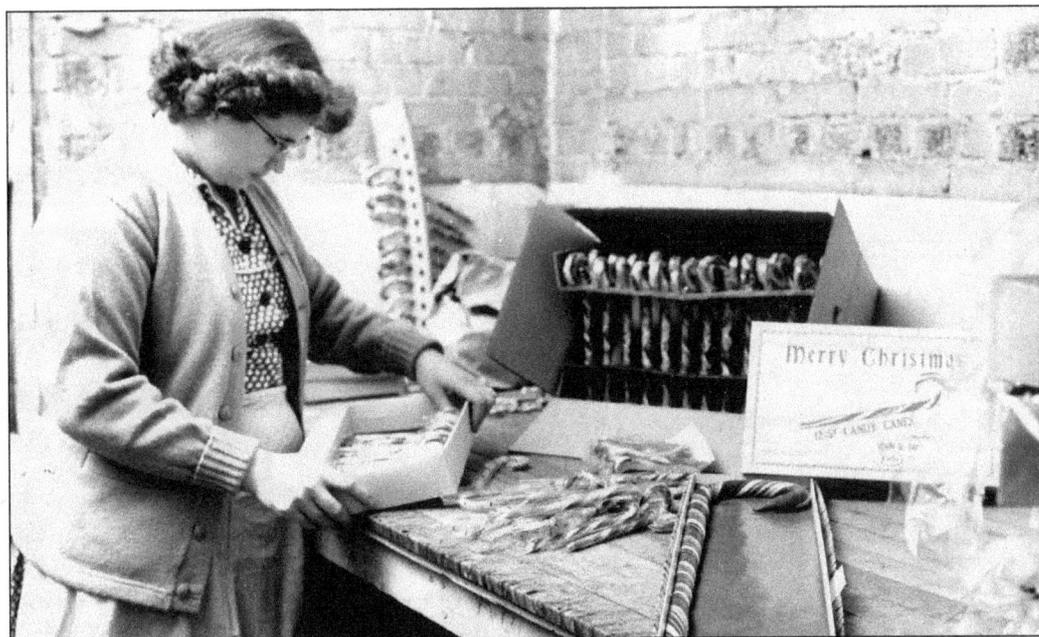

Jean Lynch packs candy for shipping at the John H. Dieter and Sons Candy Company, one of Williamsport's largest candy makers at the time. Founded in 1906, Dieter's dealt with wholesale customers but, in 1951, entered the retail market. It produced more than 200 different candy items. All the candy was made using hand-poured molds. More than 300,000 candy canes were produced during the Christmas season of 1954. (December 12, 1954.)

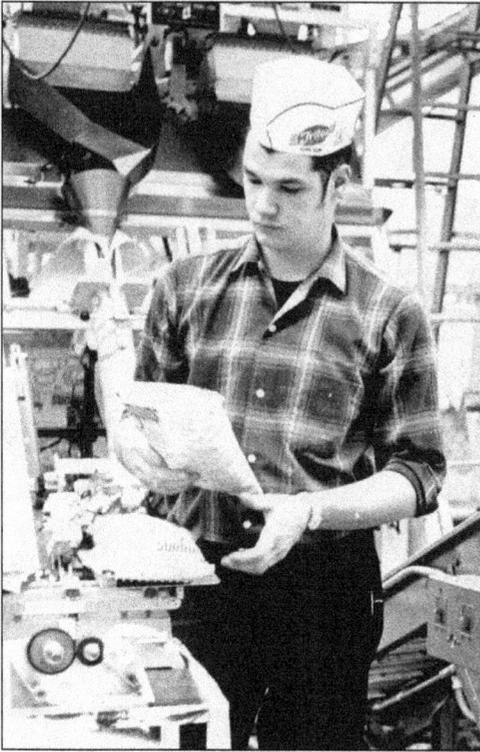

A worker at the newly opened Frito Lay plant in Williamsport's industrial park pulls a product off the line to make sure it is packaged properly. The junk food craze in the post–World War II years made these products an important part of the industrial scene, not just in Lycoming County but throughout the rest of the nation. (January 24, 1971.)

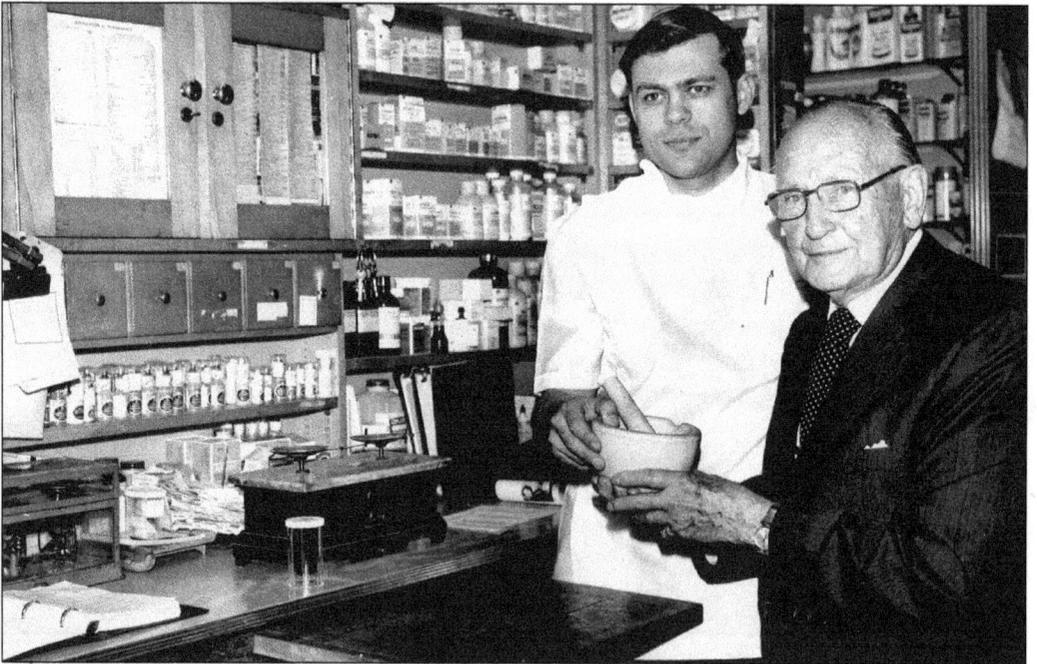

A Williamsport drugstore changes hands. Willis C. Dice (right), 85, owner and operator of the Dice Drug Company for 59 years, sold the firm to Gerald Bower of Castanea and his father, Norbert Bower, of Williamsport. The young Bower continued to operate under the name Dice Drug Company. The company closed during the 1990s. (July 7, 1974.)

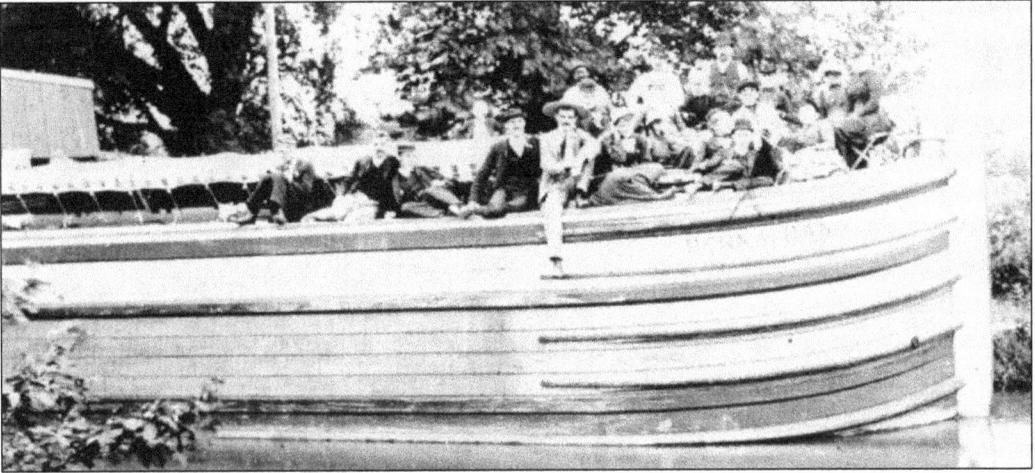

Packet boats like this on the West Branch Canal near Muncy were popular during the mid-1800s. A delightful way to travel if one was unhurried, the old packet boats ran twice a week from Williamsport to Northumberland, where transfer could be made for points east. The craft carried mail and express as well as passengers. (c. 1880.)

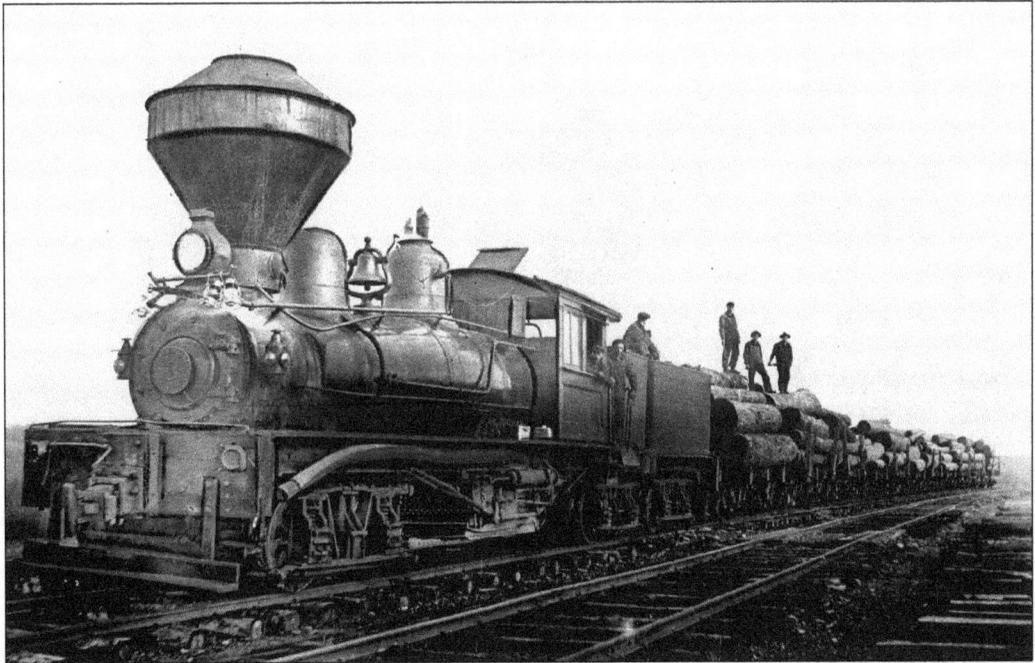

Trains were the main means of conveyance for transporting cut logs and timber from forests to be processed at sawmills and planing mills during the height of the lumber era. Logs that could not be handled locally were hauled to the West Branch of the Susquehanna River and placed in the log boom that stretched for more than 20 miles above Williamsport. (August 2, 1936.)

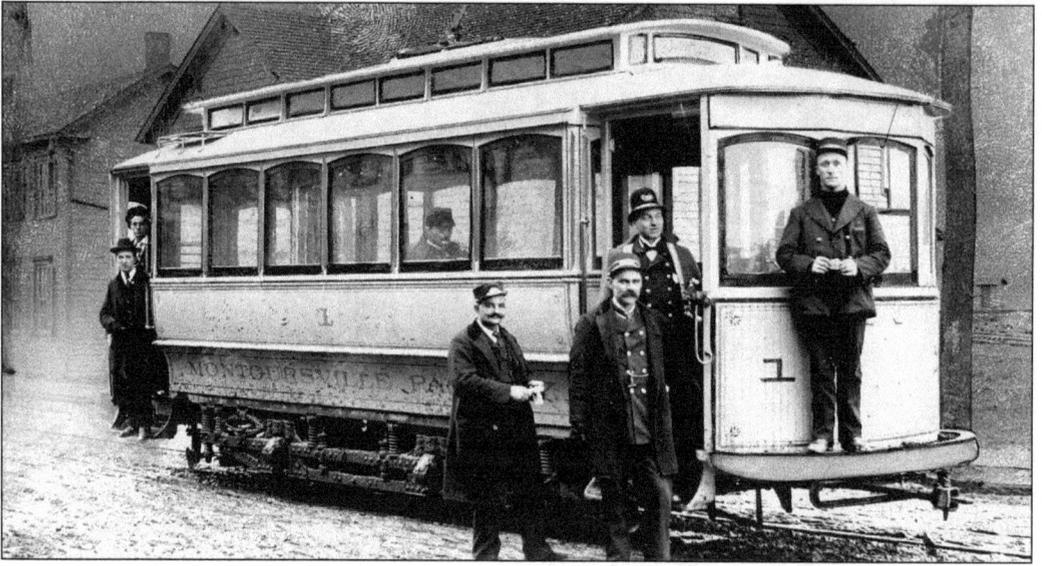

On April 15, 1863, Gov. Andrew G. Curtin signed a charter creating the Williamsport Passenger Railway Company. Shown here is one of the streetcars that traveled from Williamsport to Montoursville in the early 1900s. Until the advent of the passenger bus and the automobile, streetcars were a major mode of transportation. The barn for many of the streetcars was in the Vallamont area of Williamsport, at the corner of Glenwood Avenue and Cherry Street. (c. 1890.)

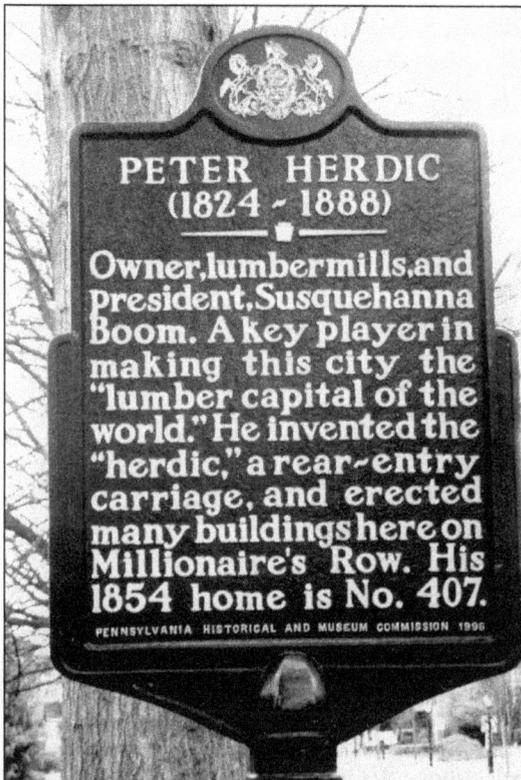

Peter Herdic, a Williamsport entrepreneur, invented a horse-drawn carriage called the Herdic in 1878. Seen as a predecessor to the taxicab, the first Herdics seated eight passengers. Painted a bright yellow, they were soon nicknamed "canaries." They used a special patented axle. Herdics went right to curbside and deposited passengers at their doorsteps.

www.ingramcontent.com/pod-product-compliance
Lightning Source LLC
Chambersburg PA
CBHW050651110426
42813CB00007B/1982